NICHOLAS POCOCK
1740–1821

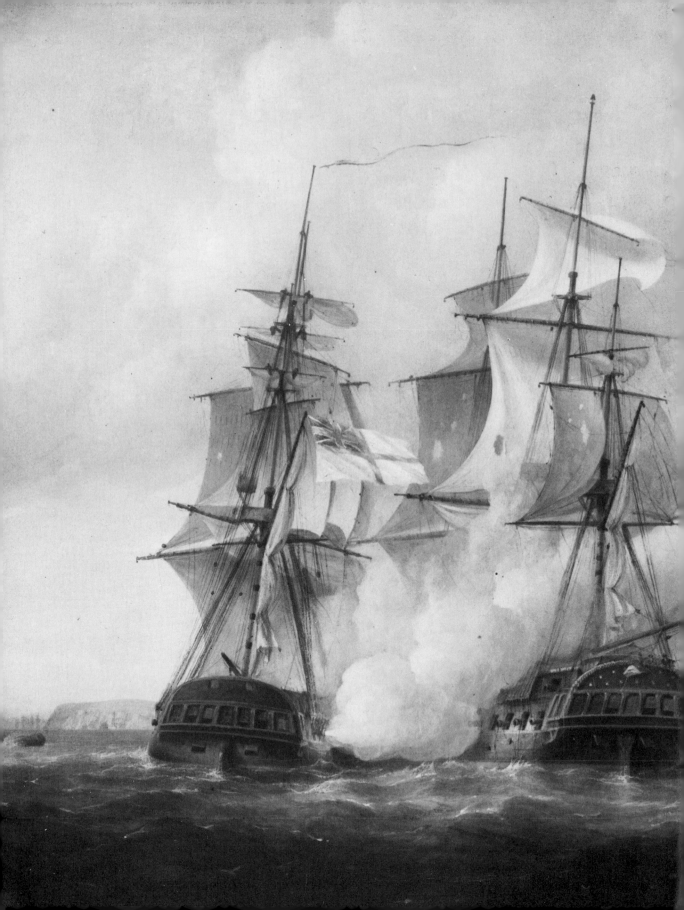

NICHOLAS POCOCK
1740–1821

DAVID CORDINGLY

NAVAL
INSTITUTE
PRESS

CONWAY MARITIME PRESS IN ASSOCIATION WITH
THE NATIONAL MARITIME MUSEUM

Dedication
To the memory of
my father
Bishop Eric Cordingly

Frontispiece: The Capture of the *Resistance*
and *Constance* (see page 10).

© 1986, The Trustees of the National Maritime Museum
First published in 1986 by Conway Maritime Press Ltd
24 Bride Lane, Fleet Street, London, U.K.

Published and distributed in the United States of
America and Canada by the Naval Institute Press,
Annapolis, Maryland 21402

Library of Congress Catalog Card No. 86 - 61107

ISBN 0-87021-993-6

This edition is authorized for sale only in the
United States and its territories and possessions,
and Canada

Printed and bound in Great Britain

CONTENTS

BLACK-AND-WHITE PLATES

FOREWORD

This book was originally conceived as a commentary on Nicholas Pocock's illustrated logbooks and was intended to accompany facsimile editions of two of the logs. Unhappily the project came to nothing and I abandoned research on the artist for several years. I am therefore most grateful to Jane Weeks and Robert Gardiner for deciding that a life of Pocock was a good subject to launch their series of monographs on marine artists. Encouraged by them I have undertaken fresh research on the artist, concentrating particularly on his naval patrons and on the marvellous series of Pocock paintings and watercolours in the National Maritime Museum.

I have received help from a variety of sources but I would particularly like to acknowledge the assistance of a Leverhulme grant in the early stages of the research, and to record my debt to Francis Greenacre of Bristol City Art Gallery who has generously supplied me with information, and whose exhibition 'Marine artists of Bristol' was a valuable survey of Pocock's early life and work. Pieter van der Merwe, an authority on the dramatist Isaac Pocock, has frequently supplied me with useful facts, and Alan Pearsall has suggested avenues of research and answered many questions. The Conservation Department at Greenwich have been most helpful about Pocock's painting methods, and I am grateful to Westby Percival-Prescott and Elizabeth Hamilton-Eddy for their advice. I would also like to thank Marie Richardson and the staff of the Photographic Department at Greenwich for providing high quality photographs so promptly and efficiently.

Members of the Pocock and Champion families have given me much assistance and I would especially like to thank Pat Bryan, Kathleen Pocock and Tom Pocock. Owners of Pocock paintings have always been helpful and I would like to thank Lord Hood and John Hill in particular. I am also grateful to the staff of all the museums, art galleries, libraries and other institutions who have kindly answered my queries including Eileen Black, David Brown, J E C Clarke, Roger Cucksey, R O Dennys (Somerset Herald of Arms), Jane Farrington, James Hamilton, Rosalinda Hardiman, Sarah Hyde, John Lavender, Harley Preston, Alexander Robertson, David Scrase, Robin Simon, Robin Thomas, M L Timothy, Norma Watt, Stephen Wildman, and Mary Williams.

Finally I would like to thank Rowena Bowater and Rosemary Clarey for typing the manuscript, Richard Ormond for much advice and my wife Shirley for her patience and support during a lengthy period of research.

D C Brighton
 September 1985

SHORT CHRONOLOGY

1740 May 2. Nicholas Pocock is born in Bristol, the eldest child of Nicholas Pocock, mariner, and Mary, née Innes.

1742 May 28. Baptised at St Stephen's Church, Bristol.

1757 March 22. Apprenticed as a seaman to his father and mother for 7 years.

1766 October 18. The ship *Lloyd*, with Pocock as master, sails from Bristol bound for Charleston, South Carolina. This is Pocock's first recorded voyage.

1766–9 Makes six voyages to Charleston as master of the *Lloyd*.

1770 Voyage to the Mediterranean in the *Betsey*.

1771–6 Makes six voyages to the West Indies, two in the *Lloyd* and two in the *Minerva*.

1774 Registers as a burgess at Bristol.

1780 February 10. Marries Ann Evans of Bristol. May 4. Receives encouraging letter from Sir Joseph Reynolds.

1782 Exhibits for the first time at the Royal Academy

1784–6 Paints five pictures of West Indian actions for Lord Hood.

1789 Moves from Bristol to 12 Great George Street, Westminster.

1790 Paints *Woolwich Dockyard*, the first of two large pictures for the Navy Board.

1791 Paints a series of views of Iceland for Lord Stanley.

1792 Sketching tour in Snowdonia, North Wales.

1794 On board the frigate *Pegasus* during the battle of the Glorious First of June.

1805 Shows 17 pictures at the first exhibition of the Old Water-Colour Society.

1809 Publication of Clarke and McArthur's *Life of Admiral Lord Nelson*, with engravings after Pocock's paintings.

1815 Exhibits for the last time at the Royal Academy.

1817 Exhibits for the last time at the Old Water-Colour Society. Moves from Westminster to Bath.

c1818 Moves to Ray Lodge, Maidenhead, the home of his eldest son Isaac.

1821 March 9. Death of Nicholas Pocock at Ray Lodge. He is buried at Holy Trinity Church, Cookham.

FAMILY TREE

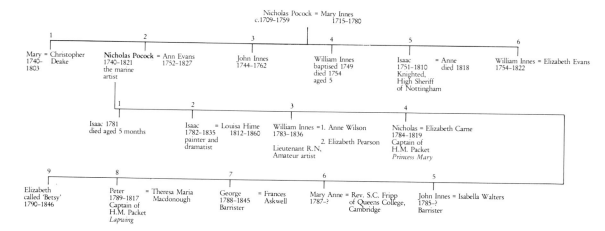

INTRODUCTION

In 1809, four years after the battle of Trafalgar, a book was published in London entitled *The Life of Admiral Lord Nelson, K. B.* It was an impressive work in two volumes and was written by the Reverend James Clarke, librarian to the Prince Regent, and John McArthur, late secretary to Admiral Hood. The illustrations included six engravings. One of them was an imaginary composition portraying the various ships in which Nelson served (plate 2). Three of them depicted the battles of Cape St Vincent, the Nile, and Copenhagen. Two of them were aerial views of the battle of Trafalgar in its opening and closing stages. All the engravings were taken from oil paintings by an ex-seaman from Bristol called Nicholas Pocock.

The choice of Pocock to supply the most important pictures in the official biography of Nelson was in some ways surprising. His background as an artist was unusual. He had taught himself to draw and did not take up painting as a profession until he was nearly forty. Much of his early life was spent at sea, and his artistic activities were almost entirely restricted to pen and ink drawings in his ships' logbooks. Although he exhibited regularly at the Royal Academy from 1782 onwards, he never became an Academician. His small, minutely detailed pictures were overshadowed at Somerset House by the historical paintings of Benjamin West and James Northcote, and by the dramatic sea pieces of de Loutherbourg.

However, the admirals who commissioned paintings of sea battles, and the captains who ordered ship portaits were less concerned with a painter's artistic qualifications than with his knowledge of seamanship. He must of course be able to paint a life-like picture, but an understanding of the complex rigging of a frigate was more important than a mastery of figure drawing. The correct setting of particular sails and the degree of tension on the sheets and braces which controlled the sails was of more interest to a naval patron than a beautifully rendered sunset. In this highly specialised branch of painting Nicholas Pocock's seafaring background was invaluable.

Many of the great Dutch and English marine artists had some experience of the sea, but none had a more thorough grounding than Pocock. He was born and brought up within a few yards of the quayside at Bristol which for much of the eighteenth century was still the second largest port in Britain. He was the son of a seaman, and was apprenticed to his father at the age of seventeen. By the time he was twenty-six he was master of a merchant ship bound for Charleston in South Carolina. After six return voyages across the Atlantic the hostilities with the American colonists, which were to culminate in the American War of Independence of 1776, compelled his employer to transfer his trading

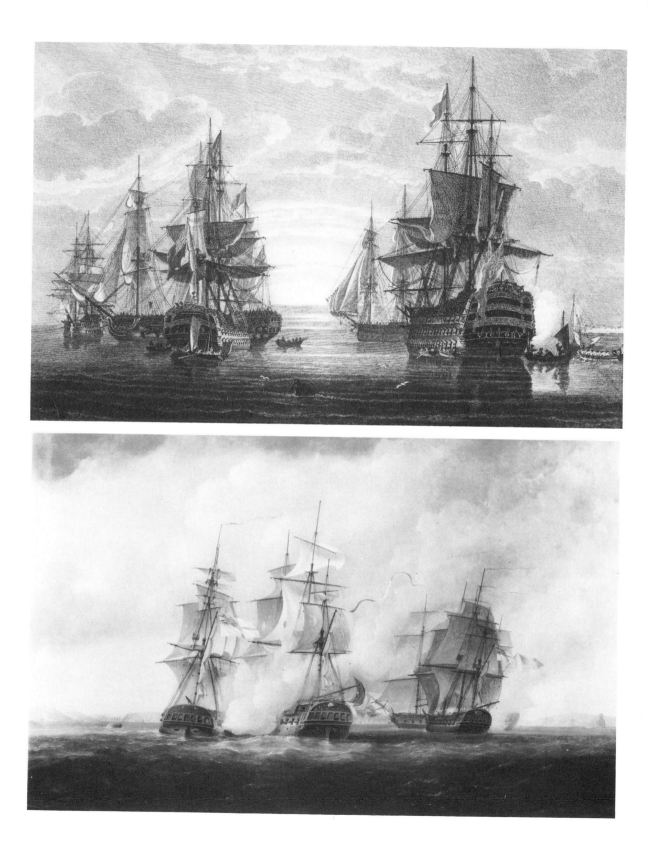

activities elsewhere. Pocock was sent first to the Mediterranean and then to the West Indies. During these sea-going years Pocock not only commanded ships in every type of weather, but also visited a number of places which were later to be the scene of famous naval actions. He was, for instance, able to draw on his local knowledge when he was commissioned to paint Rodney's victory at the battle of the Saints, and Hood's series of engagements against the French Fleet at Basseterre. Pocock also had the rare opportunity for an artist of witnessing a major fleet action from close quarters. In 1794 he was on board the frigate *Pegasus* during the battle of the Glorious First of June. He took the opportunity to fill a journal with sketches and notes describing the course of the battle.

In addition to the breadth of his seafaring experience, Pocock had a passion for accuracy. The collections at the National Maritime Museum include a number of his annotated drawings and sketch plans which show the homework he carried out before starting work on a painting. There is, for example, a pencil drawing of two ships off a coast underneath a plan of the coastline. The plan shows the position of the ships, while a cross and dotted lines, and the words 'Point of view' indicate the particular angle from which he decided to view the scene. In pen and ink at the bottom of the page is written, 'Mr. Pocock has left the note to Captain Hotham open in hopes Lady Edmondstone will have the goodness to look over Mr. P's. remarks on the Plan this choice of the point of view previous to forwarding it to Capn. Hotham'. Elsewhere on the drawing, in another hand, is written 'Approved H. Hotham'.[1]

The naval patrons did not always approve Pocock's sketches but required some alterations to be made. In 1797 he was working on a picture portraying the daring capture of two large French frigates within sight of the French fleet at Brest, by Sir Harry Neale in the *San Fiorenzo*. Pocock prepared his usual sketches and received a fascinating letter from Sir Harry Neale commenting on them.

The ships in Brest Harbour should be more distinct,
& five sail should have their topsails hoisted ready to come
out (which was the case). Mr. Pocock may place the ships
as they are in the sketch, or as they were during the Action.
The two English engaging the *Resistance*, which perhaps would
look better; either would be correct as when the *Resistance*
struck, the *Nymph* directly engaged the *Constance*; and from
Point St. Mathews to Brest signals were flying to give
information to the Port Admiral at Brest. That little spot
near the Ships is intended for the Parquet Rock from which
they were half a mile – I did not mean to include the Frame
in the Twenty-Five Guineas.[2]

The artist prepared further sketches and noted on the bottom of one of them, 'Mr. P. thinks this better as to the disposition of the ships being more extended.' Although some of Pocock's oil paintings have a lifeless air as a result of his excessive attention to detail and the wishes of his patrons, his picture *The capture of the Resistance and Constance* survived the careful preparations (plate 3). It is one of his most successful

portrayals of a naval action: he has captured the sparkle of a fresh spring day in the Channel and has produced a masterful composition from the swirling shapes of sails and flags, and the skilful placing of highlights and shadows.

By the time he reached his eightieth year, Pocock had recorded nearly forty years of maritime history. He had exhibited 183 pictures at the galleries of the Old Water-Colour Society and 113 pictures at the Royal Academy. He had filled numerous sketchbooks with hundreds of drawings, and he had published a large number of engravings. Yet in spite of this legacy, there is practically nothing to tell us what sort of man he was. The only observations on his character which have survived are the few words noted by Sarah Champion, the sister of his employer, Richard Champion. They refer to Pocock when he was still a young man in his twenties.

> In the intervals when he was not at sea,
> he spent much time at my brother's, and never seemed
> happier but when there. Having a fine taste for drawing,
> he sometimes talked of giving up the sea. Although not
> highly educated, he was a stranger to that failing too
> often attendant on want of mental culture; for I have
> usually remarked that ignorance and conceit usually
> accompany each other, but this, Captain Pocock's good
> sense and diffidence preserved him from.[3]

The letters written by Pocock's naval son, William, to his parents suggest that Pocock had a happy marriage and was a devoted father to his eight children. The few surviving letters written by Pocock himself are largely concerned with his work. They are of considerable interest because they describe his method of painting, the prices he charged, his relationship with publishers and patrons, and the attention which he paid to such details as picture frames. But they tell us nothing about his personality beyond the fact that, like so many artists and craftsmen, his work dominated his life.

But at least we have a good picture of him. The portrait by his eldest son, Isaac, gives the appearance of being an excellent likeness (plate 1). It reveals a handsome man with gentle eyes and a kindly expression. There is also a certain air of authority about the face, which is a reminder that he must have acquired the habit of command during his years as a sea captain.

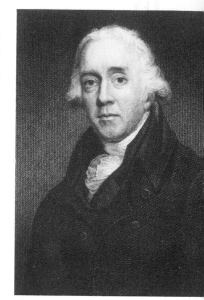

Plate 1
Portrait of Nicholas Pocock
National Maritime Museum, London
This engraving is after a painting by Isaac Pocock, the eldest son of the marine artist. Isaac was a pupil of George Romney and Sir William Beechey. He exhibited portraits at the Royal Academy every year between 1803 and 1818.

THE YEARS AT SEA

'At 7 this morning came down from Bristol Quay' are the opening words of the logbook recording Pocock's voyage to Charleston in 1768. Bristol was the starting point for all his ocean voyages and it was also his home for the first fifty years of his life. The quays were situated along the banks of the river Frome at the point where it joined the river Avon (plate 4). They were lined by warehouses and were continually crowded with sailing vessels of all sizes. An observer estimated that in the coastal trade alone 'about one thousand three hundred vessels of various burthen arrive annually.'[1]

In the 1780s, after retiring from the sea, Pocock devoted much of his time to painting views of the port and different aspects of the river Avon. Two of these views show the port in some detail. One picture depicts the southern end of the harbour area with the church of St Mary Redcliffe, in the background (plate 5). On the right are two ships on the stocks in the course of construction, and on the left of the picture can be seen the sailing vessels moored alongside the quayside – it has been suggested that Pocock may have included his own ship among them. The other picture is a general view of the port seen from the south bank of the Avon and is of particular interest because it includes the area where Pocock was born and brought up (plate 6). Rising above the

Plate 4
Bristol harbour in 1773
Bristol City Art Gallery and Museum
This detail from Benjamin Donne's map of Bristol shows the docks and quays along the city's waterfront. Prince Street, the home of Nicholas Pocock and his family for many years, is just to the east of The Quay which runs alongside the river Frome.

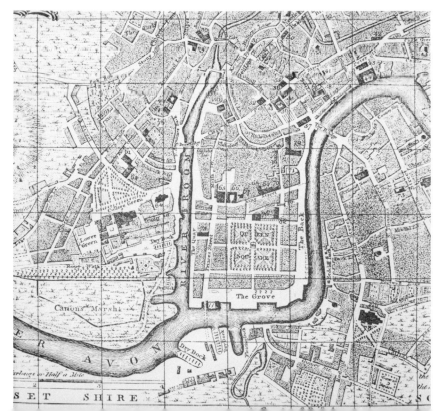

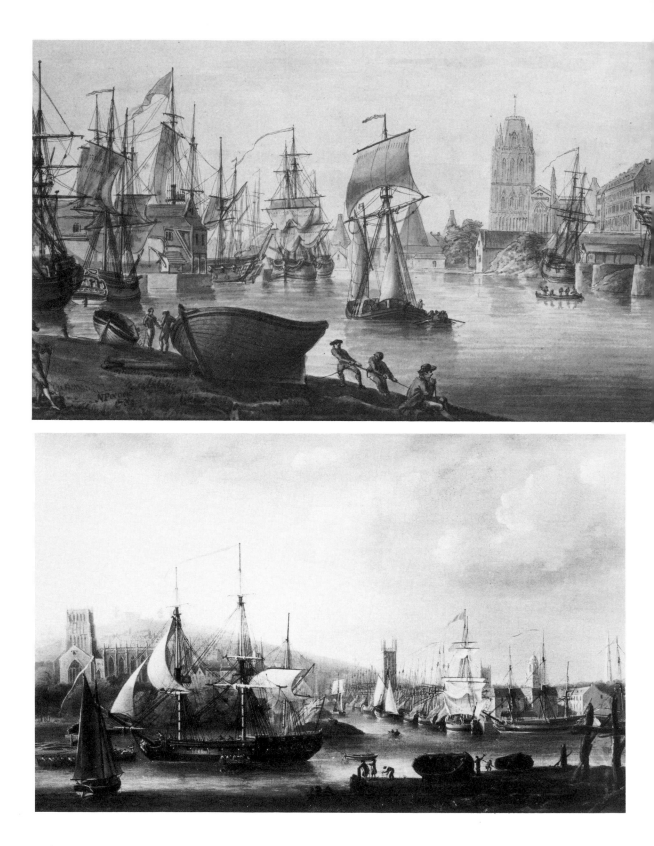

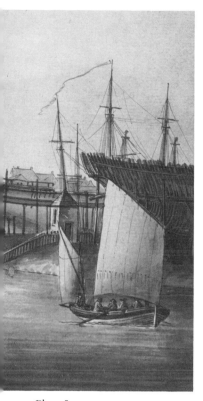

masts near the centre of the picture is a slender tower. This is the church of St Stephens where Pocock and his brothers and sisters were baptised.[2] Between the church tower and the end of the quay on the right lies Prince Street[3] which was his home for more than half his life.

Although the ratebooks for this period are incomplete they show that Pocock's father was living in Prince Street from 1756 until his death in 1759, and his mother was still living there in 1775.[4] The ratebooks do not give the house numbers but fortunately there is an entry in the earliest of the street directories which records than in 1775 Nicholas Pocock, captain of the *Minerva*, was living at 41 Prince Street.[5] A charming watercolour by Edward Cashin (plate 7) shows the appearance of the street in 1825 and it looked much the same fifty years earliers.[6] Houses with odd numbers were on the east side of the street so that number forty-one would have been on the right-hand side of the picture, just beyond the barrels in the foreground.

Very little is known about Pocock's parents. His father was Nicholas Pocock who has usually been described as a Bristol merchant. However two documents in the Bristol Record Office, which until recently were overlooked, clearly describe him as a mariner. The first is an entry in the Apprentice Book. The second reference is contained in the Burgess Book. When Pocock the marine artist was thirty-four years old, he applied for the right to vote and it was duly recorded that on 6 October 1774, 'Nicholas Pocock, Mariner, is admitted into the liberties of this City for that he is the Son of Nicholas Pocock, Mariner deceased, and has taken the Oath of Obedience and paid 4s 6d.' It is possible that Pocock senior was a shipmaster who owned his own ship and carried on his own trade as a merchant. This was fairly common practice in the eighteenth century.

Pocock's mother was Mary Innes who came from an ancient Scottish family with aristocratic forbears.[7] The couple were married on 2 November 1739 in the church of St Mary Redcliffe. They had six children: Nicholas, Mary, William Innes, (who died aged five), John Innes, Isaac, and William Innes, who was to sail with his eldest brother on several of his voyages.

There has been some confusion about the date of Nicholas Pocock's birth and it has usually been given as 1741. According to William Berry, who recorded details of the Pocock family in his *Berkshire Genealogies* published in 1837, Pocock was born on 2 May 1740 and all the evidence points to this as being correct. In 1811 Nicholas Pocock and his brother William approached the College of Arms[8] and were duly assigned a coat-of-arms and crest for their family (plate 8). Details of family births and deaths would have been lodged with the Heralds and although these details are now missing they must have been noted by William Berry who was Registering Clerk in the College of Arms for fifteen years. Further confirmation of the year 1740 is provided by the memorial tablet to Pocock in Cookham church and by his obituary in *The Gentlemen's Magazine*.[9] Neither of these give his date of birth but they both record that he died on 9 March 1821, and the former adds that he

Plate 5
Bristol harbour looking towards St Mary Redcliffe
Victoria and Albert Museum, London
Pocock painted several versions of this scene. This watercolour is dated 1784 and shows the southern end of the harbour area with the shipyards and dry-docks on the right. In the distance can be seen the church of St Mary Redcliffe and the terraced houses of Redcliffe Parade. On the left numerous merchant vessels are moored alongside the Grove.

Plate 6
Bristol Harbour with the Cathedral and The Quay
City of Bristol Museum and Art Gallery
Dated 1785 this painting shows the area where Pocock was brought up. In the centre is The Quay which was the starting point for all his voyages. The slender tower rising above the masts is that of St Stephen's Church. The Cathedral is on the left.

was aged eighty and the latter that he was in his eighty-first year.

Nothing definite is recorded about Pocock's early years until he was seventeen. Presumably he and his brothers spent much of their time playing in small boats in the harbour since the quays were within a hundred yards of their house. It is possible that he went on a few coastal passages in the Bristol Channel and he may even have sailed further afield with is father. Two months before his seventeenth birthday, however, he was formally apprenticed and began his seafaring training in earnest: '1757 March 22, Nicholas Pocock, son of Nicholas Pocock, mariner, apprenticed to his said father and Mary his wife for 7 years'.[10]

On 10 January 1759 Pocock's father died, and it must be assumed that Pocock continued with his apprenticeship for the requisite number of years to be able to qualify as a ship master. It must also be assumed that friends of the family stepped in to support them at this time. Not only financial help would have been necessary, but influence in shipping circles in order to secure Pocock command of a merchant vessel. The help came from the Champion family, and it seems likely that in the first place it came from Richard 'Gospel' Champion (1704-1766), a merchant who was the uncle of the Richard Champion who later became Pocock's employer. In 1759, when Pocock's father died, the young Richard Champion was only fifteen years old and was in London completing his education. He returned to Bristol in 1762 and entered the office of his uncle where he 'acquired the regular habits of a man of business'.[11]

The Champion family was prominent in the maritime and mercantile affairs of Bristol throughout the eighteenth century. William Champion, for instance, was the first man to suggest a scheme (adopted many years later) for introducing lock gates and creating a 'floating harbour' which would be unaffected by the tide; he also constructed a large wet dock on the banks of the Avon in 1765. The young Richard Champion was the most ambitious and resourceful member of the family. He had many interests but is chiefly remembered for his enterprising scheme to manufacture hard-paste porcelain in Bristol. In 1772 he opened a factory in Castle Green which for a brief period of thirteen years produced considerable quantities of 'Bristol porcelain', much of it richly ornamented and of high quality.

By the age of twenty-four Champion had become a member of the influential Society of Merchant Venturers of Bristol, and had established trading links with the American colonies, in particular with Charleston in South Carolina, where his brother-in-law Caleb Lloyd had settled. When Caleb Lloyd died it was decided that his brother Abraham must go out to America to take over the family business interests. Abraham Lloyd left Bristol on 12 April 1767 to proceed to South Carolina in Champion's ship *Lloyd* which was then lying at Shirehampton. 'The *Lloyd* was detained by contrary winds till 19th June' Sarah Champion noted in her journal. 'Captain Nicholas Pocock who commanded the *Lloyd* was a young man who had been some time in my brother's employ; one of three brothers whose mother was a widow, supported by this son'.[12]

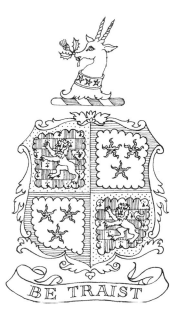

plate 8
The coat-of-arms of the Pocock family
Nicholas Pocock and his brother William were granted a coat-of-arms in 1811. The heraldic description reads: 'chequy ermine and gules a lion rampant guardant erminois a bordure engrailed or; Crest, an antelope's head erased proper armed or gorged with a collar argent charged with three estoils azure in the mouth a thistle also proper'.

16

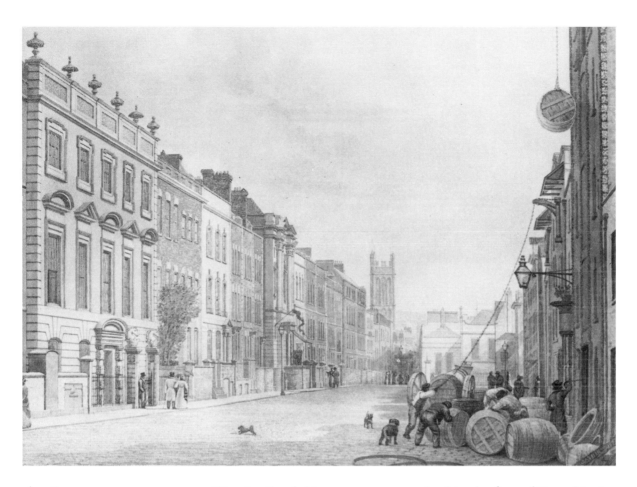

The details of this voyage are contained in the first of Pocock's six
logbooks. This was not his first voyage across the Atlantic, however. It
has been discovered that he made a voyage to the American colonies in
the previous year.[13] The local newspaper, *Felix Farley's Bristol Journal*,
reported on 18 October 1766 that the *Lloyd*, Pocock master, had cleared
from Bristol the preceding week. The *South Carolina Gazette* noted her
arrival at Charleston on 11 December, and on 11 January 1767 Pocock
set sail for Falmouth. Forty-five days was the average length of time for
the passage home so he should have been back in England towards the
end of February. On 25 April 1767 *Felix Farley's Bristol Journal*
reported that the *Lloyd* had arrived at Cadiz, and advertisements in the
same newspaper on 6 June and 13 June 1967 indicate that Pocock had
returned home to Bristol and wanted cargo for his next voyage to
Charleston. Before examining some of Pocock's voyages in detail, a
word must be said about the ships in which he sailed.

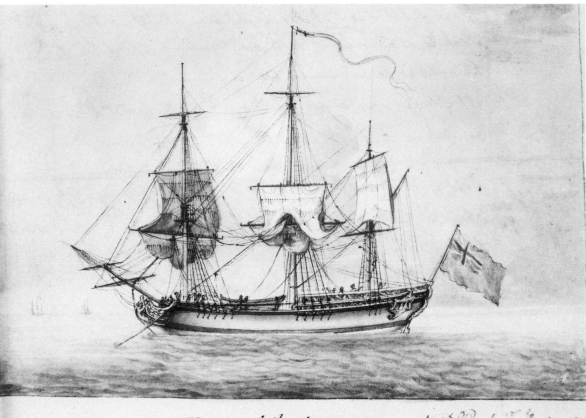

A VIEW of the SHIP LLOYD. *Nich.ᵗ Pocock fecit, May 1768*

THE MERCHANT SHIPS COMMANDED BY POCOCK

During his years at sea Nicholas Pocock was master of at least three different sailing vessels. There was the *Betsey* in which he sailed to the Mediterranean, the *Minerva* in which he made four voyages to the West Indies, and there was the *Lloyd* (plate 9). There may have been two different ships called the *Lloyd* because the illustrations in the logbooks show considerable differences between the *Lloyd* in which he sailed in 1767, and the *Lloyd* of the two voyages to Charleston in 1768. On the other hand the first *Lloyd* may simple have undergone an extensive refit.

No details of the *Betsey* or the *Lloyd* are recorded in *Lloyd's Registers of Shipping* so that it is not possible to know for certain the size, or age of these ships. Nevertheless the indications are that they were ships of between 150 and 200 tons burden. When trying to obtain an Order in Council which would allow the *Lloyd* to travel independently of a convoy in 1776, Edmund Burke wrote to Richard Champion, 'I set the tonnage down by guess at 170, and the men at 20, inclusive of master and mate.'[14] The muster roll in the 1768 logbook records a crew of 16 and this would conform that the *Lloyd* was a ship of at least 150 tons.

plate 9
A view of the ship 'Lloyd'
National Maritime Museum, London
This drawing from Pocock's logbook of 1768 shows the ship in which he made most of his voyages from Bristol to Charleston, South Carolina. She was owned by Richard Champion, and carried a crew of sixteen.

Although the merchant ships owned by the East India Company were commonly of 500 or 600 tons, most merchant ships were very much smaller. In 1788, for instance, five ships out of every six which were registered in English ports were less than 200 tons. the *Lloyd* and the *Betsey* would certainly have been among the larger merchant ships using the port of Bristol.[15]

The *Minerva* was a smaller vessel, as can be clearly seen from the size of the sailors depicted on deck in Pocock's ship portrait (plate 10). As it happens, precise details of the *Minerva* are available because she is entered in the *Lloyd's Register* for 1776:

MINERVA W. I. Pocock 130 Bristol 64 C N Pocock 12 Br. Domin E1 F3
–sws Wm. Sale len

This cryptic message may be translated as follows: The *Minerva*, a snow; formerly owned by W I Pocock (Nicholas Pocock's younger brother) and now owned by William Sale; tonnage 130; registered at Bristol; built in 1764; Captain, N Pocock; load draught 12 feet; trade with British Dominica; Lloyds rating E1/F3. The mention of William Innes Pocock as the former owner is mysterious; it is usually assumed that Richard Champion still owned the *Minerva* in 1776, and although Pocock's brother was certainly a mariner, there is no indication elsewhere that he was ever a shipowner.

The *Minerva* was rigged, not as a ship with three masts, but as a 'snow'. This was a term for a two masted vessel similar to a brig. Like a brig, the snow had square-rigged sails set on her two masts, but she differed from a brig by setting her spanker or main trysail (the loose-footed sail shown furled like a curtain in Pocock's ship portrait) on a

plate 10
A view of the snow 'Minerva', 1773
Mariners Museum, Newport News, USA
Between 1772 and 1776 Pocock made four voyages to the West Indies in the *Minerva*. As can be seen from this drawing in his logbook, she was rigged as a snow. This was a type of rig similar to a brig but with a second mast stepped close behind the mainmast to take the spanker or main trysail.

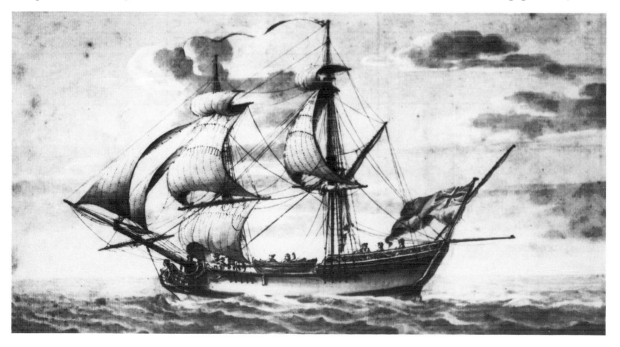

separate pole or trysail mast a short distance abaft the mainmast. The rig was introduced in the early part of the eighteenth century and had become very common for smaller ocean-going merchant ships by the middle decades of the century.

None of Pocock's vessels were armed, but in other respects they were entirely typical of their type as a comparison with Chapman's *English West India Trader* clearly shows (plate 11). In 1768 F H Chapman, the greatest naval architect of his day, published in Stockholm a magnificent portfolio of ship designs under the title *Architectura Navalis Mercatoria*. The drawings include a large number of merchant ships and men-of-war, and from these it is possible to build up an exact picture of their hull form. Chapman also includes the basic measurements of each vessel. His West India Trader is 102 feet in length (between perpendiculars), 27½ feet in breadth, with a draught of 16¼ feet and a carrying capacity of 140 heavy lasts (about 300 tons burden). She is full-built and almost flat-bottomed – a shape which enabled her to take the ground more easily than a vessel with sharp floors, and gave her the greatest possible cargo-carrying capacity. The drawings by Pocock in his 1768 logbook show that the *Lloyd*, though a smaller ship, was in other respects very similar to this West India Trader and it would be safe to assume that her hull form was much the same.

Merchant ships were usually more soberly decorated than naval vessels, but they still had their share of elegant carving. All Pocock's ships had handsome figureheads and decorative carving at the stern, although they differed in detail. The *Lloyd*, in which he sailed to Charleston in 1767, had no cabin windows on her port and starboard quarters and had fairly restrained carving on her stern; her figurehead was a triton blowing a conch shell. The second *Lloyd* in which Pocock made four voyages in 1768 and 1769 appears to have been a larger vessel. She had cabin windows on her quarters surrounded by decorative carving of traditional design, and elaborate carving on her stern. Her figurehead was a female figure, and since there seems no reason to doubt the suggestion that the *Lloyd* was named after Champion's attractive wife Judith Lloyd, the figure was probably a likeness of her. An advertisement which appeared on 2 January 1768 in *Felix Farley's Bristol Journal* suggests that the second *Lloyd* may have been the most comfortable of Pocock's commands: 'For Charles-town, South Carolina (ready to sail) the ship Lloyd, Nicholas Pocock master, having exceeding good accommodation for passengers'.

It is difficult to find detailed descriptions of life on board a merchant ship in the eighteenth century, and Pocock's logs (in common with most logs) are almost entirely devoted to navigational observations and brief comments on sail changes or the state of the weather. However, one of his illustrations for the poem by William Falconer entitled *The Shipwreck* gives a glimpse of the master's cabin during the storm (plate 12). The poem describes the voyage of a ship in the Mediterranean and the characters are fictitious, but Pocock was able to draw on his own experience when he portrayed the ship's captain, a pair of dividers in his

plate 11
The lines of a West India Trader
This drawing by F H Chapman from his celebrated treatise on shipbuilding *Architectura Navalis* shows a merchant ship of a similar type to the *Lloyd*. The ship in Chapman's drawing is 102 feet in length (between perpendiculars) with a beam of 27½ feet.

plate 12
The consultation of officers
National Maritime Museum, London
This watercolour is one of Pocock's illustrations for the 1811 edition of William Falconer's poem 'The Shipwreck'. The officers are gathered round a chart in the cabin of *The Britannia*. The storm is reaching its height and the men are discussing whether to veer the ship and scud before the wind, or lay to under bare poles.

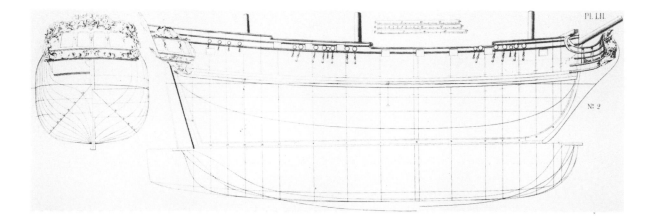

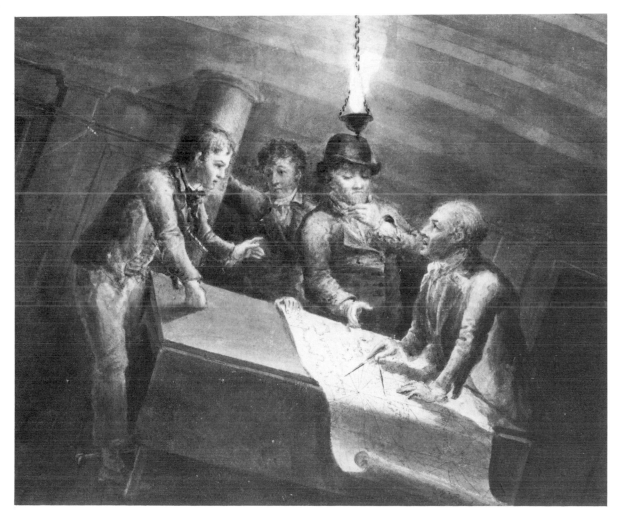

hand, listening to the the advice of the first mate and a younger member of the crew.

FROM BRISTOL TO CHARLESTON IN THE SHIP 'LLOYD'

By the second half of the eighteenth century the crossing of the Atlantic had become a fairly routine matter; 143 ships from North America and the West Indies entered the port of Bristol in 1770,[16] and a considerable number of these came from Charleston on the eastern seaboard of America. Governor Glenn calculated that in 1761 'the Trade between South Carolina and Great Britain, one Year with another, employs Twenty-two Sail of Ships.'[17] Nevertheless the crossing of any ocean in a sailing vessel was, and still is, a hazardous undertaking and it was made more dangerous in Pocock's day by inaccurate charts and primitive navigational instruments. A close study of the logbook recording the two voyages which Pocock made in 1768 reveals some of the problems which faced the master of a merchant ship at this period.

The logbook begins on the morning of 4 January (plate 13). At 7 am the *Lloyd* set off from The Quay in Bristol, a few yards from Pocock's home in Prince Street. It took her three hours to navigate the winding

plate 13
The opening pages from Pocock's logbook of 1768
National Maritime Museum, London
Although lacking illustrations, the left hand page is of interest partly because it describes the preparations for the *Lloyd*'s voyage from Bristol to Charleston and partly because it contains the Muster Roll of the Crew. The fifth name down is that of William Innes Pocock, one of Nicholas Pocock's brothers. Of the 16 man crew two came from Edinburgh, one from Dundee, one from Liverpool and the rest from Bristol or nearby ports.

course of the river Avon, and she would almost certainly have been towed by several rowing boats. The tricky winds in the Avon Gorge and the unusually strong currents made this essential for any but small coastal craft. Several of Pocock's views of Bristol show men-of-war and merchant ships being towed downstream (plates 22, 23).

At 10 am the *Lloyd* 'came to single anchor at Kingroad'. The Kingroad anchorage was at the mouth of the Avon and it played an important part in the lives of all seamen using the port of Bristol. It was sheltered from the south-westerly winds by Portishead Point and had good holding ground. In the words of *The English Pilot* of 1772, 'You may anchor in good clay ground from 8 or 9, to three fathom, as near the river as is convenient'.[18] It was here that vessels completed the loading of their cargoes, took on a pilot, and waited for a favourable wind (plate 14). It will be noted that Pocock loaded the gunpowder at Kingroad because it was too explosive a cargo to be loaded from the quays in Bristol. He also took on ballast here, presumably because it was helpful to have the ship as lightly laden as possible while coming down the Avon. He had some problems with the ballast. The hawser of the lighter bringing the limestone was cut by ice, and this delayed his departure for two days.

Eventually the loading of his ship was completed and Pocock embarked on the next stage of his journey. *The English Pilot* contains a contemporary chart of the Bristol Channel on which it is possible to follow the route taken by the *Lloyd* on her voyages as she sailed south-

plate 14
Kingroad from Portishead Point, near Bristol, 1787
City of Bristol Museum and Art Gallery
Kingroad was near the mouth of the river Avon and was used as an anchorage by shipping bound to and from Bristol. The small boat in the foreground is probably bringing ashore a pilot from the ship which has just rounded Portishead Point.

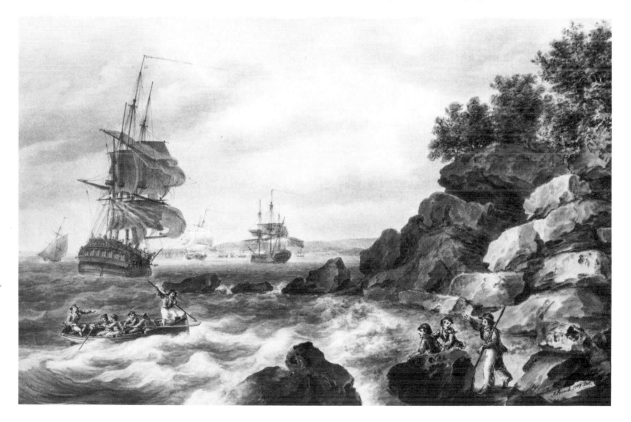

west towards Lundy Island. The numerous shoals and the eight-knot tide made the passage hazardous, particularly in bad weather, and Pocock always took on board a pilot to guide the ship down the channel until she was abreast of Barry Island or Ilfracombe.

Once clear of Lundy Island, the ship headed for the open sea, and apart from keeping a close watch for other vessels, the crew could settle down for the seven-week voyage. The passage across the Atlantic can be followed on Pocock's 'Tract of the Ship Lloyd' which appears opposite the title page of his 1768 logbook.

The arrival off the coast of South Carolina was in its way as hazardous as the passage of the Bristol Channel. The greatest danger, after a voyage of over 5000 miles, was that of miscalculating the exact position of the ship and running onto a shoal off the American coast. Pocock had doubts about his position as he made his approach on his second voyage in 1768. He sounded 25 fathoms on 30 July and continued to make frequent soundings over the next few days as he tried to establish where he was. On Monday, 1 August, he wrote,

'Reckon myself about 4 leagues to the southward of the bar. Steered in NW at 10 o'clock made the land*; take it to be Stone Inlet and Brakers.' In the margin he later noted: '*found it afterwards to be North Edisto 5 leagues from Stone.' He stood off and headed northwards. He sighted land again the next day: 'Take it to be the land between Stone and Charlestown. Cannot be certain as it is hazy.'

He finally sighted the harbour bar on the evening of 3 August, and took on a pilot to guide the ship through the dangerous shoals into the sheltered waters of Charleston harbour (plate 15). Pocock discovered that the main reason for miscalculating his position was a strong current which 'makes it impossible to fall exactly in with the Bar even though you have had an observation a few hours before'. When he came to draw up his chart of the Carolina coast he inserted a warning paragraph about this hazard: 'Note the current along shore shifts with the wind, and you will overshoot your distance surprisingly if not allowed for'. Other hazards are pointed out on this decorative chart, particularly the curving shoal, north of the harbour entrance, which was aptly named 'the Rattlesnake'.

Pocock has less trouble finding the harbour entrance on his first voyage in 1768, although he did encounter difficulties when he approached the wharves at Charleston. The *Lloyd* stood in over the harbour bar at 3 pm on 1 March. But Pocock found that 'the wharfs are so full cannot get a berth for the ship'. Six days passed before he could bring the *Lloyd* alongside. During this period the harbour was swept by strong northerly gales, and two members of his crew deserted the ship. He eventually found a berth on 7 March and spent the next three weeks unloading the cargo and ballast, and taking on board the goods for the return journey.

Apart from the gunpowder, Pocock makes no mention of the nature of the cargo which he carried on his outward voyages. However Professor Walter Minchinton, who has written two interesting articles on 'Richard Champion, Nicholas Pocock and the Carolina Trade', has

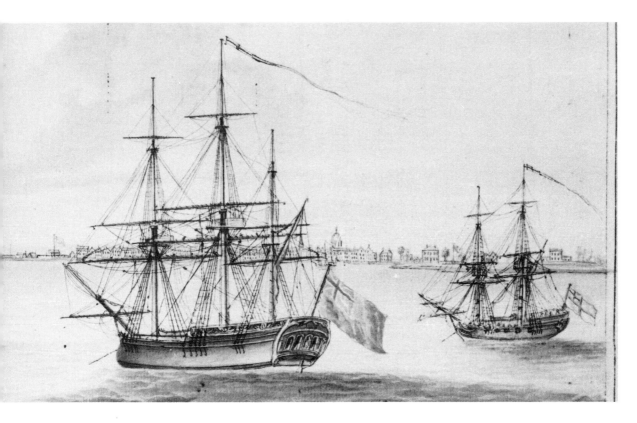

plate 15
**A Prospect of Charles Town
from the Eastward, 1767**
*National Maritime Museum,
London*
Taken from Pocock's logbook
of the *Lloyd*'s voyage to
America in 1767, this pen and
wash drawing shows the
shipping anchored in
Charleston Harbour. In the
distance can be seen the
buildings along the town's
waterfront.

discovered two advertisements in the *South Carolina Gazette* which give
a vivid picture of the cargo which was carried on two of Pocock's
voyages to Charleston. The first advertisement appeared on 17 August
1767, and the second one, which is reproduced below, appeared on 3
August 1769:

JAMES McCALL

Has just imported in the Ship *Lloyd*, Captain Pococke,
from BRISTOL
A VERY VALUABLE AND COMPLEAT
CARGO OF GOODS:
Amongst many Articles are,
Handsome flowered silks, India bordered
Chints, Silk Petticoats, Brocade and Sattin Pumps, Silk
Umbrelloes, blond Laces, white, blue and green Pavillion
Gauze, Silk, Straw, and Chip Hats, Fans and Ribbons, Mens
and Womens very neat Saddles, complete; Hose and Shoes of
all Sorts, Wilson Carpeting, and Carpets for Rooms and Tables,
very handsome China and Glass Flower Potts, very neat Glass
Salvers, with Buckets and Baskets, Glass Shades, Bird Fountains,
Candlesticks, etc., China, Earthen, Stone and Queens
Ware of all Sorts: red Hearth-Tiles, 9 and 12 Inches square;
newest fashion Broad Cloths, Wiltons, Whitneys, etc., ready

made Cloaths, white, blue and green Plains, striped Duffil and
Bed Blankets, Linens, Canvas, Drugs, Medicines, Plantation
and Workmens Tools, Gun-Powder, Shot, Lead, Iron and
Nails, etc., a great choice of WOOL and COTTON CARDS,
best double Gloucestershire Cheese, Beer, Cyder, Ale and
Perry; Raisins, Currants, Prunes, Figs, Almonds, Candy,
and Sugar-Plumbs etc., etc., etc., – These, with a great
variety of USEFUL ARTICLES, are all to be had at his store,
in Tradd-Street, remarkably cheap, especially for CASH.

The cargo on the return journey is noted by Pocock in his journal as it
is taken on board. As might be expected from a colony in an early stage
of development, it contains none of the elegant and fancy goods of the
outward journey and is largely made up of barrels of rice, turpentine,
bundles of skins and hemp.

No less than five of Pocock's crew of fifteen deserted the ship while
she was at Charleston in March 1768. It is possible that Pocock was an
unpopular captain, but it is far more likely that the desertion of these
men was caused by the general conditions facing sailors in the eighteenth
century. The life was tough and dangerous, and offered little security:
men were signed on for a particular voyage with no guarantee that there
would be a place for them on the next voyage. The pay for an able
seaman was twenty-five shillings a month, which was somewhat more
than a farm labourer's pay but was hardly comparable with the eighty
shillings a month earned by the mate, or the one hundred shillings a
month earned by the ship's master.[19] There was also the continual fear of
being pressed into the Royal Navy. Merchant seamen were prime
targets for the press gangs, particularly during times of war, and it was
not uncommon for crews to desert merchant ships when they visited the
colonies in order avoid impressment when their ships returned to their
home ports.[20]

Pocock was away from Bristol on his first voyage in 1768 for nearly
four months. The outward journey took him 53 days and the homeward
journey 45 days. Two weeks after his return to Bristol, Pocock had
discharged his cargo, loaded up the ship again and was ready to set off on
a second voyage to South Carolina. The *Lloyd* left Bristol quay on 1
June and 59 days later moored in the river off Charleston. The ship was
unloaded and on 8 August an advertisement appeared in the *South
Carolina Gazette*: 'For Bristol (to sail in ten days) the ship *Lloyd*,
Nicholas Pococke, master, for freight or passage (having very good
accommodation) apply to said master on board, at Beale's Wharf or to
George Ancrum & Co.'[21]

Gales delayed the *Lloyd*'s sailing and she did not cross the harbour bar
until 18 August 1768. Helped by the prevailing south-westerly winds,
the passage home was again faster than the voyage out, this time taking
48 days. He returned to Bristol at the end of his second voyage of the
year on 5 October. Within three weeks he was sailing down the Bristol
Channel with another cargo for the American colonists in South
Carolina.

Between 1766 and 1769 Pocock made six voyages to Charleston, but by the time he set out on the last of these voyages, the rumblings of the forthcoming war were clearly to be heard. Writing to his relations in Charleston on 18 November 1769 Richard Champion gave warning of the troubles he saw ahead, 'Did our Governors consider the madness of their measures to oblige a People who are so great a Support to our Manufactories and Commerce, and on whose mutual endeavours for the advantage of each other, the happiness of both so greatly depends, surely they would not persist'.[22] The measures referred to by Champion included the Stamp Act of 1765 which aroused furious resentment in America, and Townshend's Act of 1767 which imposed duties on a range of goods from paint to paper. Nine years after Pocock sailed out of Charleston harbour for the last time, Britain was at war with America. The opening clashes took place in New England, but soon the campaigns spread southwards. On 28 June 1776 a British force attacked the fort on Sullivan's Island at the entrance of Charleston Harbour. The attack was ill-prepared and unco-ordinated: two British ships ran aground on the shoals which Pocock had so carefully charted, and the British force withdrew ignominiously. The British had their revenge four years later when they laid siege to Charleston with an army of 8500 troops, backed up by the Navy. They compelled the town to surrender in May 1780. It was too late to turn the tide of events, however, and within 18 months the Americans had won the war, and their independence.

THE VOYAGE IN THE 'BETSEY', 1770

In spite of tropical storms, days of calm and foggy weather, dangerous currents and shifting shoals off the American coast, Pocock survived six voyages across the Atlantic without any serious mishap. In 1770 he made a voyage to the Mediterranean in a ship owned by Champion and Brice which proved to be the most eventful of all his seagoing passages.

At 4 pm on the last day of February, he set sail down the Bristol Channel in the *Betsey*. But the wind, which had been fair, shifted to the north-west, and with the flood tide at its strongest Pocock was obliged to turn back to the anchorage at Kingroad. It was the first of several setbacks. For four days the *Betsey* was delayed by gales. On 5 March they took on board a pilot, but squally winds held them up for a few more hours.

At last they set sail and by 11 pm were 'between the Holme', the two islands called Flatholme and Steepholme in the middle of the channel. At 6.30 am next morning Pocock dropped anchor off Nass Point. He gives no explanation for this, but it was possibly because the *Betsey* was making no headway against the tide. Although a square-rigged ship was capable of tacking, her sails were most effective with the wind astern. Even with a fair wind, she would have made little progress against the racing tides of the Bristol Channel, and the movements of all ships were closely governed by the state of the tide.

In the afternoon of Tuesday, 6 March, the *Betsey* weighed anchor and

headed for Ireland. By the evening of the next day she was a few miles off the Irish coast. There were no pilots to be seen off Cork, so Pocock stood out to sea to prevent any likelihood of the ship drifting onto the lee shore during the night. A pilot came on board at 9 am the next day, and two hours later the *Betsey* was safely moored in the harbour. The following day brought gales with snow and rain, but Pocock was able to employ his crew clearing the hold of the ship.

While a few of Pocock's logbooks give information about the goods carried on board his ships, the only mention of the cargo carried on the *Betsey* is a brief entry on 12 April when the ship was at Gibraltar. In an interval between gales Pocock landed 50 firkins of butter and 'sundry other articles'. He makes no mention of the cargoes discharged or taken on board at Cadiz, Minorca or Leghorn. However in the Public Record office in London are a number of the earlier Port Books for the harbours of Britain. These contain the records of the customs officers whose job it was to collect duty on goods exported out of the country. The records are by no means complete, but fortunately the Day Book of Daniel Harson of Bristol contains an entry on 26 February 1770 (two days before the *Betsey* sailed) which reads as follows:

In the *Betsey* Nicholas Pocock for Cork
Champion and Brice 500 pieces tinware val £10
10 boxes haberdashery ware
5 boxes twine val £10
20 baskets cheese
16 gross Tobacco pipes
20 gallons Vinegar[23]

There is no mention of the 50 firkins of butter so this must have been taken on board at Cork. Other likely exports from Ireland would have been calf skins, hides, woollen yarn and linen.

Pocock remained at Cork for nine days. On Sunday, 18 March, he set off for Cadiz. In the Bay of Biscay the *Betsey* encountered fresh gales, but she weathered these and proceeded south along the coast of Spain and Portugal until she was abreast of the Rock of Lisbon. Then, on Sunday, 25 March, disaster struck. The weather was deceptively pleasant with light breezes from the north-west, when, without warning, 'a sudden Gust or Whirlwind carryed away our Foretopmast & a William Giller Seaman who was furling the Foretop Gall. Sail, was drown'd. Supposed he was hurt in the fall as we Neither saw or heard anything of him.'

The death of William Giller, which is recorded so briefly, is a reminder of the dangers facing all seamen in the days of small sailing ships. A record of the deaths of master mariners in the mid-nineteenth century shows that nearly a quarter of them lost their lives when their ships were wrecked or sunk, and violent death from falling spars and gear was common.[24]

Although it is not apparent from Pocock's notes, the confusion on deck caused by the broken topmast must have been considerable. His

A View of the West end of the City of Cadiz as it appears from the Shipping in the Bay, 1770
National Maritime Museum, London
Pocock spent a week in Cadiz during the course of his voyage to the Mediterranean in the *Betsey*. He devoted a whole page of his logbook to this pen and wash drawing of the ancient Spanish port.

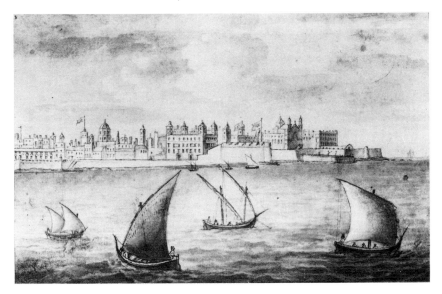

pen and ink drawing depicting the 'Foretopmast going over the Side' gives an idea of the wreckage. Fortunately the sea was relatively calm and within a short space of time the crew had cleared the wreck and got up a jury topmast – a temporary arrangement which enabled them to set a foretopsail above the foresail and balance the ship sufficiently to be able to set all except the top gallant sails on the main- and mizzenmasts.

The fair weather continued and on Wednesday, 28 March, they sighted the city of Cadiz from the mast-head. Several other vessels were in sight as they approached Cadiz Bay from the west, and at 7 pm they anchored in six fathoms before the city itself. The next morning they sailed further into the bay and moored in a more sheltered position north-east of Cadiz. During the week spent at Cadiz Pocock drew one of the most charming of the full-page pictures in his logbooks (plate 16). It shows the romantic appearance of the ancient Spanish seaport with dozens of towers rising above the strongly fortified walls, and small lateen-rigged vessels passing to and fro in the foreground.

Cadiz was the chief Spanish port for English ships in the eighteenth century. It was an important centre for the Mediterranean trade and ships bound for Italy and the Levant invariably called in to discharge part of their cargo from England and to take on hogsheads of wine, and boxes of oranges, lemons and raisins.[25]

Pocock had hoped to be able to repair the broken mast at Cadiz, but he noted in his logbook on 3 April 'cou'd get no Carpenters Employ'd our own people in getting up a Topmast as I find I cannot get one here must proceed to Gibraltar with that we have.' The crew had already spent several days mending the damaged sails while moored in Cadiz Bay.

On Saturday, 7 April, the *Betsey* set sail with a fresh breeze and clear weather, in company with another vessel, a brig bound for Malaga. In

spite of variable winds and squally rain showers she made good progress and in the afternoon of the following day she dropped anchor off Gibraltar. The next four days must have been some of the most anxious and uncomfortable days Pocock and his crew had to face. On Monday, 9 April, squalls of rain and strong gales from the west forced them to lower the top gallant masts. On Tuesday, Pocock recorded 'Very Strong Gales and squally with a tumbling sea;' they took down the lower yards, but then at 10 am the main anchor (the bower) parted. They brought up with their second anchor but they were now in serious trouble, and Pocock had to ask for assistance from a British warship in the vicinity. Captain Crosby of the *Montreal* promptly sent across a spare anchor with some of his crew to help. The storm continued to get worse with a great sea running. On Wednesday and Thursday the weather moderated somewhat. They moved further up the bay and anchored in three fathoms, and landed part of the cargo. But at midnight on Thursday a violent storm from the south-west caused the sea to break over the ship. At this point the *Betsey* had three anchors out.

By the weekend the storm had abated. The crew of HMS *Montreal* helped Pocock retrieve his lost anchor, and they got up the topmast. After a stay of nearly a month at Gibraltar the *Betsey* set sail into the Mediterranean on 5 May. On the 15th they sighted the island of Minorca to the west and altered course to make for Port Mahon the main harbour on the island. According to Pocock's calculations the harbour was in latitude 40° 2′ 'though in the books 'tis said to be 39° 42″' he noted in his log. The *Betsey* anchored in the harbour on 19 May and remained there for the next two weeks.

At 7 am on 2 June the *Betsey* weighed anchor. The weather was fair and in light airs from the north-east she slipped out of the harbour. Two hours after sailing, Port Mahon was five miles astern. In five days she was passing Cape Corso the most northerly point of Corsica, and in his logbook Pocock recorded several views of the mountainous island. On 7 June the island of Capraia could be made out to the south-east, and at noon the same day they were passing within four miles of the little island of Gorgona. At 9 pm that evening they dropped anchor in Leghorn Road in a depth of seven fathoms. This was the usual anchorage for ships waiting to enter Leghorn harbour. To the west was a low bank marked by an arched tower called the Malora or Melora, and to the east was the lanthorn, the elegant lighthouse built on a rock.

Leghorn was, like Cadiz, a transit port for Mediterranean trade. Goods from other countries were brought in, stored in warehouses, and then loaded onto ships bound for the Levant or out of the Mediterranean to northern Europe. English ships had been calling in increasing numbers during the eighteenth century. Although we do not know what the *Betsey* took on board, the records of other Bristol ships give us an idea of the sort of cargo she might have carried. In December 1795 the *Nancy* brought back from Leghorn 260 casks of oil, 260 bags of juniper berries, 20 cases succus liquoritice, 300 kegs of anchovies, and 5 tons of natron (natural soda).[26] A comparison with other ships shows

this to have been a fairly typical cargo.

The *Betsey* stayed no more than nine days at Leghorn. She set sail on 17 July bound for London. The return journey, a distance of some 2700 miles, took the *Betsey* three months. The explanation for this can be found in the logbook. The summer weather in the Mediterranean was predictably pleasant, but day after day brought calms, or light variable winds. Many of Pocock's drawings show the *Betsey* drifting on a flat calm sea with her sails hanging vertical. It took her a month to cover the 1000 miles from Leghorn to Gibraltar. And it took her another month to cover the 1500 miles from Gibraltar to Beachy Head on the coast of Sussex. The delays over this part of the journey were caused not by calms or light airs but by contrary winds: for nearly two weeks she had to beat into northerly winds as she made her way up the coast of Portugal and Spain. As she passed through the Bay of Biscay the winds dropped. Then, as she entered the English Channel, she ran into typical British weather: 'Strong gales and squally with constant Rain and a great tumbling Sea' he noted on 2 September. The steep seas caused them to ship a great deal of water. Pocock lowered the topgallant sails, reefed the topsails, and took down the topgallant yards.

At last on 11 September they passed Dungeness, and brought to off Dover in order to take on a pilot for the last part of the voyage. On 12 September the *Betsey* anchored off Sheerness on the south bank of the Thames estuary. The next day she entered the mouth of the river Medway and moored in Stangate Creek where she remained for the next three weeks. Pocock then proceeded by slow stages up the Thames. It is possible that he had orders to discharge his cargo at different wharfs along the banks of the river. He finally moored ship off Horsley Down on 8 October. We hear no more of the *Betsey* in Pocock's life. Within two months he was back on board the *Lloyd* preparing for a voyage to the West Indies.

THE LATER VOYAGES TO THE WEST INDIES

Pocock made six voyages to the West Indies between 1771 and 1776, and in later years he frequently drew on his knowledge of the Caribbean for some of his finest paintings and watercolours (plate 17). His ships would have been among the seventy or eighty vessels which went out to the islands from Bristol each year. The outward cargoes were probably tools and materials for the sugar estates, and domestic articles and clothing for the families running the estates; the return cargoes would certainly have included sugar, rum and cotton.

His first two voyages were made in the ship *Lloyd*. He set off from Bristol on 14 January 1771 and by August of the following year had completed two voyages to the island of Dominica. His illustrated logbook covering this period was still in the possession of one of Richard Champion's descendents until recently. (It is now in Bristol Record Office). His other voyages were made in the *Minerva*, and are recorded in two logbooks. One of these logbooks covers the period from 16 November 1772 to 11 February 1776 and is in the collections of

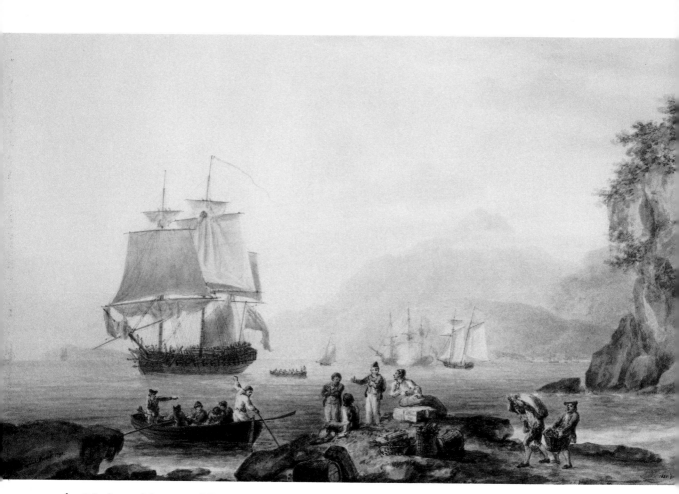

the Mariners Museum, Newport News, Virginia.

The second logbook, recording a single voyage from Bristol to Nevis and the island of St Kitts, is now missing. At one stage it was in the possession of Mr Robert Walter of Hertfordshire but he sold it in 1913. The only details which we have of its contents are those contained in the catalogue of the sale which was held at Hodgson's on 18 June 1913.[28] The logbook was lot 43 and the entry was as follows:

Log Book – Journal from Bristol towards Nevis
in the Snow *Minerva*, begun April 24th, 1776, written
on 13 pages, the entries from April 26 to June 1 being
illustrated with 31 small drawings in Indian ink; and
7 full-page water-colour drawings, viz.: View of
St. Christopher's from Nevis Road; St. Eustatius from
the S. E.; View of Five Island and St. John's Harbours,
Antigua; prospect of St. John's Harbour from
Southward; Christianstaed in the Island of St. Croix;
Fredericstaed Town and Bay; Christianstaed from the
Protestant Quay; also numerous drawings of Coast lines,
etc., and one in sepia of H. M. *Yarmouth*. About 45 leaves,
folio.

plate 17
**View of Basseterre, the
capital of the Island of St
Kitts**
*National Maritime Museum,
London*
Dated 1791 this watercolour is
one of many West Indian views
which Pocock painted in the
years following his retirement
from sea-going life. He had
sailed close by Basseterre while
returning from the island of
Dominica in 1771.

Although this voyage in the spring of 1776 was the last one which Pocock made in the *Minerva*, it is possible that he made another voyage in the *Lloyd* later in the year. The evidence for this may be found in Hugh Owen's biography of Richard Champion where there is an account of an incident involving Edmund Burke, the celebrated member of Parliament for Bristol.

Champion had been one of Burke's leading sponsors during the Bristol election of 1774. He kept Burke regularly informed of the latest developments in the American colonies and soon became one of his close friends. In 1776, when Britain moved on to a war footing with America, the British Government refused to allow merchant ships to cross the Atlantic without the protection of a convoy. The sanction of the Privy Council had to be obtained before any merchant was permitted to risk sending a ship on her own. Richard Champion at once sought the help of Burke in procuring the necessary Order in Council so that he might send his ships to the West Indies without waiting for a convoy.

> Edmund Burke, with a keen appreciation of Champion's interests, being already provided with the name of his vessel, supplied the other information required on the spur of the moment. 'You did not send number of men or tonnage; I set the tonnage down by guess at 170, and the men at 20, inclusive of master and mate'. Richard Burke, at the request of his brother Edmund, sent off by express the Order in Council and a protection for Captain Pocock, the master of Champion's ship, the *Lloyd*[29]

This was in October 1776, but there is no record of Pocock making another voyage in the *Lloyd* or any other vessel.

The war with America was a serious blow to the merchants of Bristol: hitherto lucrative markets were now closed to them and their ships often suffered from the attacks of American privateers. Richard Champion was among the merchants most badly hit because he had relied to a great extent on the family links he had established in Charleston. A letter which he wrote on 5 December 1776 indicates that he was also affected by privateers. The letter, which was addressed to the American firm of Willing, Morris and Co, is of particular interest because it concerns two of Pocock's younger brothers who had both risen to become masters of merchant ships. After bemoaning the circumstances which had caused the war, Richard Champion wrote:

> It is a melancholy Consideration that all the Connexion we can now have with each other, is to solicit good offices on behalf of those who have the Misfortune to be taken in this unhappy War. I have to entreat that in favour of Capt. Isaac Pocock, who commands a Vessel belonging to me called the *Marquis of Rockingham*, if he should have the Misfortune to be taken. She is bound to the West Indies. As she could not be in time for the Convoy, and it will be a very great

Inconvenience to me, not to have her in the West Indies, to bring home my remittances, I put a few Guns aboard her, as a means of defence only ... I solicit your friendship to procure the release of Capt. Pocock and permit him to depart with the first ship for Statia [St Eustatius] or any port of the West Indies he may want to go

If Capt. Wm. Innes Pocock of my Snow *Champion* laden with Herrings from Gottenburgh to Statia, should have been also taken I beg the same indulgence to him.[30]

As it happened Isaac Pocock's ship the *Marquis of Rockingham* was captured by the *Sturdy Beggar* of Maryland, and he was for a time a prisoner on the American privateer. He was, however, shown 'the greatest civility', and in due course his ship was retaken and carried into Antigua.

Richard Champion himself eventually decided to emigrate to America. Production stopped at his porcelain factory in 1778. After a brief spell as Deputy Paymaster (a post secured for him by Edmund Burke) he made preparations to join his relations in South Carolina. He and his wife set sail from England in October 1784. They eventually settled in Camden, 'a village or as they call it, a town, 130 miles from Charles Town, where the heat is less intensive'.[31]

METHODS OF NAVIGATION

Before the 1730s, navigation at sea was conducted by fairly rough and ready methods. It was possible to determine latitude to within thirty miles or so by observing the altitude of the sun at midday with an instrument such as the cross-staff or back-staff and the aid of nautical tables. But there was no accurate way of determining longitude. Seamen were largely dependent for this on 'dead reckoning', which is the art of finding the position of the ship by keeping a record of her course and her speed through the water, and making allowance for the force and direction of wind and currents.

By the 1760s a series of inventions and discoveries had so revolutionised the practice of navigation that it was possible to determine both latitude and longitude with accuracy, even after a long voyage. The instruments which helped to bring about the change were John Hadley's reflecting quadrant which was demonstrated to the Royal Society in 1731; the sextant developed from it in the 1750's by Captain Campbell and John Bird; and the famous marine chronometer invented by John Harrison. (It was his fourth chronometer of 1759 which passed the test for accuracy on board ship.) In addition, there were the important observations and mathematical calculations made by various scientists and astronomers which resulted in such publication as Maskelyne's *Nautical Almanac* of 1766.[32]

Apart from Hadley's quadrant few, if any, of the new discoveries would have been available to the captain of a small merchant ship in the 1760s, and Pocock relied on the traditional methods of navigation. He

would have used charts but these could not always be relied on. He noted in the log of the *Betsey* on 31 July 1770. 'The coast of Spain and the islands of Ischia, Majorca and Minorca are all laid down too far to the southward in the Mariners Compass Assistant, etc., as well as in most charts, especially that from the French.' However his navigation proved accurate enough to ensure that he always made his landfall without mishap.

The observations in the logbooks indicate that Pocock was using a methods of navigation known as 'Mercator's Sailing'. This was a type of 'Plane Sailing', which was so called because it implied that the ship was travelling across a flat or plane surface. A table of Meridional Parts was used for the necessary calculations by this methods. This is not the place to describe Mercator's Sailing in detail, and those interested may refer to *The Practice of Navigation and Nautical Astronomy* by Henry Raper where a number of detailed examples are given. However some explanation of the various abbreviations which appear in the daily entries in the log-books may be useful.

On the left side of each page Pocock ruled up five columns (place 18). The column headed 'H' lists the hours of the day and is taken from midday to midday. The 'K' column gives the ship's speed through the water in knots. The third column is headed with a symbol that is sometimes 'HK' and sometimes 'FK', an abbreviation which appears to mean fractions of knots, or fathoms. The 'Courses' column gives the ship's compass heading and the 'Winds' column gives the wind direction: the Beaufort scale for defining the strength of the wind had not yet been introduced. At the bottom of the first three columns will be found a number followed by 'Miles p log'. This mean 'Nautical miles per log' and it is the total number of miles run during the course of twenty-four hours. The figure is calculated by adding up the figures in the 'K' column, doubling this total because the readings were taken at two-hourly intervals, and then adding on the numbers recorded in the 'FK' column.

To the right of the rectangle containing the picture are two columns in which Pocock plots the position of his ship. He uses a variety of abbreviations here, but the meaning of each is roughly as follows: 'Co' is the course steered; 'Dis' is the distance run; 'x latt' is the difference of latitude; 'Dept' is the departure from the meridian; 'x long' is the difference of longitude; 'long in' is the longitude which the ship is assumed to be in; 'Mer Dis' is the meridional distance in nautical miles – this is taken from the point of departure and it will be noted that this figure increases as the voyage proceeds; 'long made' or 'LM' is the change in longitude made over the day's run.

In addition to the information contained in the columns on either side of each picture, there is a space (usually under the picture) for the latitude observation made at midday, and a space above the picture for detailed notes about the day's run. Here Pocock records the sail changes carried out, the condition of the sea, the visibility, and the strength of the wind.

plate 18
Two pages from Pocock's logbook of the ship 'Betsey'
National Maritime Museum, London
Returning home from the Mediterranean in the autumn of 1770 the *Betsey* encounters bad weather. The entry for 3rd September reads, 'Strong Gales and Squally with Continual hard Rain and a Great Tumbling Sea. Shipped a Great deal of Water'.

It is sometimes suggested that the logbooks were not completed at sea but were fair copies of the ship's log. This is unlikely. Those who have examined other logs of this period will know that a neat appearance and fine hand-writing are a common characteristic. There would also seem little point in copying out hundreds of figures and navigational observations a second time. The hurriedly recorded notes of the day spent in Charleston, and the water-stained appearance of some of the pages likewise indicate that these were working journals. Obviously he would not have attempted to draw delicate pictures during the height of a gale, but there would have been ample time to complete the illustrations during calm periods at sea.

It was not unusual for seamen to acquire some skill at drawing. Naval officers in particular found it was useful to be able to make sketches of enemy harbours and fortifications. It was also important to be able to make a pictorial record of the coastline for navigational purposes. In the days when pilot books and charts were incomplete and often inaccurate, the masters of ships frequently carried out their own surveys. This could

include the drawing of coastal profiles of the type which appear in all Pocock's logbooks (plate 19). By noting the compass bearing and the distance away of a particular view, the seaman could make use of the landmarks to determine his position on future voyages. The two church spires of Charleston, for instance, were of great assistance when making the difficult approach to the harbour entrance. Coastal profiles similar to Pocock's, though less elegant in execution, may be found in modern pilot books.

The collections at Greenwich contain several examples of illustrated logbooks by other seamen. There is a journal kept by Lieutenant Thomas Hamilton of the *Eagle* from April to June 1778 which has pen and wash drawings of his ship; and there is a handsome log kept by Captain James Hamilton on a voyage from England to Madras in 1781 on the East Indiaman *Dutton* which has fine water-colour drawings of coastal scenery as well as the ship. One of the most impressive is the recently acquired journal kept by Captain Columbine. On his voyages to the West Indies and around the Scottish Isles he made numerous watercolour drawings of headlands, harbours and picturesque landscapes which are highly accomplished and full of documentary interest.

Although the coastal views in Pocock's logbooks were, in most instances, navigational aids, the hundreds of small drawings of his ship do not appear to have had any practical purpose. One can only assume that Pocock included these drawings because he enjoyed doing them and he wished to practise his draughtsmanship.

plate 19
Coastal profiles from the Logbook of the 'Betsey'
National Maritime Museum, London
It was common practice in the 18th century for ship's officers to draw pictures of coastlines in their logbooks. These could be used as navigational aids on subsequent voyages.

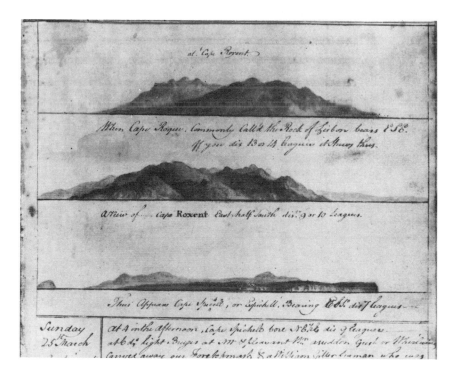

Three

A SECOND CAREER

VIEWS OF BRISTOL

Sarah Champion had noted in her journal that Captain Pocock, 'sometimes talked of giving up the sea,' and it is clear form the drawings in his logbooks that for many years he had been preparing for the day when he did so. At some moment between 1776 and 1780 he finally left the employment of Richard Champion and set up on his own as an artist. Exactly what prompted him to abandon his seafaring life must remain a matter for speculation, but *The Gentleman's Magazine* for December 1835 provides an interesting clue. In 'Memoir of Isaac Pocock', it devotes a paragraph to Nicholas Pocock and notes, 'It was not, however, until he was rather advanced in life that he took to the art as a profession, and on the recommendation of Admiral Hood, he devoted his studies to marine subjects'. As will be seen later, Hood was Pocock's first important naval patron.

For the next twelve years or so Pocock worked from his home in Prince Street, painting marine subjects and views in and around Bristol. In the collections of Bristol City Art Gallery are dozens of his pencil and watercolour sketches.[1] They reveal that his favourite subject was the river Avon: he drew the view looking down on the river from high up on Durdham Down; he sat on the river bank in the Avon Gorge and painted the barges and sailing vessels passing Hotwells and St Vincents Rock (plate 20); he painted the Kingroad anchorage at the mouth of the Avon. He also painted views of the Severn estuary, and picturesque landscapes in the region of Kings Weston and Blaise Castle (plate 21).

The most impressive of the Bristol landscape paintings is *The Avon Gorge at sunset*, a large picture owned by The Society of Merchant Venturers (plate 22). Taken from the upper slopes of the Avon Gorge the painting shows a frigate being towed downstream by five rowing boats. Various other vessels are rowed, drift with the current, or use their sails to catch the light evening breeze. The wooded slopes of the gorge, the banks of the river, and the surface of the water are painted with the diffident touch of an artist who was still relatively new to the medium of oil paint, but the sky, the hazy distance and the soft light filling the canvas are portrayed with the skill and sensitivity which Pocock was to show in many of his later works. A smaller, and in some ways more successful, version of the picture in a private collection is dated 1785, and the almost illegible inscription on the Merchant Venturers' picture indicates that it was probably painted in the same year.

It was during this period that Pocock undertook a series of eight aquatint engravings of Bristol views (plate 23). The first of the views to be published was the picture of Bristol harbour looking towards the

plate 20
Shipping on the Avon with a view of the Hotwells
Ashmolean Museum, Oxford
This is one of the series of eight views of the river Avon at Bristol which Pocock produced from 1781 onwards. Many versions of each subject were carried out, each one being hand coloured by the artist. This view of the Hotwell House which was built over the hot springs is dated 1791. It is painted in watercolour over an aquatint base and an etched outline.

plate 21
View over Kingsweston Hill towards the Bristol Channel
City of Bristol Art Gallery and Museum
The most accomplished of all Pocock's large watercolours depicting scenery along the river Avon, this picture shows Kingsweston house and the stables in the foreground with the mouth of the Avon in the distance. Beyond is Portishead Point and shipping in the Bristol Channel.

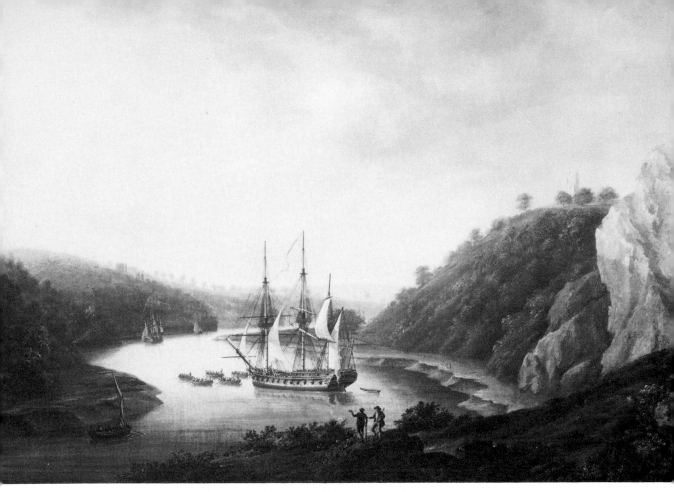

Cathedral; this was inscribed 'Published by N. Pocock, Princes Street, Bristol. Dec 31st 1782.' The remainder were issued between 1782 and 1801. The aquatint engravings were popular and seem to have sold well. On 11 April 1791 John Pinney, the Bristol sugar merchant, wrote to his son in Frankfurt, 'It is very difficult to get a set of Mr Pocock's views, but as I have one by me which I purchased some time ago for my new house, I will get them framed and glazed and send them by way of Holland'.[2]

In the same year that he published the first of his Bristol views, Pocock exhibited four pictures at the Royal Academy. He had sent in a picture in 1780 but it had arrived too late for exhibition. However, it was seen by Sir Joshua Reynolds and prompted him to write an encouraging letter to the Bristol artist: 'It is much beyond what I expected from a first essay in oil colours; all the parts separately are extremely well painted but there wants a harmony in the whole together; there is no unison between the clouds, the sea and the sails.' He advised him to learn from the pictures of Van de Velde, and also 'to paint from nature instead of drawing; to carry your palette and pencils to the waterside. This was the practice of Vernet whom I knew in Rome.'[3]

The encouragement from the President of the Royal Academy, followed by the acceptance of his pictures for exhibition, must have

plate 22
The Avon Gorge at sunset
The Society of Merchant Venturers, Bristol
Painted five years after Pocock's first experiment in oil colours, this painting shows the rapid strides which he made in the medium. The rocks and foliage are still lacking in assurance, but the frigate and the evening sunlight are portrayed with a masterly touch.

plate 23
The Avon at Black Rock
City of Bristol Museum and Art Gallery
This is another of Pocock's eight engraved views of the river Avon. Dated 1787 it is carried out in aquatint and watercolour over an etched outline. The view is taken from near the Hotwell, looking along the Avon Gorge towards Cook's Folly which can be seen above the bend in the river.

confirmed Pocock's decision to give up the life of a seaman and become a professional painter. The application and careful attention to detail, which he had previously brought to his charts and journals, he now devoted to the art of marine painting.

Three months before receiving the letter from Sir Joshua Reynolds, Pocock married a Bristol girl by the name of Ann Evans. The ceremony took place at St Augustine's Church, Bristol, on 10 February 1780.[4] The best man was Christopher Deake, a seaman from south Wales who had married Pocock's sister Mary. Pocock's wife bore him nine children over the course of the next eleven years. In the Huntingdon Art Gallery are some delightful watercolour sketches of the children (plates 24, 25) as well as two pencil sketches of his wife.

POCOCK'S TECHNIQUE AS A PAINTER

Although he acquired considerable technical skill in the mediums of oil paint and watercolour, there seems little doubt that Pocock was a self-taught artist. His early years at sea gave him little opportunity to acquire any formal schooling in draughtsmanship. He never mastered the art of figure drawing, and part of the charm of many of his pictures, particularly the landscapes, is that they have the naive quality of the amateur artist.

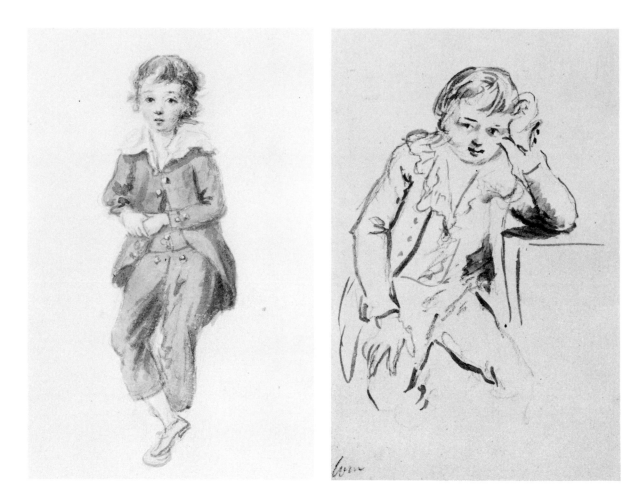

There are several examples of Pocock's early work in the collections of Bristol City Art Gallery, including *A view of a ship of war clearing hawse and making the signal to unmoor* (plate 26). This is inscribed 'Drawn by N. Pocock Bristol Dec. 1762' and is one of the earliest drawings which can definitely be attributed to him.[5] It was carried out four years before he made his first voyage to South Carolina. He continued to draw during the course of his sea-going years but his simple pen and wash technique scarcely changed. His logbook illustrations for the voyage of the *Minerva* in 1776 are much the same as the drawing of a ship of war which he had made fourteen years previously.

It was not until he left the employment of Richard Champion that he began to make progress. This was not simply because he had more time available to practise but because he began studying the work of other artists. In the letter which he wrote to Pocock in 1780 giving him useful advice on the art of marine painting, Sir Joshua Reynolds had mentioned Willem van de Velde the younger, and the French artist Claude-Joseph Vernet. Of the two it was Van de Velde who exerted the strongest influence on Pocock. Echoes of his paintings of shipping in

plate 24
Isaac Pocock as a child
Henry E. Huntington Library and Art Gallery
Pocock produced a considerable number of drawings and watercolours of his children, most of which are now in the collections of the Huntington Library and Art Gallery. This shows Pocock's eldest child Isaac aged about eight years old.

plate 25
William Pocock as a child
Henry E Huntington Library and Art Gallery
Pocock's second son William Innes Pocock later became a lieutenant in the Royal Navy, and was an accomplished painter in watercolours.

stormy seas may be found in many of Pocock's pictures, including *Ships of the East India Company*, (plate 55) and a large watercolour entitled *An Indiaman off the Casketts in a gale*. The Dutch artist's 'tranquil marines' inspired a beautiful series of estuary scenes which were painted by Pocock between 1791 and 1794. One of the finest of these is the *man-of-war and fishing boats in a calm* at Greenwich (colour plate I). A large and carefully composed picture, it is filled with that soft glow of sunlight which is so characteristic of his best work. There is a similar calm in the Huntingdon Art Gallery, and another in a private collection (plate 27). Dutch fishing boats often appear among the vessels portrayed in these pictures, and there are a number of features characteristic of Van de Velde: men fishing from open boats among the larger ships at anchor; the artful placing of a post or two in the foreground; the broadside view of a warship on the distant horizon; and the skilful use of diagonal spars to balance the composition.

Definite proof of Pocock's debt to the Dutch seventeenth century school is provided by several of his studies. Among his drawings at Greenwich is a delicate pencil sketch inscribed 'Sketch in imitation of van de Velde'. A sale of Pocock's work after his death included a 'Copy of a picture by Van De Velde, in the possession of John Wells, Esq.,' a 'Sea Piece, after Van de Velde', and also a 'Copy of a Painting by Capello, originally in possession and much valued by Sir J. Reynolds'.[6]

plate 26
A View of a Ship of War clearing hawse
City of Bristol Museum and Art Gallery
Dated 1762 this is one of Pocock's earliest pen and wash drawings. The ship portrayed has twisted her two anchor cables while lying at anchor, and the crew are engaged in a tricky operation known as 'clearing hawse' which involved loosing one cable so that the other could be hauled up.

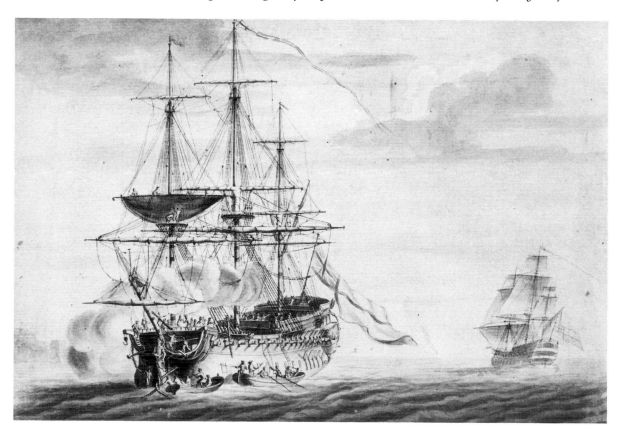

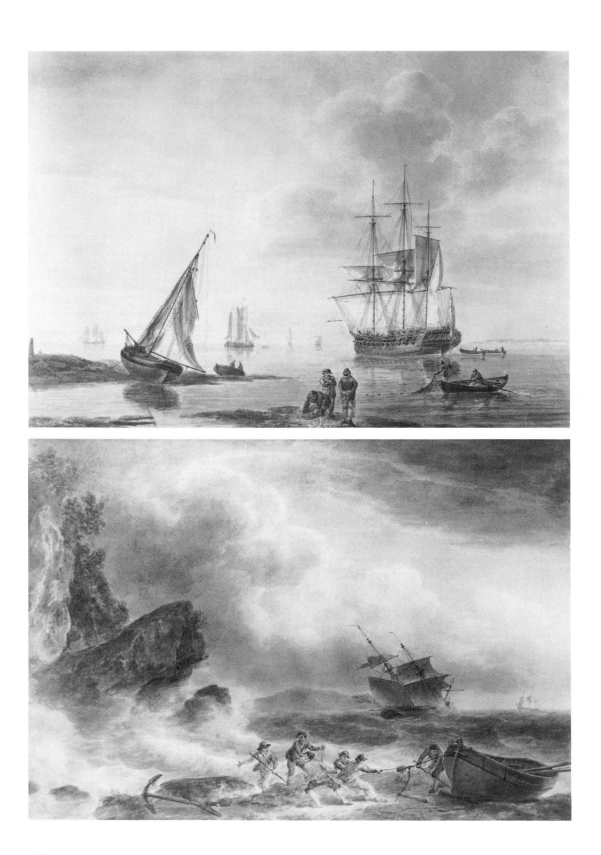

plate 27
Shipping in a calm
Private collection, England
During the 1790s Pocock
painted an inspired series of
watercolours showing men-of-
war and fishing boats in calm
waters. The Peter boat on the
right indicates that this is a
view on the Thames estuary
with a frigate heading
downstream and a visiting
Dutch vessels in the middle
distance.

plate 28
Stormy scene on a rocky coast
Ulster Museum, Belfast
In the foreground a group of
seamen use blocks and tackle
made fast to an anchor to haul
their boat clear of the surf.
Beyond them a brig heels
before the gale, her main topsail
loose and in danger of blowing
to pieces.

Capello must be the Dutch marine artist Jan van de Cappelle who was celebrated for his pictures of sailing vessels at anchor on calm waters.

Reynolds also mentioned the French artist Claude-Joseph Vernet in his letter. Vernet's paintings of shipwrecks on stormy coasts and Mediterranean harbours illuminated by the morning or evening sun were widely collected by English connoisseurs in the eighteenth century. A great number of engravings of Vernet's work also reached England and every English marine artist must have been aware of them. Although no copies by Pocock of the Frenchman's work have come to light, his influence is clearly visible in several of Pocock's storm scenes – a good example is *Stormy scene on a rocky coast* which is in the Ulster Museum (plate 28) and can also be observed in Pocock's illustrations to Falconer's poem *The Shipwreck* .

Perhaps the most interesting influence on Pocock's development as a painter was the work of the English marine artist Charles Brooking who was born at Deptford in 1723 and died in poverty at the age of thirty-seven. At Greenwhich there is a large sketchbook of 'Naval Studies by N. Pocock' which contains a drawing in pencil and grey wash of a ketch-rigged yacht and other vessels sailing in a breeze off a distant coast. Pocock has signed his initials in one corner and has written 'Brooking' at the top of the picture. There are five similar drawings preceding this one in the sketchbook which also seem to be copies of Brooking's work. Further examples appeared in Hodgson's sale of 2 April 1913. Lot 70 was 'Four drawings in Indian ink of actions between squadrons of English and French ships of the line, three of which are signed in the right-hand corner 'N. Pocock, 1782' with the name of 'C. Brooking' in the opposite corner, in one case with the addition of 'Invt. 1746'.'[7]

Brooking's influence on Pocock is more elusive than that of Van de Velde. His beautiful cloud formations may have inspired some of the skies which are a notable feature of Pocock's paintings. A particular characteristic of Brooking's pictures of ships at sea was the employment of broad bands of shadow across the surface of the water. These stretch from one side of the picture to the other and are sometimes in a zig-zag pattern. This is a recessional device for linking the scattered ships in a sea battle or coastal scene and can be seen in several of Pocock's sea pieces, as well as in the work of his contemporaries Dominic Serres and Thomas Whitcombe.

Among the other pieces of practical advice contained in Reynold's letter was that of 'uniting landscape to ship-painting'. Of the various marine subjects tackled by Pocock it is the coastal scenes which combine sailing vessels with a carefully observed view of an estuary or harbour entrance which are among the most successful. *Port of Tenby* (plate 29) is a good example, and is one of several pictures which he painted of the rocky coastline of southern Wales.

Many years after receiving the encouraging letter from Sir Joshua Reynolds, Pocock wrote a letter to his friend Richard Bright of Bristol in which he gave some advice of his own on the art of painting in watercolours. It is a fascinating letter, and explains his technique in

detail. The letter was accompanied by a sketch (colour plate II) in which he indicated the colours which he used and showed how he combined them 'to produce any colour or effect whatever'. It is presumed that the 'Miss B' referred to in the letter is Richard Bright's daughter.

London Feby 6th 1804

Dear Sir,

Your obliging favor covering a draught at 30 days date for 19 L. [?] I receiv'd safe and at the same time the board enclosing the drawing mentioned in your letter. I have not yet had time to open it, but it looks in perfect order and I dare say uninjured. I shall lose no more time in replacing it than I can profitably help and hope tobe successfull in choice and execution.

I have inclos'd a Sketch of Scales of tones produced with 3 Colours only and which are sufficient to produce any colour or Effect whatever – the sketch of boats is done as follows. The Cloud first with light red and blue only. The Water the same with a little blue added to it the same pencil just touch'd on the yellow oker for the nearest wave. The near vessel blue and red, with rather more red than in the sky, it is the most Aerial tint and any colouring may be wrought upon it, with great Clearness and force. When I send the drawings I add a few more Observations and a colour or two more which may be used to advantage, but the Simple colours here used produce the Clearest and most natural effect, besides having the advantage of being easily remembered. If the drawing intended to be colour'd is small, the Paper, after the outline is traced upon it

plate 29
Port of Tenby
City of Bristol Museum and Art Gallery
Pocock was at his best when painting watercolours of coastal scenes with shipping. This view of Tenby in Pembrokeshire is one of many fine pictures which he painted of Welsh ports and harbours.

may be wetted well on both sides, then laid on the Carpet
or a green baize cloth (not upon a bare table or board)
until the water is so much absorb'd, as that the paper
appears dry – yet retaining a considerable degree of
dampness – in this state you may begin to colour upon it,
especially such a subject as the drawing you mention.
The misty clouds exhaling are produced by a large brush
dipp'd in the water (without colour) and squeez'd between
the finger and thumb. It will in this dry state soften
the Edges of the Clouds and vary the forms at pleasure by
taking off the Colour from the mountain or the sky
wherever fancy may choose to exercise itself.

The exact facility with (which this) can be perform'd
will be apparent to Miss B after a very few trials. The
Clouds in the Sketch C. are compos'd of exactly the same
colours as used in the drawing.

Being pinch'd for time and unwilling to defer the
acknowledgement of your kind favor as well as any
information or pleasure it may afford Miss B. I hope will
apologise for this scrawling letter, which I fear'd to
defer until tomorrow as I shall be yet more engaged.

I remain with great respect
Dear Sir your sincere
and obliged servant
Nicholas Pocock

PS. I have left the boats in the Sketch as they were
done unpremeditatedly with the Single touch they were laid
in with – (that) Miss B. may see the advantage the colour
was and the manner in which it laid on, which must be bold
and as near in darkness as will produce the wish'd for
effect in the first laying there is no fear of being too
dark, in drying it always appears fainter.

The pure technique advocated by Pocock closely followed the
practice of that group of English watercolour artists known as the
topographical draughtsmen. They included Edward Dayes, the Sandbys
and Michael Angelo Rooker. Indeed Pocock's instructions bear such a
close resemblance to the advice given by Dayes that it is possible that he
may have received some lessons from him. The two artists worked
together on a commission for Lord Stanley following his return from an
expedition to Iceland in 1791.

Edward Dayes particularly warned the student against 'too great
quantity of colours'. For a picture of Fountains Abbey he
recommended, 'The whole effect of the light and shade may be acquired
by the aid of Indian Ink, indigo (or Prussian blue), and Indian red: after
which the tints may be obtained from burnt terra di Sienna, or Roman
ochre (according to their brilliancy, combined with more or less of the
Indigo for the vegetation.' In a sentence which is echoed by Pocock, he
concluded, 'These materials are enough in the hand of a master to do
anything with, from the slightest sketch to the most finished drawing.'[9]

Although Pocock advocated a very pure technique in this letter and

practised in this manner for much of his working life, he did on occasions adopt other methods, particularly in his later work. He sometimes used white bodycolour to portray the smoke of gunfire or to pick out wave crests or flags, and he occasionally resorted to the use of a knife to scratch out highlights.

Pocock seems to have been most at home in the medium of watercolours, but the commissions which he received from naval officers and other patrons were usually for oil paintings. Some of these paintings were of a considerable size – his picture of *The fight between the Brunswick, the Vengeur and the Achille* is a six-foot canvas – but, with a few notable exeptions, his finest oil paintings were on a small scale.

Considering his apparent lack of any formal training, Pocock acquired a remarkable control of the technical aspects of oil painting. He worked systematically, building up the picture in a series of thin layers, and showed an unusual ability to paint very fine detail – a talent that was no doubt helped by his years of practice at drawing tiny pen and wash illustrations in his logbooks.

He usually painted on a medium or medium-fine canvas which had been commercially prepared, although on occasions he used paper stuck on canvas. Apart from the mixing of a special white he mostly made use of good quality commercial paints. On a half-chalk, lean priming (commercial ground) he put an imprimatura which ranged from a milky colour in the sky through tones of warm greys to a darker, brownish colour in the foreground. He then laid in his mid-tones. He mixed up a basic tint which was usually a neutral, weak grey. For the sails he added white and a warm number; for the sea he added white and a green; and the darker clouds were often made up from the mid-tone with varying amounts of black and white and lake added to it. The brilliant, almost luminous, blue of some of his skies was achieved with the use of Prussian blue. This colour went into commercial production in the 1740s and was very popular during the latter part of the eighteenth century. He usually employed yellow ochre, crimson lake, and white for his sunsets.[10]

Pocock was adept at the use of glazes and very thin, finely ground scumbles. A notable characteristic of his technique was the employment of a thin layer of oil across the surface of the picture after he had laid in his mid-tones and shadows. This shut off or locked the underlying layers and enabled him to draw in delicate detail without disturbing the paint which he had already applied. His approach to fine detail was that of a miniaturist. He probably worked with a sable brush, using a free-flowing, long oil vehicle and he showed an astonishing command in his free-hand drawing of masts, spars and rigging. A good example of this is to be found in his *Ships of the East India Company* (colour plate VI) where it is necessary to use a magnifying glass to appreciate the delicacy with which he has portrayed the shrouds, stays and halyards and the intricate shapes of hull decoration and gear on the sunlit bows of the merchant ship in the foreground.

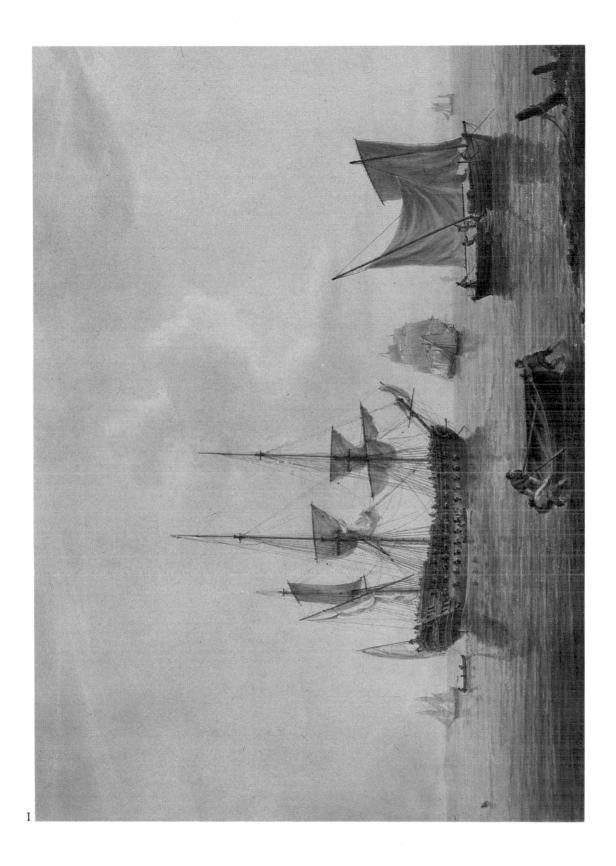

I

1 — compos'd of Indico & light red as at a, b but mix'd together & laid on quickly very liquid & with a large Swan quill pencil

2 — the Same Stronger

3 — do. with a little more of y.e red

4 — do. with yet more red

5. do. with a little yellow Oker

6 do.

7 do.

8. do. with more blue

9.10 & 11 do. with variations of yellow red or blue at pleasure.

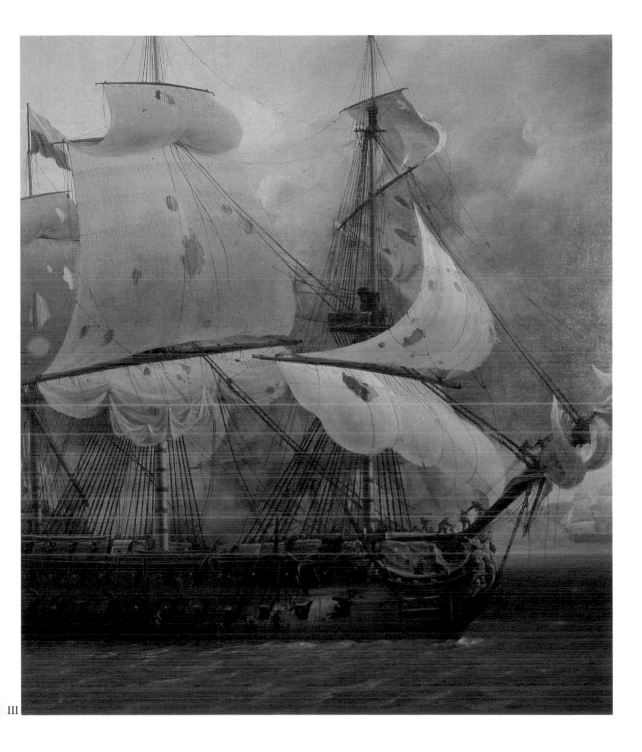

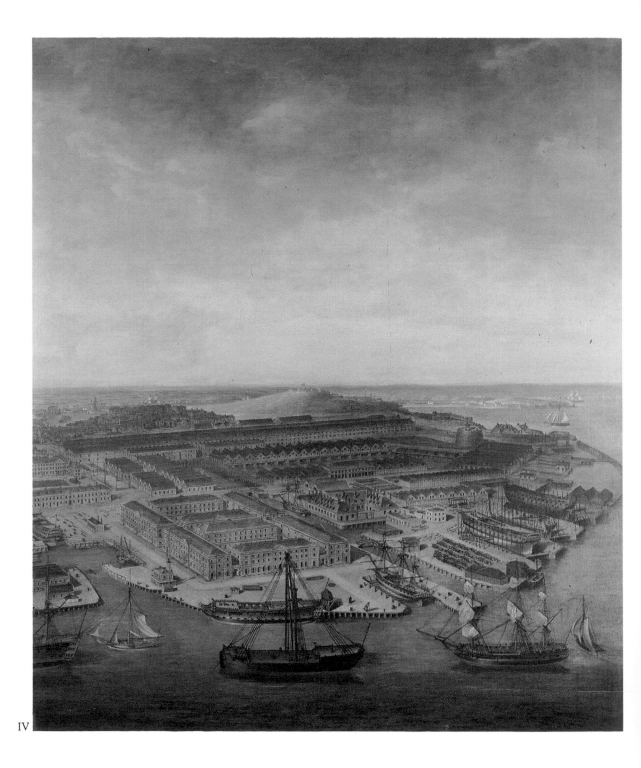

IV

V

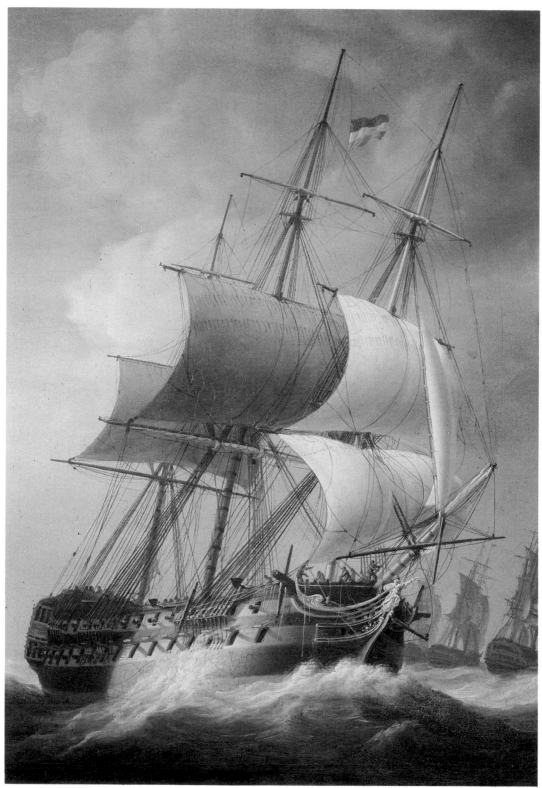

VI

Wind East

I ——————— M

3
Brave

4

Spencer
11

2

5

6

Alexandre
9

Diomede
ran on Shore wreck'd

10

Northumberland

8

7

1	2 Jupitre	4		5	6	7 Imperial R. Admiral Le Siegle	8 Superb Sir J Duckworth	10 Northumberland Rear Admiral Sir A. F. Cochrane

Donegal
Capt. Malcolm

Agamemnon
Sir Ed: Berry

Canopus
8. Admiral Louis
Capt. Austen

R. 13. Furie Escaped

Point of View

VII

1 2 3 4 5 6 7 8 9 10 11 12 13

LONDON LIFE

GREAT GEORGE STREET, WESTMINSTER

In 1789 Pocock and his family left Bristol and moved to London. Their new home was 12 Great George Street and here they were to stay for the next twenty-eight years. The street was in a pleasant part of Westminster with St James's Park at the western end and Westminster Bridge and the river Thames to the east. A narrow side street beside Pocock's house led south to Broad Sanctuary, an open area in front of Westminster Abbey which, before the developments in Victoria Street, towered over all the other buildings in the neighbourhood.

The terrace which included Pocock's house was demolished in 1900 but the architecural details are recorded in the *Survey of London* Volume 10.[1] Built in the 1750s the terrace had a finely proportioned facade in the Georgian style and was similar in appearance to buildings in Harley Street and Bloomsbury of the same period. There are several illustrations of the street in existence, and William Capon's *Views of Westminster* gives a vivid picture of the locality.[2]

plate 30
Storey's Gate and Great George Street, Westminster, 1820
The London Library
An illustration from *Old and New London* by Edward Walford, this shows Storey's Gate at the east end of St James's Park. Beyond the gate is the terrace in Great George Street where Pocock lived from 1789 to 1816.

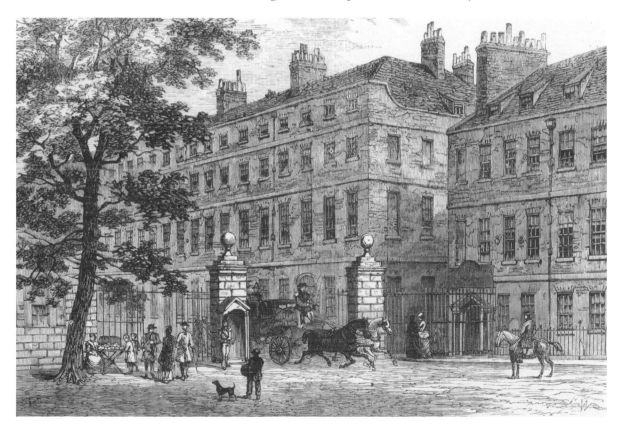

It is easy to imagine why Pocock felt it necessary to move to London. Then, as now, it was the artistic and commercial centre of the country and any artist who wished to make a good living must make himself known in the capital. There was a limit to the number of customers in Bristol who were prepared to buy Pocock's local views but in London, if he extended his subject matter, he could expect commissions from a wide and wealthy clientele. In particular, if he concentrated on sea battles, he could expect patronage from naval captains, admirals, and even the Lords of the Admiralty who were based in Whitehall, a few minutes walk from his new home. There was also the matter of the engravers and publishers, most of whom were based in Cheapside and the Strand. Pocock had already made a promising start in Bristol with the publication of his Bristol views. Although further research is needed to establish the extent to which he came to depend on the print publishers for his income, there is no doubt that they played an important part in his life. At least 200 of his subjects were engraved, either as illustrations for publications such as the *Naval Chronicle* or William Falconer's lengthy poem *The Shipwreck*, or were sold as separate sheets, in the print shops. In 1828, a year after the death of Pocock's wife, George Jones & Company, auctioneers at Leicester Square, sold a quantity of the copperplates and engraved impressions remaining in the artist's studio. The auctioneer's catalogue gives some indication of Pocock's activities in this sphere. The lots range from coastal subjects such as 'A View of Liverpool from the Channel below the Rock, 14 plain, 6 coloured, and 107 for colouring' to engravings of sea battles; 'The Brunswick and Le Vengeur after the Action on 1st June 1794, 106 plain, 5 coloured, and 27 for colouring, with 72 copies of the Narrative'.[3]

ILLUSTRATIONS OF ICELAND

The years following his move to London were among the busiest of Pocock's life. He went on several sketching tours of Wales and southern England, and he continued to paint and exhibit views of Bristol and the surrounding area. He also carried out an interesting commission for Lord Stanley of Alderley.

In 1789 John Stanley, as he then was, led a scientific expedition to Iceland. It was a venture which had been encouraged by Stanley's friend Sir Joseph Banks, the influential President of the Royal Society. The brig *John* was chartered for the voyage, and the crew was under the command of Lieutenant Piercie, RN. Stanley visited the Orkneys, the Faroe Islands and reached Iceland on 4 July 1789. The scientific members of the expedition collected plant specimens and made notes of all the fauna and flora, while Lieutenant Piercie made sketches of the islands, bays and interesting rock formations.[4]

On the return of the expedition to London, Edward Dayes and Pocock were commissioned by Stanley to prepare a set of watercolours based on Piercie's sketches.[5] It has sometimes been suggested that Pocock himself sailed with the expedition but this was not the case. All

plate 32
Sketch of members of John Stanley's expedition to Iceland
Courtauld Institute of Art
The figures represented are the botanist, Mr S (presumably John Stanley the expedition's leader), a servant, natives and the interpreter.

plate 31
Extinct volcanoes from Sneefell's Jokul in Iceland
Leger Galleries
In 1791 Pocock painted a series of watercolours illustrating John Stanley's expedition to Iceland. He did not accompany the expedition himself, but worked from drawings made by Lieutenant Piercie.

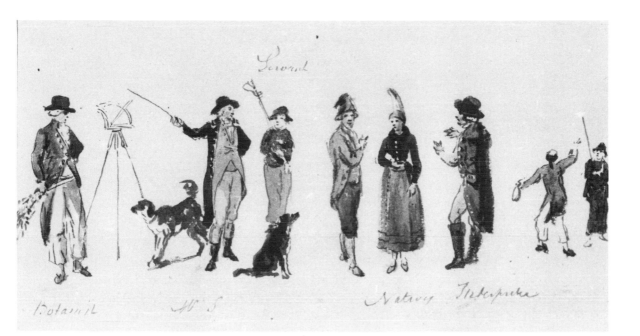

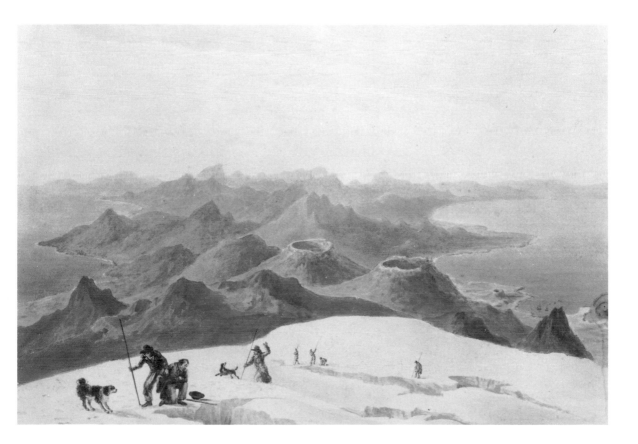

his Iceland views are signed and dated '1791', the year after the expedition's return, and it was his frequent practice to base his foreign views on information brought home by naval officers and travellers.

Pocock's views of Stanley's expedition are among the most charming and accomplished of all his watercolours. They include a variety of coastal views showing the brig *John* sailing past basalt pillars and huge caves, and they also include some picturesque inland views, notably *A view of the extinct volcanoes seen from Sneefel's Jokul* (plate 31).

In 1792 Pocock was asked by Thomas Pennant, the author and naturalist, to prepare a selection of the same views for his ambitious volume *An outline of the Globe: the Northern Regions*.[6]

The pictures are smaller than Lord Stanley's set, but because they have been hidden in the manuscript volume and protected from daylight, they are all in pristine condition. It is so unusual to find unfaded examples of Pocock's watercolours, that one is surprised by the sparkling colours. They are a sad reminder that the great majority of Pocock's exhibited works are dull shadows of their original appearance.

The 1790s were fruitful years for Pocock and the majority of his best watercolours belong to this period. His peaceful estuary scenes in the style of Van de Velde (noted in an earlier chapter) were almost all painted within this decade, and so were many of his finest coastal views, such as the lively *Warships in the Solent* in Truro Museum (Plate 33). *Caernarvon Castle from the south-east*, which is dated 1796, is one of the

plate 33
Warships in the Solent
County Museum and Art Gallery, Truro
Two frigates, a brig, and a number of small craft are shown sailing in a fresh breeze off the coast near Portsmouth. The crew on the foredeck of the nearest warship are setting the jib and staysail. The foresail and forecourse are flapping in the wind and have not yet been hauled tight.

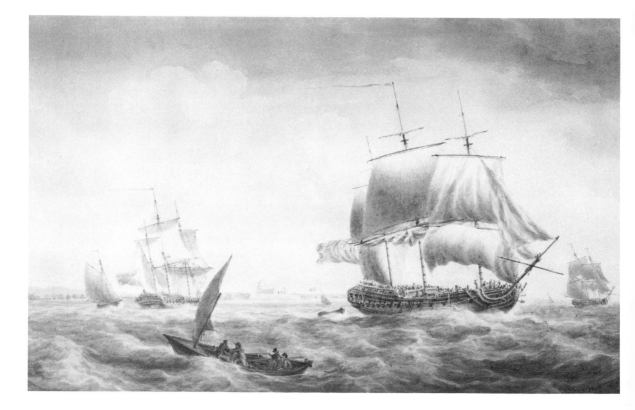

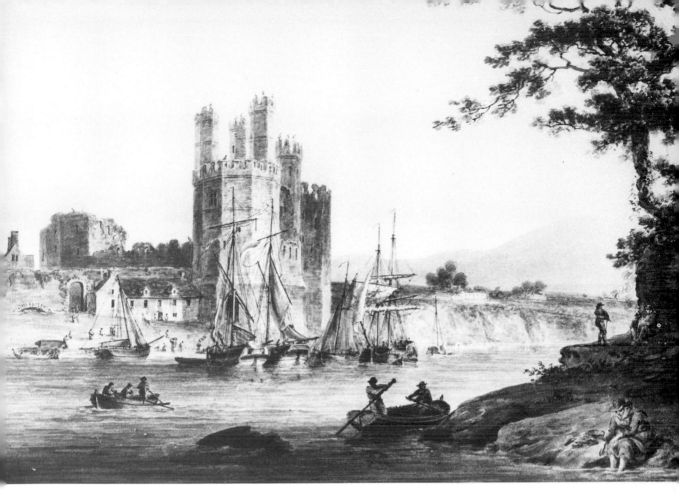

plate 34
Caernarvon Castle from the south-west
National Library of Wales
Dated 1796, this is a particularly fine example of one of Pocock's topographical views. The scenery of north Wales provided him with a rich source of subjects, and he painted a great number of pictures of the castles, harbours and rocky coasts in the vicinity of Anglesey, and the Menai Straits.

most impressive of his topographical landscapes (plate 34). Similar in style to the drawings of Edward Dayes and Michael Angelo Rooker, the picture is given an individuality by the loving attention which Pocock has bestowed on the sailing vessels moored beneath the castle walls, and the boatmen in the foreground.

THE OLD WATER-COLOUR SOCIETY

On 30 November 1804 ten artists met at the Stratford Coffee House in Oxford Street, with the aim of forming a society specially for painters in the medium of watercolours. The artists present were William Wells and Samuel Shelley, the instigators of the scheme, together with Robert Hill, William Henry Pyne, Francis Nicholson, John and Cornelius Varley, John Claude Nattes, William Sawrey Gilpin and Nicholas Pocock. They elected a President, Treasurer and Secretary, drew up a set of rules, and decided to call themselves 'The Society of Painters in Water-Colour' later changed to 'The Old Water-Colour Society'). Pocock was one of the four members of the first committee.

Suitable rooms were found at 20 Lower Brook Street off Bond Street and on 22 April 1805 the new society opened the first exhibition of its member's work. Pocock made an important contribution by showing seventeen watercolours. Eleven of these were pictures of naval actions,

which must have helped the popularity of the exhibition in the year of Trafalgar; the remainder were Welsh views, landscapes, and scenes on the south coast.

The exhibition was an immediate success. According to the *Somerset House Gazette*, 'The exhibition was daily crowded with visitors. Connoisseurs, dilettanti, artists and critics, vied with each other in loud commendations of the collected works. The noble in rank and the leaders of fashion graced it with their presence.'[7] They were also prepared to buy the pictures which was unusual at public exhibitions. In the seven weeks it was open that first year 12,000 people visited the exhibition and it became an annual event. By the time of the fourth exhibition in 1808 the number of visitors had risen to 19,000.

The formation of the society must have been a landmark in Pocock's life. Although his oil paintings of sea battles probably provided his main source of income, it was the medium of watercolours which most suited his style. The exhibitions were an ideal setting for the coastal views at which he excelled, and they also gave him an opportunity to exhibit some of the sketches and smaller versions of his large oil paintings. He exhibited every year for fifteen years and showed a total of 183 pictures – considerably more pictures than he showed during the thirty years he exhibited at the Royal Academy.

If the exhibitions of the society helped Pocock, there is no doubt that his presence also helped the society. He was sixty-three at the time of the first exhibition and, as J L Roget points out in his *History of the Old Water-Colour Society*, Pocock was at that time 'An artist of position, deservedly in high esteem'.[8]

It is mentioned by some authorities that Pocock was offered the Presidency of the society in 1806 and that he declined the office. While there seems no reason to doubt this information which would seem to be in keeping with his modest character, it is odd that no mention is made of this by Roget in his comprehensive history. Roget simply records that in 1806, when the society met on the anniversary of the first meeting in Oxford Street, Gilpin, Shelley and Hills were re-appointed President, Treasurer and Secretary; Pocock, Glover and John Varley, formed the new committee.

It is probable that Pocock found many friends among the members of the Old Water-Colour Society for they had common aims and the success of the exhibitions must have been a common source of satisfaction. Roget mentions one such friendship: referring to A F Fripp, he writes, 'When he was elected an associate, old secretary Hills expressed to him the pleasure he had had in voting for the two grandsons of his dearest friend, Nicholas Pocock.'[9]

In the same year that the Old Water-Colour Society was founded, Pocock carried out his interesting series of book illustrations for Falconer's *Shipwreck*. The watercolours were engraved by James Fittler. The writer was a seaman and he described in dramatic terms the voyage of a ship to the Mediterranean and her destruction on a rocky shore during the height of a storm. The poem was so popular that by 1811 it had run

plate 35
The launch of the 'Britannia'
National Maritime Museum, London
Pocock illustrated two editions of William Falconer's poem *The Shipwreck*. This is one of his illustrations for the 1811 edition and draws on his intimate knowledge of the shipyards at Bristol and along the Thames estuary. The result is a lively and accurate view of the scene when a small ship was launched. The shipyard is near Deptford and the vessel has just been freed from the blocks holding her on the stocks.

plate 36
The gale increasing
National Maritime Museum, London
Another illustration for the 1811 edition of Falconer's poem *The Shipwreck*, this picture shows the *Britannia* heeling before the rising force of the gale. The crew have been sent aloft to take in the topsails and are out along the yards, struggling with the flapping canvas.

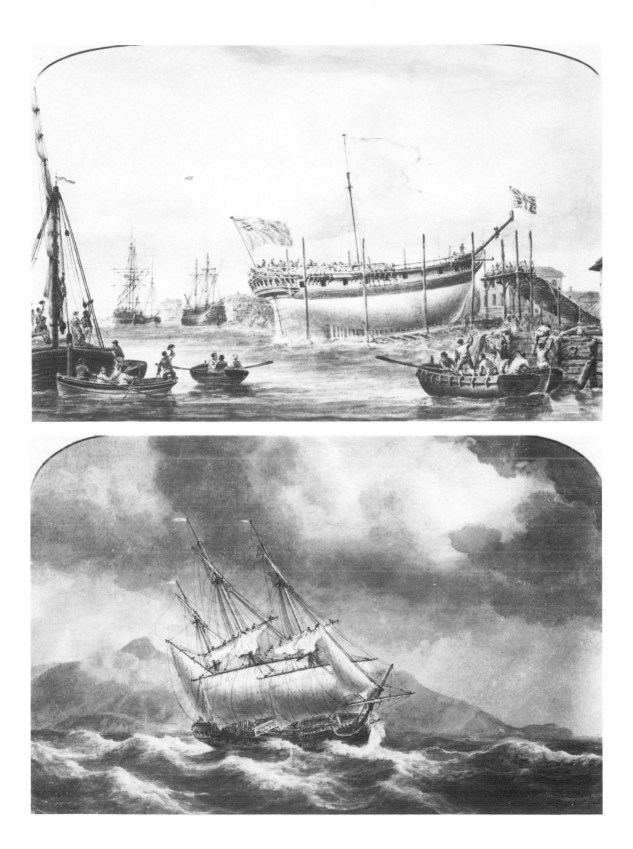

into thirty editions. Pocock illustrated the editions of 1804 and 1811. His original watercolour drawings for the former are in the British Museum. His watercolours for the 1811 edition are in the collections at Greenwich (plates 35, 36, 37). Although they have lost most of their blue-grey colouring through fading, they are still full of atmosphere and are entirely in keeping with the Romantic spirit of the poem. Pocock was, of course, able to draw on his memories of the *Betsey*'s voyage to Italy when carrying out this commission. He was evidently pleased with his illustrations because he showed six of the *Shipwreck* pictures at the exhibitions of the Old Water-Colour Society in 1810 and 1811.

The only reference to Pocock in Joseph Farington's diary appears at this same period. On 18 February he writes:

> Willm. Wells called on me. He spoke of his having
> formed a design to make a collection of drawings of all
> the vessels, boats up to vessels of the largest size
> used in every part of the world. He spoke highly of
> Pococks excellence in drawing ships correctly and in
> placing properly in the water and before the wind.[10]

Among the collections of Pocock material at Greenwich there is a drawing of a Chinese vessel which may have something to do with the project which Wells mentioned to Farington; underneath the drawing is written,

Mr. W. Wells presents his compliments to Mr. Pocock

plate 37
The wreck
National Maritime Museum, London
In the eighth of the nine illustrations for Falconer's poem *Shipwreck*, the *Britannia* is shown just after she has struck the rocks. With her back broken she is lifted by another great wave. The crew cling to the mainmast and mainyard, everything else having gone by the board.

56

and is very sorry he cannot find his Drawings of a Chinese Pilot Boat and is ashamed to send the present sketch from recollection fearing it will not be of use. Mr. Wells will call for the two paintings if Mr. Pocock will be so good as to order his servant to deliver them.

William Wells (1768–1847) had been a captain in the service of the Honourable East India Company. He became a successful shipbuilder and was well known as a sportsman and art collector.

SKETCHING TOURS OF ENGLAND AND WALES

Pocock's reputation as a marine painter has probably been responsible for the neglect of his landscapes. This is a pity because his watercolour drawings of picturesque scenery in the Welsh mountains and the southern counties of England are among the most attractive pictures which he painted. They are similar in style to the topographical drawings of Thomas Sandby, Edward Dayes and Thomas Hearne but they have a special charm of their own. Pocock had a distinctive way of portraying figures and foliage, and he was fond of introducing into his landscapes a few donkeys, a horse and cart, or a group of children playing in the foreground (plate 38). He seems to have travelled widely in search of suitable subjects and it is probable that he made regular sketching tours during the summer months.

A watercolour entitled *Melincourt Cascade* which is dated 1789 (plate 39) indicates that he had already visited south Wales in the year that he moved to London, while a letter which he wrote to Richard Bright of

plate 38
Children and goats
Victoria and Albert Museum, London
Pocock often portrayed peasant children in the foregrounds of his landscapes, no doubt using his own children as models. This is probably a view of the mountains in Snowdonia where he made a number of landscape studies.

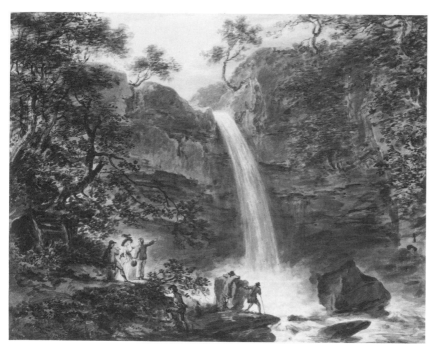

plate 39
Melincourt Cascade, Neath, South Wales
Victoria and Albert Museum, London
This is the type of picturesque Welsh scenery which was frequently portrayed by English landscape artists in the latter part of the eighteenth century. Dated 1789 the watercolour is mentioned in a letter which Pocock wrote to one of his patrons, Richard Bright of Bristol, in 1792.

plate 40
Bangor, with Penmaenmawr in the distance
Victoria and Albert Museum, London
Typical of many of Pocock's landscapes this shows the rocky coast around Bangor in north Wales, with the Menai Straits in the background.

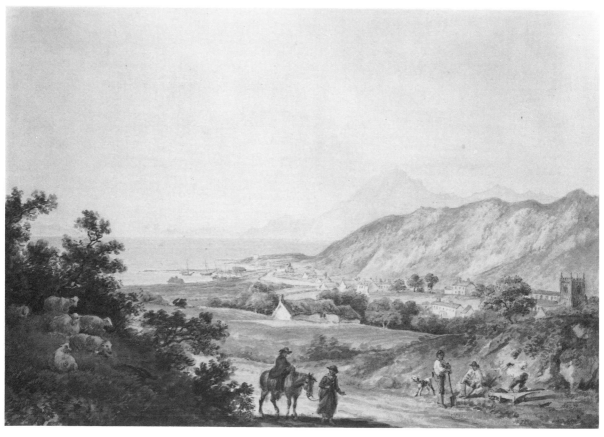

Bristol in 1792 tells us that by this date he had also made sketching tours to Monmouthshire and north Wales:

London Nov. 18th 1792

Sir
Though it is a long time since you favord me with an
order for a drawing as a companion to the small one you had
of mine (a view of Monmouthshire) I have often had it on my
mind that this Opportunity by my brother Wm. to send two
for you to select whichever you prefer. One is a view
toward Snowdon on the Lake of Llanberis taken in Company
with Mr. Eagles this summer. The other Melincourt
Waterfall. There is one also of Cadar Idris in [illegible]
with figures – if neither of these are suitable Companions
to that you have please name a subject & I shall receive it
by the return of my Portfolio – The price of the drawing
is four Guineas which please to pay to my brother.
 I remain with great respect
 Sir your most obligd
 Humble servant
 Nicholas Pocock[12]

Apart from the above mention of his visit to Snowdonia with Mr. Eagles, it is difficult to work out the exact dates of his various sketching tours. He exhibited pictures of Welsh scenery frequently between 1790 and 1814 and it seems likely that on occasions he worked up finished watercolours from his sketches without returning to the spot.

His Welsh views are mainly confined to four areas: views along the Usk valley from Abergavenny to Brecon; views of Swansea Bay and in particular Briton Ferry; the area around Carmarthen Bay including Llanstephan Castle and the port of Tenby; and an area in north Wales which included the Isle of Anglesey, coastal scenery along the Menai Straits, and the mountains of Snowdonia.

It was the last of these four areas which provided him with the greatest variety of subjects. He painted the castles at Conway, Caernarvon and Dolbardern. He painted peaceful views of Beaumaris Bay, and the rocky headlands and inlets near Bangor (plate 40). He also painted a number of pictures of Plas Newydd, the home of the Earl of Uxbridge. The house, which is today owned by the National Trust, is situated in a lovely setting on the south side of Anglesey and from its lawns may be seen the waters of the Menai Straits with the mountains of the Snowdon range rising beyond. It was an ideal place for a watercolour artist in search of picturesque views, and it seems possible that Pocock may have stayed there as a guest of the Earl. The evidence for this is to be found partly in the titles of such pictures as *The Glyder mountain, with view of Port Penrhyn, with the Augusta yacht belonging to the Earl of Uxbridge* and *Plas Newydd, Anglesea, the seat of the Earl of Uxbridge*; partly in the fact that Pocock's son Isaac exhibited a picture in 1814 of *The late Earl of Uxbridge*; and partly from one of Pocock's sketchbooks

at Bristol which contains a drawing inscribed 'Boat-house in the Earl of Uxbridge's grounds.'

This same sketchbook provides some information of sketching tours made by Pocock in other parts of Britain, particularly in south-west England. Unfortunately only three of the drawings in this sketchbook are dated. They are: 'Lord de Cliffords – from Penpole – in 1805'; 'Sketch of a party returning from H. M. S. Royal George – Oct 8th 1808 – in Torbay'; and 'H.M.S. Perseus going out of Teignmouth harbour. Dec. 23 1812'. There are several sketches of scenes around Weymouth and Teignmouth, together with drawings of scenery in the Bristol area, and a number of Welsh views. Curiously enough Pocock exhibited very few pictures of the south coast of Devon although the numerous harbours and wooded estuaries would seem to have ideally suited his style.

A more fruitful source of subject-matter for him was the coastline of Hampshire and Sussex. He painted some delightful views of Southampton Water (plate 41), and portrayed the fishing boats and beaches of Brighton (plate 42), Eastbourne and Hastings in dozens of sketches as well as several finished pictures which he exhibited at the Old Water-Colour Society.

In 1810 he showed two pictures of Dover, and during the course of the next two or three years he must have paid a visit to Kent because

plate 41
Southampton Water, 1793
Private collection
The coastal villages of Sussex and Hampshire provided Pocock with numerous subjects. He exhibited several pictures of Southampton Water at the Old Water-Colour Society, most of his views being taken from Hythe looking across to Netley Abbey.

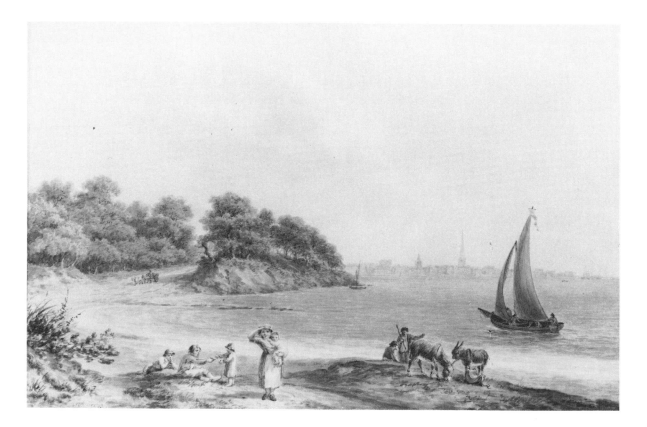

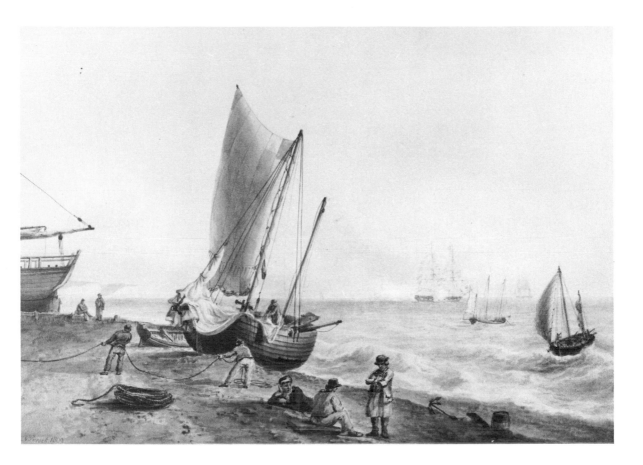

plate 42
View of the beach at
Brighton, 1809
National Maritime Museum,
London
Exhibited at the Old Water-
Colour Society in 1809 this
watercolour shows the Brighton
hogboat drawn up on a beach,
with the cliffs at Rottingdean
in the distance. Lord Craven's
yacht, dressed overall, is
anchored off-shore and is firing
a salute in honour of the Prince
of Wales' birthday.

pictures of Ramsgate, Broadstairs and Margate appear among the lists of
his exhibited works for the first time. These lists, together with the
dates on his surviving watercolours also suggest that between 1810 and
1814 he was in south Wales, making sketches in Tenby and the area
round Swansea Bay. Pocock was then in his seventies, and although
there was a decline in the quality of his oil paintings in his later years, his
watercolours retained the same delicacy and charm of his earlier work.

That Pocock enjoyed painting landscapes as much as marine subjects
is suggested by a passage in a letter which he wrote to Richard Bright in
1804:

> There is a felicity sometimes attends an artist in
> some subjects the home and rural view, I am
> fond of, and I am flatter'd that your judgement
> coincides with mine, for the Cart or Cottage scene
> I thought one of my happiest efforts.[13]

Five

SEA BATTLES AND NAVAL PATRONS

THE WEST INDIES

Ten years before the naval wars against Revolutionary France began in earnest, Pocock was given the opportunity to paint a number of pcitures of actions which had taken place in waters well known to him from his early voyages. The West Indian campaigns of Rodney and Hood were centred around the islands at the eastern end of the Caribbean. The battle of the Saints took place a few miles north of Dominica, the island which had been Pocock's destination for five of his voyages as master of Richard Champion's ships *Lloyd* and *Minerva*. He had also visited Nevis and St Kitt's which were the scene of other naval actions against the French.

Although these battles took place four thousand miles from Britain, they attracted considerable interest at home. This was partly because British merchants in the City of London and in Bristol had profitable trading links with many of the West Indian islands and partly because Britain had suffered humiliating defeats during the American War of Independence, and welcomed any news of British successes on land or at sea. Hood's action off St Kitt's in January 1782 was a major reverse for the hitherto victorious fleet of the distinguished French Admiral Le Compte de Grasse. When it was followed by the rout of the French fleet at the battle of the Saints and the capture of De Grasse's flagship the *Ville de Paris*, the British public at last had something to celebrate. In the words of a popular ballad which was inspired by Rodney's victory,

> True Britons all of each degree
> 　　　Rejoice around the nation
> Full bumpers drink and merry be
> 　　　Upon this just occasion
> Let mirth on every brow appear
> 　　　Rodney victorious is we hear
> For he had drubbed haughty Monsieur
> 　　　Success to gallant Rodney [1]

Pocock did well out of the general rejoicing, and over the next six years he painted a series of paintings and watercolours of West Indian sea battles. The most important of these commissions came from the Hood family. Five major paintings by Pocock are still hanging in the collection of the present Lord Hood at Bridport; according to family tradition they were commissioned by Lord Bridport, the naval brother of Rear Admiral Sir Samuel Hood and presented to him in honour of his achievements.[2] In return Admiral Hood commissioned paintings from Pocock and presented them to Lord Bridport. A passing reference to the

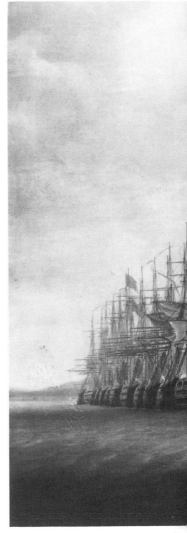

joint commission appears on the back of a Pocock watercolour depicting Hood's action at Frigate Bay. The inscription indicates that the watercolour is a study for two large pictures. 'Painted for Lord Hood, 6 feet by 4, and for Lord Bridport, 1807, 4 feet by 2 feet 6'.[3]

The five pictures in the Hood collection were painted between 1784 and 1786. Each one is a six foot canvas, and they are uniformly framed in splendid carved and gilded frames, each surmounted by the gilded coronet of a peer of the realm.[4] Two of the pictures depict the battle of Martinique, a fierce but inconclusive action between Hood and de Grasse which took place on 29 April 1781. Two pictures illustrate the actions at Frigate Bay on 25 and 26 January 1782. The fifth picture shows the van of the British fleet under Hood's command coming under attack from the French at the battle of the Saints on 12 April 1782.

The most impressive of the series is the picture which shows the

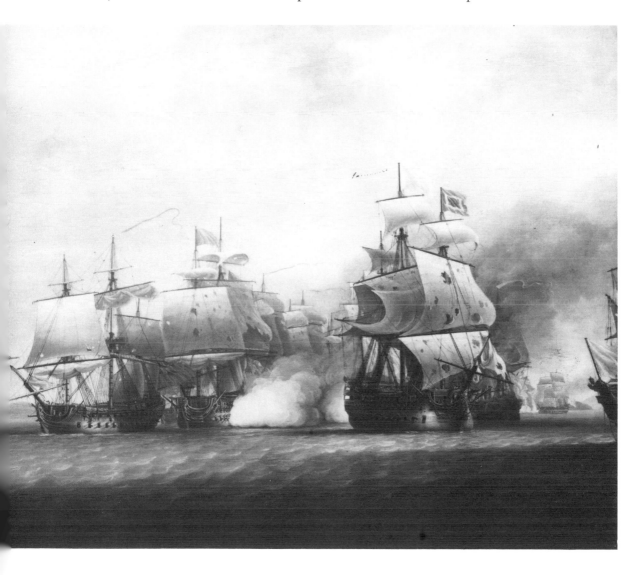

Battle of Frigate Bay on 25 January, (plate 43). The earliest of the paintings to be completed it is signed and dated 1784 and depicts the action at around 4pm. The contemporary inscription on the frame reads, 'The Rear and part of the Centre of the English Fleet engaged with that of the French while in the Act of taking up the Enemy's Ground in the road of St. Kitts, and anchoring in a Line of Battle ahead.' The British ships on the left have dropped anchor and are taking in their sails under cover of fire from the British ships in the centre of the picture. The French are on the right, with the *Ville de Paris*, the flag ship of De Grasse, the focal point of the picture. The massive 110-gun ship flies the admiral's white flag at her main topgallant mast head.

No doubt Pocock received most of his information for this and the other pictures from Hood himself although there is an interesting watercolour in the present Lord Hood's collection which indicates that he received further information from a detached observer of the battle. The watercolour is inscribed, 'Sketch of the action made by Doctor Cochrane for Nicholas Pocock' and it is taken from a high vantage point on St Kitt's island, looking down across Frigate Bay from the north side. Stretched across the bay are the two opposing fleets, the British in the process of anchoring, and the French sailing past firing broadsides.

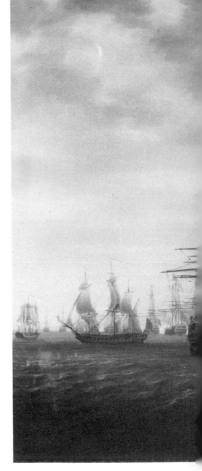

Of the various versions of the Hood pictures in other collections one which should be noted here is *The Battle of Frigate Bay 26 January 1782* which is in the National Maritime Museum (plate 44). One of several Pocock paintings which were owned by Admiral Lord Gambier and bequeathed to Greenwich Hospital in 1833, it is one of the finest of Pocock's large battle pieces. Dated 1788, it is almost certainly the version which was exhibited at the Royal Academy that year with the title 'Representation of the action between the British and the French fleets on 26th January, 1782, off Basse Terre, St Christopher's'. Seven foot wide, and painted with a confidence which is rare in Pocock's early oil paintings, it must have made a considerable impression on visitors to the Academy and added to his reputation, particularly among the naval hierarchy in London.

The painting shows the scene in Frigate Bay on the day following the action depicted in Lord Hood's picture. The British fleet, having taken possession of the bay, are anchored in a dog-leg formation across the shallow ground. The French ships (on the right) are trying to dislodge the British from their position but are being repulsed by the guns of the anchored fleet.

Pocock has chosen to made a battered French ship the principal subject of the picture. The massive two-decker has just run the gauntlet of the British broadsides, and is turning away from the British line, while beyond her stern another French two-decker comes under the attack from the blazing guns of the *Alfred*. On the right other French ships head out to sea, their sails and rigging showing the pounding they have received. The island of Nevis is visible in the far distance. On the left of the picture, British frigates, sheltered by the line of battle ships, stand by to give assistance and repeat the admiral's signals.

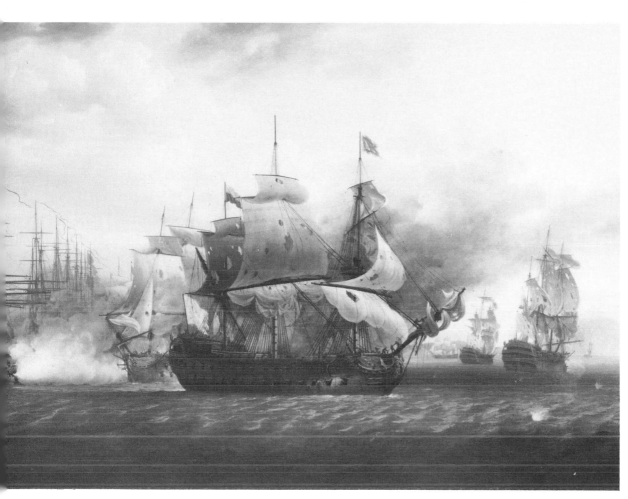

plate 44
**Frigate Bay, 26 January 1782:
the repulse of the French**
*National Maritime Museum,
London*
On the day following that in
which Hood had anchored his
fleet in Frigate Bay, the French
under De Grasse launched a
concentrated attack. They were
met by ferocious broadsides
from Hood's anchored ships,
and, as Pocock graphically
shows here, they were forced to
retire with their sails and hulls
rent and battered by shot.

Painted eight years after his first attempt at oil painting, the picture
demonstrates that Pocock had learned to use a number of compositional
devices pioneered by the seventeenth century Dutch marine artists – in
particular the use of shadows on the water's surface to break up the flat
expanse of sea, and lead the eye into the picture. The French two-decker
in the centre is beautifully drawn and repays the closest analysis (colour
plate III). The massive shrouds and stays supporting the masts contrast
with the curved and trailing ropes of the running rigging. The touch of
sun on the bows spotlights the French seamen who can be seen hanging
from ropes while they inspect the damaged hull. Other seamen on deck
heave on the braces and halyards, and hurry forward to repair damaged
sails.

To modern eyes accustomed to the drama of Turner's later seascapes,
and to the brilliant colouring and fluent brushwork of seascapes by
Courbet and Boudin, there is no doubt that a work like *Frigate Bay* has a
curiously static appearance. And yet within the context of eighteenth
century marine painting, and, given the restraints imposed by a
demanding naval patron, it is a considerable achievement.

PAINTINGS OF THE ROYAL DOCKYARDS

The National Maritime Museum has four large oil paintings of the royal dockyards at Chatham, Deptford, Plymouth and Woolwich (plates 45, 46, 47, 48). They are meticulously executed aerial views which show every building, dock and slipway in each of the yards. Although clearly commissioned for a particular purpose, the origin of the pictures has been a mystery for many years, and their attribution a matter of some doubt. The pictures of Woolwich and Plymouth bear Nicholas Pocock's signature and are dated 1790 and 1798 respectively. The other two pictures have no inscriptions. Apart from the foreground ships and certain passages in the distant landscapes, the paintings have never seemed typical of Pocock's work. There is a wooden quality and hardness of colouring in the Chatham and Deptford pictures in particular which is unlike Pocock, even at his most uninspired.

A search of the Admiralty and Navy Board letters has at last thrown light on this interesting commission, and we now know how the pictures came to be painted, who painted them, and how much they cost.[5]

On 18 May 1785 the Navy Board issued an order to William White, the master mast-maker at Deptford, requesting him 'to assist Mr Farrington in executing Views of His Majesty's Dockyards'.[6]

Nineteen years later in February 1804 the Lords of the Admiralty demanded to know by what authority Farrington had been employed, how much he and his assistants had been paid, and 'for what purpose these views or plans have been drawn'.[7] The reply from the Navy Board, dated 7 March 1804, explains the whole matter. It also makes it clear why only four dockyard pictures were ever completed when there were a

plate 45
Chatham dockyard
*Oil painting by Joseph Farington
National Maritime Museum,
London*
The Navy Board commissioned Pocock and Farington to paint panoramic views of four of the royal dockyards. They worked from perspective plans drawn by the master mast-maker at Deptford. For this meticulously rendered picture of the yard at Chatham, Farington was paid £94.10s. The dockyard has changed very little in its appearance to this day.

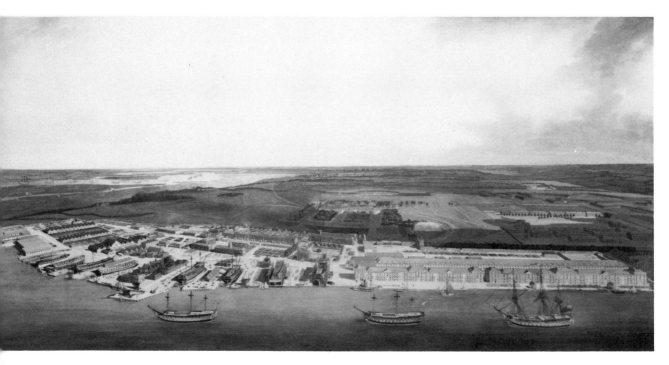

total of six royal dockyards.

We desire you will please to acquaint their Lordships that Mr White the Master Mast Maker at Deptford Yard was employed in drawing the perspective Plans of the Dockyards previously to their being painted by Messrs Farrington and Pocock, and not as an assistant to them; those gentlemen were not retained any particular time in the performance of their part of the Work; but were paid a Specific Sum, as previously agreed on with us for each respective piece which they were to complete as soon as their other Avocations would admit – that no person is at present, nor has been for some time past engaged on this service – the Views were drawn and Painted by our directions, and are now hung up in our Board Room, that we may have reference to them as occasions arise; those already prepared are of Deptford, Chatham, Woolwich & Plymouth Yards, that for Portsmouth being in hand when Mr White was rendered incapable by illness of proceeding theron – And the Amount of the Expence of each of the Plans that have been completed is as follows –

Deptford Yard	£63-0-0
Chatham Yard	94-10-0
Woolwich Yard	84-0-0
Plymouth Yard	84-0-0[8]

An examination of The Farrington Diary has confirmed that the 'Mr Farington' in the Navy Board correspondence was none other than Joseph Farington who, in addition to his fame as a diarist, was also a topographical artist. His works include a number of views of London and the waterfront. His diary does not begin until July 1793 so that the

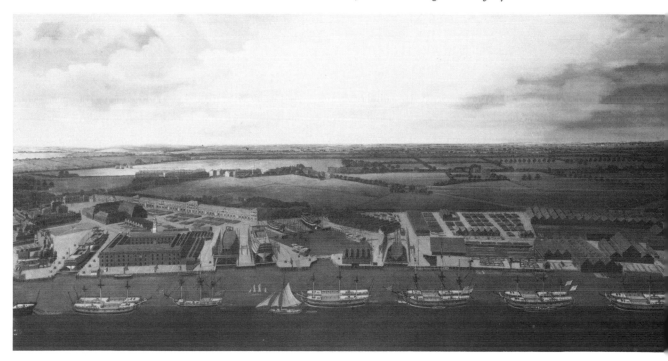

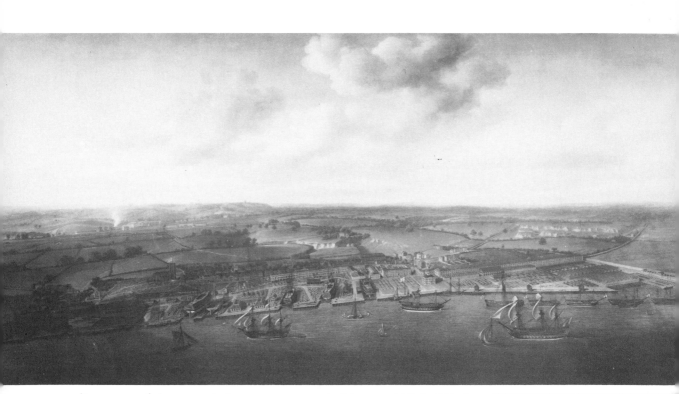

earlier stages of the commission are not recorded, but on 12 July 1794 he wrote, 'Went to the Navy Office and was directed by Mr Margetson, the Secretary, to write to the Board to desire them to order payment for the picture of Deptford Yard — I accordingly wrote'.[9]

A few days later, on 17 July, he called again at the Navy Office, '& spoke to Mr Margetson abt. payment for the picture. He said that the minute of the agreed price had not been presented to the Board: but He would mention it again. I told him the price agreed for was 60 guineas'.[10] On 23 July he was told that his picture of Deptford Yard was not 'so well approved as the Chatham'. Not until 4 August was a payment order at last made out for the sum of £63.

Farington's diary entries make no mention of Pocock, nor do they mention the paintings of the dockyards at Plymouth and Woolwich. Since Pocock signed and dated the latter two pictures, it would seem that he was responsible for them, and that Farington painted Chatham and Deptford. It is possible that Pocock collaborated with Farington on the whole project and painted the shipping in each one, leaving Farington to paint the buildings (Samuel Scott had performed a similar service in 1732 when he added the ships in George Lambert's six paintings of East India Company forts)[11], but this seems unlikely. The style of the Chatham and Deptford pictures is very different from the other two. Apart from bearing Pocock's signature, they are also typical of his work. *Plymouth Dockyard* (colour plate IV) in particular has a softness of colouring, and sensitive handling of clouds and water which is entirely characteristic.

With the current interest in the preservation of the historic

plate 47
Woolwich dockyard
*National Maritime Museum,
London*
Pocock's two dockyard
paintings lack the confident
handling of Farington who was
adept at architectural drawing,
but they show a better
understanding of shipping. This
picture is signed by Pocock and
dated 1790.

plate 48
Plymouth dockyard
*National Maritime Museum,
London*
Pocock was paid £84 for this
picture which was completed
eight years after his view of
Woolwich yard. According to a
letter from the Navy Board
dated 7 March 1804, 'the Views
were drawn and Painted by our
directions, and are now hung
up in our Board Room that we
may have reference to them as
occasions arise.'

dockyards, the four paintings have considerable documentary value.
They provide a graphic account of the royal yards in their heyday, and
we now know that they were based on the most accurate information
supplied by a senior employee of the yards at the express command of
the Navy Board. Exactly how long the paintings remained in the Board's
possession is not known, but the pictures eventually passed into the
Greenwich Hospital collection and thence to the National Maritime
Museum.

THE FIRST OF JUNE NOTEBOOK

In 1928 an article on Nicholas Pocock was published in the fifth annual
volume issued by the Old Water-Colour Society's Club. It was written
by Randall Davies and contained an interesting quotation from a letter
written by Captain Roger Pocock, a descendant of the marine artist:
'Among some old papers I once found a quarto note-book filled with
manuscript notes by the painter, and illustrated with four watercolour
sketches of stages in the engagement of the Glorious First of June, Lord
Howe's Victory. I don't know what became of the manuscript, but I
framed the four sketches'.[12]

Four years later Captain Pocock wrote to the curator of the Royal
Naval Museum:

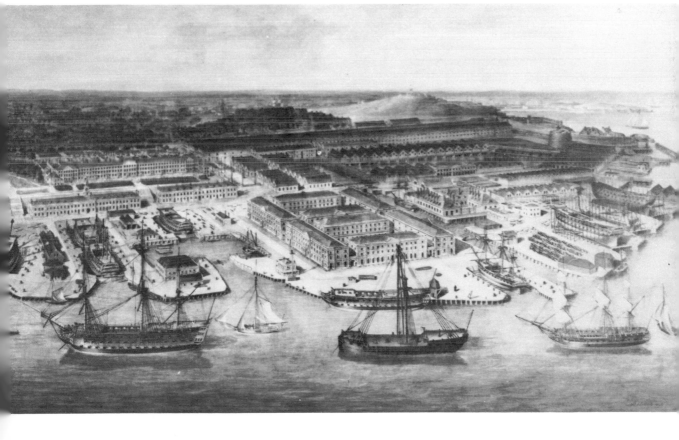

Sir,
With reference to the paintings of Nicholas Pocock, Master Mariner and marine landscape painter.

Gifts Offered
My sister Lady Simson, at this address has four watercolour diagrams 12″ × 15″. Studies for the four pictures of Lord Howe's Victory of 1st June. With these is the M.S. notebook, and correspondence on the subject. I cut the diagrams from the book, mounted them, copied the names of ships on the margin, as referred to by index letters on the paintings, then framed them to prevent injury.
We feel that these should belong to the nation subject to your acceptance.[13]

He went on to describe other pictures by Nicholas Pocock which were also in the possession of Lady Simson and suggested that the museum should send a representative to examine them. The material subsequently entered the collections of the National Maritime Museum at Greenwich.

The notebook referred to by Roger Pocock is the journal kept by Nicholas Pocock during the four-day engagement between Lord Howe's fleet and the French fleet under Villaret-Joyeuse in the summer of 1794. The battle took place in the Atlantic, some four hundred miles west of Ushant, and although the French never regarded it as a defeat because they succeeded in their aim of safeguarding a grain convoy from America, the British nation rejoiced when they heard that Howe had captured six prizes, sunk the *Vengeur* and scattered the French navy.

The provenance of the notebook is important because Pocock's name does not appear on the manuscript or the accompanying drawings, and no documents have come to light to explain his presence on board the frigate *Pegasus*. Was he an official war artist, or had he been invited on board unofficially by one of the ship's officers? The latter seems most likely as his name is not recorded in the captain's log or the ship's muster book.

Whatever the reason for Pocock being present at the battle, there can be no doubt about the authenticity of the notebook. In addition to the fact that it turned up among papers and drawings in the possession of the Pocock family (Lady Simson, formerly Lena Ashwell Pocock, and her brother Roger, were direct descendants of George Pocock, the sixth son of the marine artist), the autograph expert of Sotheby's has positively identified the writing as being in the same hand as the logbooks and letters of Nicholas Pocock.[14] Moreover the watercolour sketches of the battle are entirely characteristic of Pocock and are similar in style to other drawings in his sketchbooks.

It should also be noted that the Print Room at Greenwich has a number of Pocock watercolours which depict various stages in the battle (plate 49). The watercolours have every appearance of having been carried out on the spot: they combine hastily applied brushwork with careful observation of significant detail. A sketch showing damaged

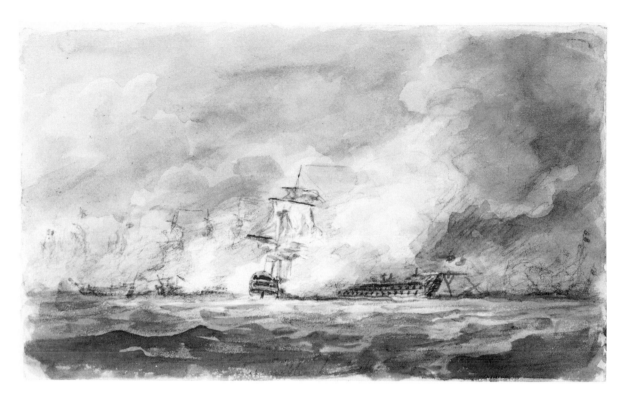

ships and floating wreckage in the aftermath of the battle has an immediacy which could only come from first-hand observation (plate 50). It is the same immediacy which can be found in the drawings made by Van de Velde the Elder when he was observing sea battles during the Anglo-Dutch wars one hundred years earlier.

Although a number of eye-witness accounts of the Glorious First of June have survived (including the log-books of the ship taking part) Pocock's notebook has a special interest because it contains the observations of a marine artist who recorded thirty years of maritime history. The events of 28 May to 1 June 1794 provided Pocock with a fund of visual information on which he was able to draw when he later came to paint pictures of this battle as well as the victories of the Nile, Copenhagen, Trafalgar and numerous other engagements of the Nelson era.

THE FRIGATE 'PEGASUS'

When two fleets went into action in the eighteenth century, the battle was fought by the massive ships-of-the-line. In conventional engagements they ranged alongside each other in two parallel lines and battered each other into submission with broadsides. The purpose of the frigates was not to take an active part in the fighting, but to reconnoitre, to stand by on the disengaged side of the fleet during the battle so that they could assist ships in trouble, and to repeat the flag signals made by the commander-in-chief on board the flagship.

On the 1 June the frigate *Niger* was the repeating frigate for the van, the *Aquilon* for the rear squadron, and the *Pegasus* for the centre. The third of Pocock's sketches of the battle (plate 76) shows the *Pegasus* (in the middle of the picture) stationed a few hundred yards to windward of the British line and in a good position to observe the signals of the *Queen Charlotte*. In fact the crew of the frigate were so efficient at reporting the flagship's signals that on one occasion they acknowledged a complicated signal as it was being run up the halyards. 'Damn that ship, how could she know what we meant?' said Sir Roger Curtis, Howe's first captain.[15]

The *Pegasus* was a 28-gun ship which had been built at Deptford in 1779. She was in the West Indies with Sir Samuel Hood's fleet in 1782, and had the distinction of being the first command of Prince William Henry, later King William IV. She would have looked somewhat similar to the frigate *Triton*, which was the subject of a fine ship portrait by Pocock (plate 51). In 1794 the *Pegasus* carried a complement of two hundred men. Her captain was Robert Barlow, a capable man who was well liked by Lord Howe.

The battle on 1 June lasted for nearly four hours. It was, like all naval battles of the period, a noisy, confused and bloody affair. The logbooks of the ships which took part and the accounts of various eye-witnesses record numerous incidents of tragedy and heroism. Two incidents deserve a particular mention.

The first concerns the gallant conduct of the 98-gun ship, *Queen* (not to be confused with the *Queen Charlotte*). 'The *Queen* I also had an

plate 51
Portrait of H. M. frigate 'Triton' shown in three positions
National Maritime Museum, London
This rare ship portrait by Pocock was painted for Admiral Gambier, the designer of the frigate. It is typical of Pocock, the former seaman, that instead of showing the vessel sailing before a fresh breeze with all sails set (the usual convention for ship portraits) he portrays her hove to, with the foretopsail and foretopgallant backed, and the seamen engaged in hoisting the foresails. The frigate has just dropped the pilot who is heading for home in the two-masted lugger in the foreground.

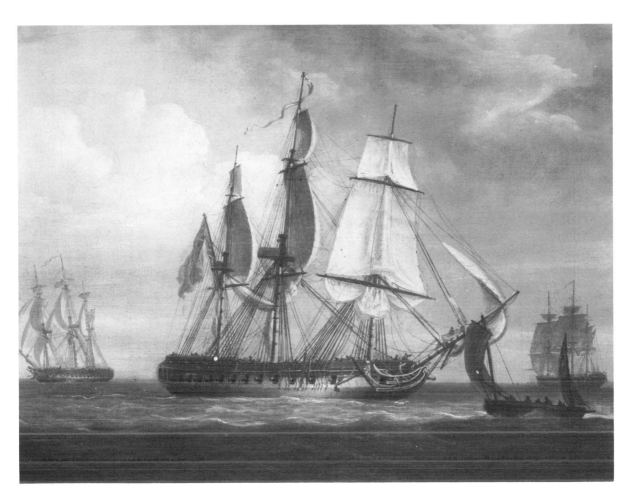

opportunity of observing' Pocock wrote. 'There appeared something so superior in her fire to that of the enemy that I cannot desist mentioning her'. It appears that the *Queen* fired an astonishing total of 130 broadsides, and used 25 tons of powder and 60 tons of shot, a feat that was unequalled and was regarded as fantastic in less efficient ships.[16] Her performance was all the more remarkable in that her captain had been wounded and her master killed on 29 May. On 1 June she was fought by Admiral Gardner assisted by a handful of lieutenants. Gardner was one of those men of nervous temperament who have the ability to rise to a great occasion. 'I had nothing to do but to look at the Admiral – and his very appearance put fresh courage and life into me' observed one of his lieutenants.[17] The casualties on the *Queen* (thirty-six killed and sixty-seven wounded) were greater than on any British ship except the *Brunswick*, and she suffered such damage in the battle that Lord Howe sent the *Pegasus* to give her assistance. Captain Barlow took the *Queen* in tow at 2.30 pm, but the crew of the disabled ship succeeded within a few hours in getting up a jury mainmast. She cast off four hours later, and eventually reached home unassisted.[18]

The second incident concerns the famous duel between the *Brunswick* and the *Vengeur* which was the subject of one of Pocock's larger oil paintings (plate 52). The only reference to the incident in his notebook is at the conclusion of the battle when he writes, 'the ship 4 is the *Vengeur* which sunk the same evening'. Smoke probably hid the two ships from him for much of the time although it is interesting to note that the point of view chosen by Pocock for his painting is the same view which he would have had from the deck of the *Pegasus*, positioned as she was in his third sketch.

The *Brunswick* engaged the *Vengeur* at 10 o'clock on 1 June, soon after the battle had begun. The anchors of the two ships became hooked and they were so closely locked in combat that the *Brunswick* was unable to open her lower deck ports and had to blast them off with her guns. For four dreadful hours they pounded away at each other until 'at $\frac{1}{4}$ past 2 the *Vengeur* hauled her colours down, and displayed a union

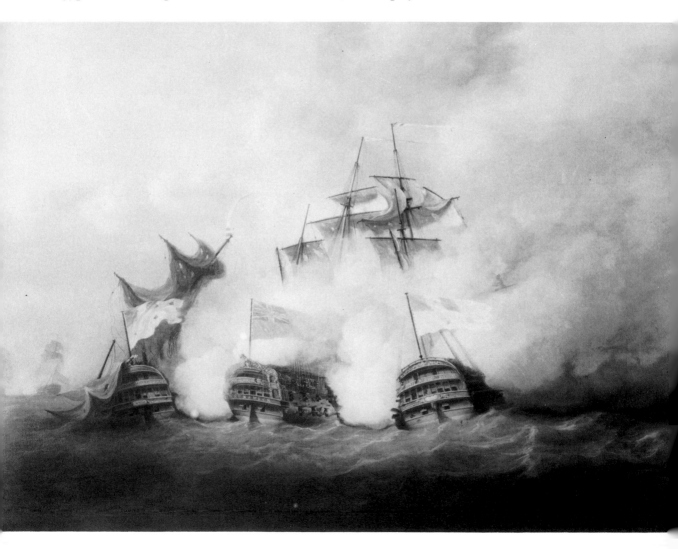

jack over her quarter, and hailed for quarter having struck, her masts going soon after and asinking'.[19]

The *Brunswick* got clear, and the *Culloden* managed to take off the French captain and about one hundred and thirty of his crew before the French ship went down. The final moments were vividly recorded by Mr Baker of the *Orion* in his journal:

At half-past five o'clock, we were witness to the most shocking scene possible. *Le Vengeur* being very much mauled between wind and water in the action filled with water and lay upon her beam ends. Numbers of unfortunate wretches were seen clinging to her side. Soon they were floating in the water and crying for assistance. In a minute's time, she heel'd right over and went to the bottom. Numbers were seen floating on the water, of whom the *Rattler* cutter picked up several, but much the greater part of the crew were lost.[20]

It is a pity that Pocock's weakness at working on a large scale prevented him from producing a more memorable picture of the *Brunswick* and *Le Vengeur*. The six-foot canvas, which he exhibited at the Royal Academy in 1796, is workmanlike but dull. The *Brunswick* is shown in the centre of the picture blazing away with her port and starboard guns. On the left the French 74-gun ship *L'Achille* has just had her mainmast shot away, while her mizzenmast trails over her stern. (She later surrendered and was one of the six ships captured on 1 June). *Le Vengeur* is on the right, all but her stern and topsails hidden under the dense clouds of smoke. The stern galleries of the three ships are drawn with immaculate precision, the sea is full of movement and there is a nice contrast between the cool grey gun smoke and the warm, pink-tinged clouds but the painting as a whole is lacking in sparkle.

Pocock did, however, produce one oil painting of the Glorious First of June which does have sparkle and atmosphere. Entitled *The Defence at the Battle of the First of June*, (plate 53) it portrays a moment in the battle which he would have seen from the deck of the *Pegasus*. Measuring no more than twenty inches across, it is one of the most authentic depictions of a sea battle ever painted. It is totally lacking the bravura and the drama of de Loutherbourg's famous painting, *The Glorious First of June*, but it has a deadpan realism and a mastery of brilliantly observed detail which brings that distant battle to life. We enjoy de Loutherbourg's great canvas as a magnificent piece of theatre, but we turn to Pocock to find out what it was really like to be present among the ships on that June day nearly two hundred years ago.

The *Defence* was a 74-gun ship commanded by Captain James Gambier. On 1 June she sailed boldly into battle under full sail, including her maintopgallant – the only British ship to do so. This additional canvas caused her to draw ahead of the line, but when it was suggested to Gambier that he might reduce sail, he replied, 'I am acting in obedience to the Admiral's signal'.[21] At 9 am the *Defence* came under fire from the French but she held back her first broadside until she had closed with the enemy. At 10.30 her mizzenmast was shot away, and at

11.30 she lost her mainmast. In spite of the confusion her gun crews continued to pound away. Midshipman Dillon observed that, 'The lower deck was at times so completely filled with smoke that we could scarcely distinguish each other, and the guns were so heated that, when fired, they nearly kicked the upper deck beams'.[22]

Pocock depicts the scene around midday. The *Defence* is shown, broadside view, in the centre of the picture, partially obscured by smoke from her starboard guns. To the left is a French ship bearing down across her stern. The *Defence*, now totally dismasted, is engaging a second French ship, *L'Achille*, which is viewed from the stern, on the right of the picture. Glimpses of other ships can be seen through the dense pall of smoke which hangs across the scene. Very few other marine paintings show the effect of gun smoke so vividly, and it is a reminder that, after several broadsides had been fired in a sea battle, it was frequently impossible to see anything more than a few yards away. The painting also shows the damage which guns could inflict on the masts and sails of the ships taking part. The deck and sides of the *Defence* are littered with broken spars and trailing rigging, the sails of the attacking French ships are spattered with holes from grape shot and pieces of wreckage float past in the foreground.

COMMISSIONS FOR NAVAL OFFICERS

Although Pocock's depictions of the major sea battles of his day are most frequently reproduced, he also painted numerous pictures of smaller actions. Most of these were commissioned by naval officers who had taken a prominent part in the actions. The correspondence between Pocock and Sir Harry Neale relating to the lively painting *The capture of the Resistance and Constance* has already been noted in the Introduction.[23] Scattered among the drawings and correspondence of the artist may be found similar examples of detailed instructions from senior officers. There is, for instance, a letter from Sir Richard Strachan who commanded a squadron which captured four French ships off Cape Ortegal on Spain's north-western coast in November 1805.

Sir Richard Strachans compliments to Mr Pocock
and inform him he just recollects that the French Admirals
mizen topmast should be shot away at the time the picture
is meant to represent – the French admiral is that
ship engaged by *Namur* – the ship with the main topsail
aback – and main yard carried away.
The French adml should have his ensign landing [?] as
if fallen over the stern, and the flag & mizen topmast
hanging after.
The *Courageux* stern should be like a frigate.[24]

plate 54
The cutting out of the 'Hermione'
National Maritime Museum, London
The *Hermione*, a former British ship, was captured by the Spanish and anchored in a Venezuelan harbour protected by the shore battery (shown on the left). Captain Hamilton of the *Surprise* sent his men in boats to recapture the *Hermione*, which they did without the loss of a single British seaman. Pocock depicts the moonlit action at its height, with the *Surprise* just visible in the distance on the right.

Sir Richard accompanied his text with a scratchy pen and ink sketch of two damaged ships and a ship's stern. There is no date on the letter, but it is addressed to Pocock's house in Great George Street, Westminster and it probably refers to the painting in the Royal Collection, *Sir Richard Strachan's action off Ferrol, 1805*. The painting is signed by Pocock and dated 1812. It is one of his most dreary pictures, and shows a line of eight warships on a flat, lifeless sea. The spectacular damage suffered by all the ships (the leading vessel is totally dismasted) is carefully recorded but little attempt has been made to bring drama to the composition.

A painting of higher quality is the night scene entitled *The cutting out of the Hermione* (plate 54). Exhibited at the Royal Academy in 1800, this lively picture illustrates one of the most daring cutting out expeditions ever undertaken. Captain Edward Hamilton of the frigate *Surprise* (which can be seen on the horizon to the right of the picture) took a hundred men in small boats and crept alongside the *Hermione* in the middle of the night. The *Hermione*, a former British ship whose crew mutinied and went over to the Spanish, was anchored in the harbour of Puerto Caballo, Venezuela, protected by the guns of the shore battery. Hamilton's men overcame the crew of 392 Spaniards, cut the anchor cables and took the ship in tow. One hundred and nineteen Spaniards died in the attack, without the loss of a single British seaman. This canvas is a rare instance of Pocock revealing himself as an artist of the Romantic movement. The moon rising above the mountain peaks, the lurid flames lighting up the night sky and silhouetting the spars and rigging of the ship, the wildly gesticulating figures on the deck and in the small boats, produce a theatrical effect which is closer to de Loutherbourg and Vernet than any other painting by Pocock. The picture, now in the National Maritime Museum, was presented to Greenwich Hospital in 1830 by Admiral Sir Charles Hamilton, brother of Captain Edward Hamilton, and was presumably commissioned by Captain Hamilton or a member of his family.

By no means all of Pocock's ship paintings depict warships. In 1803 he exhibited a painting at the Royal Academy with the title 'The Hindostan, G. Millet, commander, and senior officer of eighteen sail of East Indiamen, with the signal to wear, sternmost and leewardmost ships first'. Usually known by the shorter title *Ships of the East India Company at sea*, (plate 55) the painting is perhaps the most accomplished of all Pocock's works. The grouping of the ships and the handling of light and shade is masterful and recalls the finest works of Charles Brooking and Van de Velde the Younger.

A close examination of the principal ship, the *Hindustan*, shows the artist at the height of his powers. By illuminating the bows of the vessel and casting the stern into shadow he has thrown the sails on the foremast into brilliant relief against the dark sails on the main and mizzenmasts. The curving form of the massive hull is drawn with the utmost subtlety. The tension on shrouds and stays is portrayed with extraordinary realism, and the figures on deck are shown working the

plate 55

Ships of the East India Company at Sea
National Maritime Museum, London.
Eighteen East Indiamen, under the orders of Captain George Millet in the *Hindustan*, being given the order to wear, the sternmost and leeward ships first.

ship and not added as afterthoughts.

It seems likely that this picture was commissioned by George Millet, the commander of the *Hindustan*, and was intended to commemorate the safe return of the ship from her second voyage to China. Millet arrived back in June 1802 and Pocock's picture is dated 1803. There are references to Millet in a letter from Pocock to his son William Innes Pocock some years later which suggest that Millet was well known to him,[26] but until the provenance of the painting has been established it cannot be assumed for certain that Millet was the patron. Two other paintings in the collection at Greenwich may appropriately be

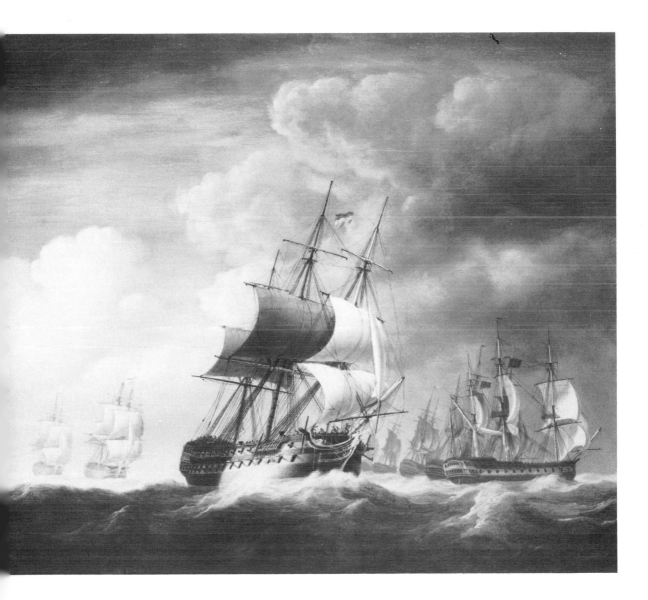

considered here. The first is the *Portrait of H.M. Frigate Triton* which is a small canvas almost exactly the same size as *Nelson's Flagships*. Unlike Holman, Luny, Whitcombe and other marine artists of his day, Pocock very rarely painted ship portraits. This commission was a rather special one because the patron was Vice-Admiral James Gambier, the designer of the *Triton*.[27] The frigate was built at Deptford in 1796 and Pocock's picture is dated 1797.

The artist has adopted the traditional formula for a ship portrait with the vessel shown in three positions sailing in a fresh breeze. The colouring is subdued with the sea painted in cool shades of grey-green. The picture lacks the flair which Robert Salmon was able to bring to his ship portraits, but the frigate is skilfully drawn and the picture as a whole has a breezy sense of atmosphere.

A naval commission on a larger scale was the six-foot canvas entitled *Duckworth's action off San Domingo, 1806* (plate 56). The scene is viewed from a few feet above water level, as if from the deck of a ship taking part in the action. The principal ships, the French flagship *Imperial* and Sir John Duckworth's *Superb* are shown heading for the spectator, their bows breaking from shadow into the sunlight which shimmers on the bow waves and the patch of sea ahead of them. The main topmast of the French ship has been hit and is toppling downwards. The straining sails and the position of flags and pennants reveal the strength and direction of the wind, which, as always with Pocock, is exactly as it was at the time shown. This is confirmed by a remarkable album which is among the Middleton papers in the National Maritime Museum and has not previously been published.

The album was prepared by Pocock in order to give full details of the events portrayed in *Duckworth's action* and four other of his paintings. As much as anything in the rich collection of Pocock material at Greenwich it illustrates the almost obsessive care taken by the artist to achieve accuracy in his battle pieces. The four other paintings described in the album are: *Sir Robert Calder's Action, July 22 1805*; *Lord Nelson's victory at Trafalgar – the commencement of the battle*; *Trafalgar – the close of the battle*; (plate 57) and *Sir Richard Strachan's action November 4 1805*. For each painting Pocock prepared a small watercolour version of the picture, a plan of the action showing the position of each of the ships with an explanatory key, (colour plate VII) and he provided a concise written description of the course of each battle. On each plan he shows the wind direction, the compass direction, and the point of view from which the picture was taken.

A study of the watercolour drawings shows that they represent paintings which were all at one time in the collection of Lady Gainsborough, and this explains how the pictures came to be commissioned. Lord Gainsborough was the direct descendant of Charles Middleton, the admiral who was created Lord Barham in May 1805. From April 1805 to January 1806 Barham was First Lord of the Admiralty. It is clear that he commissioned Pocock to paint pictures of the major actions which had taken place during the brief but eventful

plate 56
Duckworth's Action off San Domingo, 6 February 1806
National Maritime Museum, London.
A squadron under Sir John Duckworth engaging five French ships commanded by Rear Admiral Leissègues. The mainmast of the French flagship, *Imperial*, has just been shot away by a broadside from Duckworth's *Superb*.

period of his time in that office. This is confirmed by a letter from Pocock which accompanies the album of drawings. The letter, written a few months before Lord Barham's death in June 1813, reads as follows:

London 23d Nov.r 1812

My Lord,
I have been prevented by untoward and vexatious occurrences from sending the Explanations of the Paintings so soon as I hoped. They were done from the Gazette Letters & such other Information as I could Collect and I hope the Plans Views & References will make the Pictures understood by those who are not Nautical men & be acceptable to your Lordship.
I take the Liberty also to inclose two books of Plans of my son William's who is now a Lieutenant on Board the *Eagle* in the Adriatic. I understand that Mr York had adopted it, in Ships for Convoys. to Foreign Stations, & hope it will one day

be serviceable to my son. My reason for getting his plans
engraved were to shew he had pass'd his leisure time meritoriously
in his Profession for which he had a very early prepossession.
I beg leave to present most respectfull & best wishes to Mrs
Noel[29] [illegible] Good Family and to subscribe myself
 My Lord
 Your Lordships truly Obliged
 & very Grateful
 Humble Servant
 Nicholas Pocock[30]

plate 57

**The battle of Trafalgar, 21
October 1805; the close of the
action**
Private collection, England.
This is one of a group of
paintings commissioned by
Lord Barham of naval actions
which took place during his
brief spell as First Lord of the
Admiralty.

 Although Lord Barham was nearly eighty-years old when he became
First Lord of the Admiralty he was a formidable figure and a man of
influence in public affairs – hence Pocock's desire to bring his naval son
William to his notice. To have such a man as a patron, in addition to
Lord Hood, Lord Gambier, and naval officers of less exalted rank is an
indication of the status which Pocock had achieved as a marine artist.
What he did not achieve was patronage by the Royal Family which the
Van de Veldes had enjoyed a century earlier, and which his worldly
contemporary, Dominic Serres, enjoyed in his role as Marine Painter to
King George III.

THE LIFE OF NELSON

Pocock devoted much of his later years to illustrating Nelson's sea battles. The Print Room at Greenwich has solander boxes filled with preparatory drawings and sketch plans of Nelson's major actions, as well as a series of watercolours illustrating lesser known incidents in the Admiral's life. There are the six oil paintings which the artist prepared for Clarke and McArthur's *Life of Nelson*, and there are other versions of *The Battle of the Nile* and *The Battle of Trafalgar* in private collections.

The first of Pocock's portrayals of Nelson's battles to be exhibited were two pictures of the battle of the Nile. They were shown at the Royal Academy in 1799 with the lengthy titles which were a characteristic feature of many of Pocock's later exhibits. One was entitled 'View of the French line of Battle in the Bay of Bequieres, with the approach of the British Squadron under Rear Admiral Lord Nelson, to the attack on the evening of the glorious 1st of August, 1798', and the other was 'View of the position of the two fleets (taken from the van of the French line) in action at half past nine o'clock at night, La Guerrire, Le Conquerant and Spartiale dismasted, the l'Orient on fire, August 1st, 1798'.[31] The painting showing the beginning of the action was engraved for the first volume of the *Naval Chronicle*, and in a later number the publishers reproduced a detailed plan of the action as it was shown in Pocock's picture.[32] The caption accompanying the plan reveals that the picture 'was sketched by Mr Pocock, from the drawing of a French officer in Admiral de Bruey's fleet; an officer of Lord Nelson's placed the ships of his Majesty's squadron to the best of his judgement, from the points of view the drawing was taken'.[33] Although it has already been noted elsewhere that Pocock was assiduous in obtaining correct information for his pictures, this is the only instance recorded of him using information supplied by an enemy officer in addition to that provided by British sources.

The most important of Pocock's Nelson projects was undoubtedly the commission for Clarke and McArthur's *Life of Nelson*. Preparations for this great two-volume work began shortly after Nelson's death in 1805. Pocock completed his painting of the Battle of Copenhagen in 1806, and in the Royal Academy exhibition of 1807 he exhibited this picture together with two pictures of the Battle of Trafalgar, and a new version of the Battle of the Nile. His imaginary composition of *Nelson's ships* was painted in the same year, and in 1808 he painted the Battle of Cape St Vincent. All six were engraved by James Fittler and reproduced in *The Life of Nelson* with lengthy explanatory texts. Four of the engravings were also accompanied by plans of the action. This prestigious commission appears to have come from John McArthur, one of the authors. He was certainly the first owner of the paintings. No records have yet come to light concerning the prices paid for the pictures, but judging by the tone of Pocock's later letters it seems unlikely that he made very much money from the project, and that any profits went to the publishers.

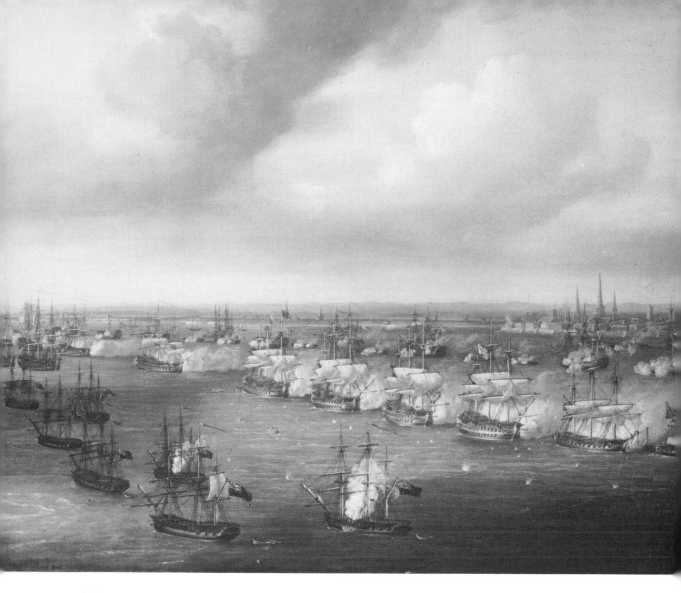

Of the six paintings, *Nelson's ships* (colour plate VIII) is undoubtedly the finest. Although small in scale it is Pocock's masterpiece, combining his expertise in ship painting with a sense of poetry which is lacking in so many of his paintings. The concept of the picture (possible suggested by the authors) is a brilliant one: five of the ships commanded by Nelson are shown gathered together at Spithead in the golden light of evening. On the far left is the *Agamemnon* of 64 guns which Nelson commanded as a captain and then as a commodore. Then comes a broadside view of the *Vanguard*, Nelson's flagship at the Nile. In front of her is the *Elephant* in which Nelson fought at Copenhagen. She is viewed from the stern and flies at her foremast the flag of Vice-admiral of the Blue. The centre of the picture has been left open, a compositional device frequently used by the Elder Van de Velde in his grisailles, and used with even greater effect by Van de Velde the Younger. Stealing across the calm waters in the middle distance is the *Captain*, the 74-gun ship which Nelson

plate 58
The battle of Copenhagen, 2 April 1801
National Maritime Museum, London.
Nelson attacks the Danish forts and floating batteries in front of Copenhagen with a squadron of two-deckers, frigates and bomb ketches.

commanded as a commodore at the battle of Cape of St Vincent. Dominating the right foreground is the *Victory*. She is shown at anchor, her topsails drying in the sun, and the flag of Vice-admiral of the White catching the light breeze at the top of her foremast. She is firing a salute with her starboard guns as an admiral's barge is rowed alongside her starboard quarter. Various small boats are gathered beside her massive hull. In the far distance, on the right, can be glimpsed the buildings of Portsmouth's waterfront.

In spite of the clumsy treatment of the reflections and the rudimentary drawing of the clouds, the picture has a dreamy, almost visionary quality which is most memorable. It also has that atmospheric unity which Sir Joshua Reynolds found missing in the first picture which Pocock submitted to the Royal Academy in 1780. It will be recalled that Reynolds had written 'there wants a harmony in the whole together; there is no union between the clouds, the sea, and the sails'. Twenty-seven years later, at the age of sixty-seven, Pocock at last achieved his objective.

The other Clarke and McArthur pictures are less successful. *The Battle of Copenhagen* (plate 58) is a scrupulously detailed aerial view of the action. In the foreground British bomb vessels are shown firing mortar shells in a high arc over the warships onto the distant batteries of the Trekroner fortress. The composition recalls the similar panoramic views used by earlier marine artists, particularly those of the Dutch and Flemish schools.[34] For the marine artist it was an invaluable device for showing the entire battlefield and enabled him to produce a far more comprehensive view than would be seen from water level. Pocock makes good use of cloud shadows passing across the sea, and the bright scarlet of the Danish flags, but the picture somehow lacks conviction. It is valuable as an historical document but has less appeal as a work of art.

The Battle of the Nile (plate 59) is more successful. As with *Nelson's ships*, Pocock shows his gift for filling the canvas with golden light. Indeed the sunset effect, combined with the graceful palm trees and the gesticulating figures in the foreground, is reminiscent of the celebrated harbour scenes of Claude, an artist much admired in England by the artists of the Romantic movement and well known through engravings after his work. There is no evidence to show that Pocock owned any of these engravings or copied Claude's work, but he would certainly have been aware of the artist who was widely considered the most celebrated of all landscape painters.

Many of Pocock's preparatory sketches for *The Battle of the Nile* have survived and show the care which he took to obtain the most telling viewpoint. His weakness at figure drawing is betrayed by the clumsy oriental figures in the foreground, although here, as with so many of his watercolours, the weakness is not obtrusive. On the contrary the figures have a naive charm which, together with the evening glow and the long shadows, lifts the picture above the level of mere reportage.

The two paintings of the Battle of Trafalgar do not have the same quality. Pocock again planned the pictures carefully[35] and drew

plate 59
The battle of the Nile, 1st August 1798
National Maritime Museum, London.
Pocock shows the scene in Aboukir Bay as the British fleet sails in to attack the line of anchored French ships. The sun is low in the sky, and by the time the battle was at its height, night had fallen.

plate 60
The battle of Trafalgar, 21 October 1805: breaking the line
National Maritime Museum, London.
The British fleet in two divisions led by Nelson and Collingwood cuts through the French line of battle.
Pocock carried out meticulous research and made numerous sketch plans for the pair of Trafalgar paintings, so that they are probably the most accurate of all the representations of this much painted battle.

plate 61
The battle of Trafalgar, 21 October 1805: the close of the action
National Maritime Museum, London.
This aerial view shows the scene of devastation at around 6pm, with the British ships lying alongside their prizes in the foreground, and the remaining French ships fleeing in the distance.

numerous sketch plans showing the position of the ships at different stages of the battle. The picture showing the commencement of the battle (plate 60) has a certain amount of atmosphere engendered mainly by the skilful use of sunlight to illuminate the advancing British fleet as it breaks the French line of battle. But *The Battle of Trafalgar: the close of the action* is less convincing (plate 61). No doubt the scene at 6 pm on 21 October 1805 closely resembled the shambles portrayed by Pocock, and the admirals were probably satisfied with the accurate depiction of the shattered French fleet, but one has only to look at similar paintings by Van de Velde the Younger, de Loutherbourg, or Turner to see the extent of Pocock's failure.

The sixth of the 'Life of Lord Nelson' pictures was *The battle of Cape St Vincent: the Captain capturing the San Nicholas and San Joseph* (plate 62). According to the caption in Clarke and McArthur, 'This painting was taken from an accurate drawing of the late Captain Ralph W. Miller, who was Commodore Nelson's Captain in that memorable battle.' It is a lively picture with a pearly blue sky and a dashing treatment of the turquoise sea. Nelson's ship, the 74-gun *Captain*, is in the left foreground, her fore topmast shot away. She is shown coming alongside the Spanish ship *San Nicholas* of 84 guns in the moment before Nelson boarded her and forced her to surrender. As with so many of Pocock's paintings (and indeed with those of his distinguished predecessor Charles Brooking) a black-and-white reproduction does not do justice to the sparkle and the acutely observed detail of the original.

Pocock had his seventieth birthday in 1810 and the signs are that he was still working as hard as ever. In that year he exhibited eighteen pictures at the Old Water-Colour Society, four pictures at the British Institution, and two at the Royal Academy. He also carried out a series of watercolour drawings illustrating lesser known incidents in the ilfe of Nelson. The project is of interest partly because the watercolours have an assurance and a freedom which is absent in many of his meticulous renderings of naval actions, and partly because the pictures are accompanied by three letters from the artist describing their subject matter and setting out his price for the job. It is not known for certain which publication the pictures were intended to illustrate nor is it known to whom the letters were addressed. Something of Pocock's businesslike approach to his commissions is revealed in the first of the letters:

<div align="right">

12 Great George Street Westmr.
2d June 1810

</div>

Sir
 Having made Eight drawings of the Subjects you were pleas'd to
Suggest to me for the Life of Lord Nelson I take the Liberty
of giving you the trouble of a line, to inform you therof
and to request the Honour of an Answer Whether I shall
send them to you for Inspection, or retain them untill
it may Suit your convenience to look at them here,
and I wish for instruction how they may be managed so

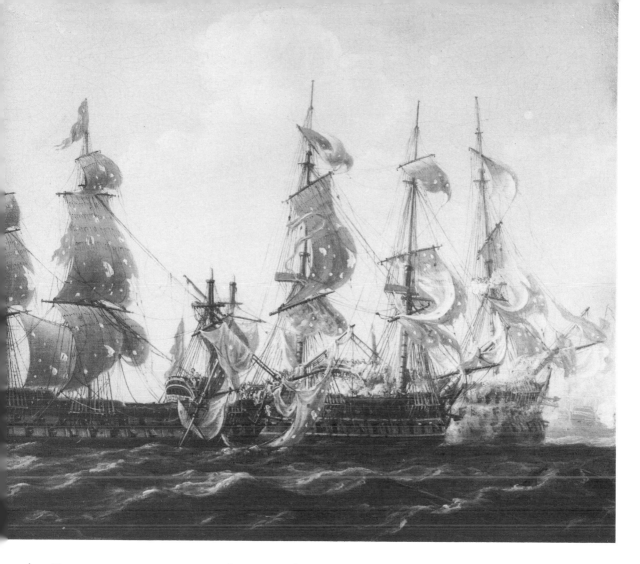

plate 62
The battle of Cape St Vincent, 14 February 1797: the 'Captain' capturing 'San Nicholas' and 'San Joseph'
National Maritime Museum, London.
A lively depiction of the manoeuvre which came to be known as 'Nelson's Patent Bridge for Boarding First-Rates.' Nelson's 74 gun ship, the *Captain*, is on the left of the picture and has run alongside the 80 gun *San Nicolas*. Having captured her, the British seamen and marines are storming the *San Joseph*, a first-rater of 112 guns which is on the right of the picture.

as to be mounted or otherwise as may be best to bind up with the books and I have made another View of Stromboli, from a drawing I was favour'd with by Lord Manners and which proves the print you were so good as to Shew me, very Correct. There remains now only one Mounted viz. the *Boreas* in Company with a French Frigate off St. Eustatius – it may be taken off if too Stiff, or I will retain it and do another in Stead if you prefer it they are rather minute for my practice and my Eyes, but I hope they will please you and prove that I have done my best with them.

I remain most respectfully,
Sir your obliged
and most Humble Servant
Nicholas Pocock

1 View of St. Eustatius with the *Boreas* in Company with the French Frigate.

2 The *Agamemnon* cutting out a Convoy of Vessells (with Implements for the Siege of Mantua) in Oneglia Bay.

3 The *Agamemnon* Engages 4 french Frigates and a Corvette.
4 Storm the *Agamemnon* having lost her Main and Mizen topmasts,
 is saved from being lost on a lee shore –
 by the exertions of Capt Ball in the *Alexander* who towed
 her Clear at the Imminent peril of both floundering.
5 *Victory* off Stromboli, Moonlight.
6 *Victory* Naples Bay Morning. [plate 63]
7 *Victory* Cutting thro: the French Line. (Battle of
 Trafalgar). [plate 64]
8 Storm the Day after the Battle the *Victory* under
 Courses Endeavg. to Clear the Land. the *Royal Souvereign*
 disabled and in Tow. by the *Euryalas*. &c. &c.
No. 4 But just begun Mr. P. having made a Mistake
by counting Stromboli (a duplicate).[36]

The second letter which is dated 29 June 1810 mentions that Pocock
has made an additional drawing 'of the *Whole* Island of St. Eustatius;
with the Boreas and Her French Companion, to replace that which is
mounted, or to be returned in case the first is preferr'd'. The letter
continues

As to the price I am to state that when I first began
is though that being of a Small Size the price also shd.
be Small, but I found on proceeding that the Size call'd
for great nicety and precision in finishg, and the whole
being finish'd on calculating the time they cost me I found
that not less that 5Gs each wou'd pay me equal to what
any other drawings or paintg. wou'd produce – I have
therefore Charged £42 for the Eight ...[37]

The third letter, dated 9 July 1810, gives details of two further
drawings which Pocock carried out for the project:

One is the *Agamemnons* Engagement with the *Ca
Ira*, within Gun Shot of a Tremendous Force and no Support
near. The other is a view of St. Johns Harbour Antigua
taken on the spot by myself with the Fleet at Anchor
– the *Curieux* Brig (in the foreground) making Sail
with dispatches for England. Here though there is no
fighting I thought the anxiety and Promptitude of
Lord Nelson wou'd be exemplified, and with a Correct
View of Antigua wou'd give the Whole a Variety.[38]

It seems possible that the watercolours were part of an ambitious
project by Cadell and Davies to capitalise further on the public interest
in the victories of Nelson and his fellow seamen. Among Pocock's
papers are several references[39] to illustrations which he produced for
'Naval Records', and at the back of the 1809 edition of Clarke and
McArthur's *Life of Nelson* is a list of forthcoming publications from the
publishers, Cadell and Davies, including the following:

NAVAL RECORDS of the LATE and PRESENT WARS;
consisting of a Series of Engravings from Original Designs
by NICHOLAS Pocock Esq. illustrative of our PRINCIPAL

plate 63
**The 'Victory' in the Bay of
Naples, 25 June 1804**
*National Maritime Museum,
London.*
This is one of a series of ten
watercolours of famous and
lesser known incidents in the
life of Lord Nelson. Pocock
arranged 5 guineas for each
drawing because in spite of
their small size they 'called for
great nicety and precision in
finishing'.

plate 64
**The 'Victory' cutting through
the French line at the Battle
of Trafalgar**
*National Maritime Museum,
London.*
The *Victory* is shown, centre
left, with Nelson's vice-
admiral's flag at her foremast.
She is half hidden by gun
smoke and is in the act of
breaking through the line of
French ships.

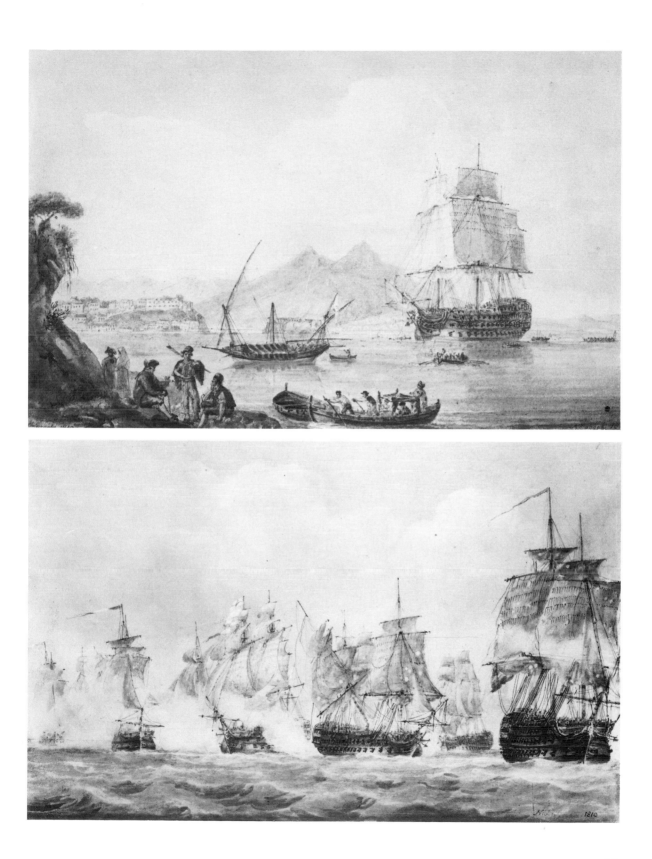

plate 65
View of Southampton, 1799
An engraving after Pocock published in *The Naval Chronicle* volume 1, plate VI The caption reads, 'This View of Southampton was taken by Mr Pocock from the banks of Southampton Water, near a ship-yard at Hythe; and comprises the prospect of this romantic town and adjacent country, from the entrance of the river Itchin to Freshbrook.'

plate 66
View of Liverpool, 1800
An engraving after Pocock published in *The Naval Chronicle* , volume II, plate XXIV. The caption reads, 'View of Liverpool, taken by Mr Pocock, as it appears when coming up the Mersey, at about a Mile distance: a Marble-Head Schooner is introduced in the Fore-Ground.'

ENGAGEMENTS AT SEA, since the commencement of the War with France in the Year 1793; accompanied with Historical Accounts, by the Rev. JAMES STANIER CLARKE, Librarian to His Royal Highness the Prince ...

The project evidently came to nothing because no publication by Clarke with such a title appears in the British Library catalogue of printed books, nor is there any reference to it in the Caird Library at Greenwich.

Pocock's references to 'Naval Records' are gloomy. He talks of giving Cadell and Davies 'the Assistance of my drawings gratis untill a successful issue attends the Publication when a proper & reasonable remuneration may be made'.[40] His son William Innes writes to Pocock, 'Cadell & Davies have sent me an account of Naval Records – making you a Partner. I know that you never allowed your name to be included in that way – & looked only to remuneration for loan [?loss] of Drawings in case of Brilliant Success'. William bitterly concludes, 'My loathing of the dirty work of tradesmen increases with every new transaction that I witness'.[41]

Whatever the outcome, the watercolours devoted to lesser-known incidents in Nelson's life remain a valuable record (plates 63, 64). Unhappily most of them have suffered the fate of so many of Pocock's watercolours. Prolonged exposure to light has destroyed the cool blue-green tints, and reduced them to shades of pink and brown.

If the 'Naval Records' project failed, at least Pocock was able to contribute regularly to *The Naval Chronicle*, a fascinating compilation of naval biographies, naval history, nautical anecdotes and occasional 'Disquisitions on Ship Building and Marine Zoology'. The majority of illustrations in the first two volumes were engravings after pictures by Pocock, and between 1799 and 1813 more than sixty of his works were illustrated. Most of the subjects were inevitably naval actions, but he also contributed a large number of pictures of harbours and anchorages. These ranged from views of Southampton (plate 65), Liverpool (plate 66) and Torbay to more distant locations. Some of these were of places like Mahon harbour in Minorca, Charleston harbour, Cadiz, and Prince Rupert's Bay in Dominica which were places Pocock had visited in his voyages as a merchant sea captain; others such as Rio de Janeiro were drawn from information supplied to him. The standard of the engravers' work varies, and is sometimes rather crude, but the views themselves are invariably picturesque, and have the same unassuming charm which is a feature of Pocock's early Bristol views.

THE LATER YEARS

THE LATER YEARS AT WESTMINSTER

Among the papers in the possession of the Pocock family are two letters written by Nicholas Pocock to his naval son William. One of the letters is mainly concerned with illustrations for 'Naval Records' and is quoted elsewhere. The other letter gives a brief glimpse of life in Westminster in the later years before the family moved to Maidenhead. Unfortunately the first part of the letter has been torn off and there is no date, but it was probably written between 1811 and 1814. The missing part appears to refer to a letter Pocock had received from his son containing information for a picture which he was working on:

> ...the outlines are very neatly and spiritedly executed
> and the Drawings of Bastia will enable me to practice
> by Candle from 6 o'clock 'till 8 at which time we sup
> & then to Cribbage until ten then to Bed. This short
> morning has been expended in writing.
> Your description of Mr Rawles' feeling expressed as
> strongly in your description as on his Phiz. made
> me smile, although my heart ached both for his
> sake and my own. I fear my sympathy proceeded
> from my being a fellow sufferer in disappointment
> & that my Charity began at home. However that
> be a letter he wrote to me dated 3d. Saturday
> last together with your description set me
> ruminating on honesty pity villainy hardheartedness
> &c. that I made a bad night of it.

The letter continues with family affairs, contains a further uncomplimentary reference to Mr Rawles (who was probably Samuel Rawle, the engraver of several of Pocock's pictures) and continues:

> My Debtors are very provoking & I only wish
> them to feel as Miserable as I shoud be in the same
> case with them.
> You have now furnished me with occupation enough
> for more time than I shall have to spare for
> some time.
> Give my love to the Scottish.
> > I am dear William
> > Your truly affectionate father
> > Nicholas Pocock

> 1 Large Picture goes on Tolerably
> 2 Dutton nearly finished
> 3 Ld Howe 28th May)
> 4 do – 29 –) Bird's Eye. Immense labour

plate 67
Llanstephan Castle on the coast of Carmarthenshire
Victoria and Albert Museum, London
This watercolour was exhibited at the Old Water-Colour Society in 1814 and was painted by Pocock at the age of seventy-four. The style and handling are exactly the same as the pictures he was painting twenty years earlier. The donkeys and the figures have the same naive charm, and the armed naval cutter is painted with confident precision.

5 Corsica – shall soon be done much less trouble.[1]

The letter concludes with a sketch of one of the pictures he was working on, and a request for more information about the names of the ships in the action off Bastia. Apart from the revealing reference to his debtors and his melancholy reflections on being 'a fellow sufferer in disappoitment', the most interesting passage is the list of pictures. It reveals that Pocock in his mid-seventies was as busy as ever with naval commissions. Although he showed no pictures at the Royal Academy in 1813 and 1814 he continued to exhibit at the Old Water-Colour Society until 1817. Among the seven works he showed in 1814 was the attractive coastal scene *Llanstephan Castle* (now in the Victoria & Albert Museum) which shows no failing in his powers (plate 67). He also painted a series of four watercolours illustrating the famous engagement between the British frigate *Java* and the American frigate *Constitution* which took place off Brazil in December 1812 (plate 68). The British vessel was totally dismasted and put up a heroic fight before surrendering. The *Constitution*, more familiarly known as 'Old Ironsides', has been preserved to this day and is moored in Boston Harbour as a museum ship. The watercolours, each signed and dated

1813, are in the National Maritime Museum. Although the colours have faded, the drawing of ships and rigging is carried out with a sure touch, and the sea in each picture is vigorously painted and full of movement.

1815 was the last year that Pocock exhibited at the Royal Academy. He showed three pictures. The first was *Captain Manby's methods of giving relief to a ship in distress*[2]; the second was *Capture of L'Etoile, French frigate of 44 guns, by HMS Hebrus*. The third picture was so large and accomplished that it has led rise to the myth that it was painted by Pocock's naval son William Innes Pocock. The full Royal Academy title was 'Portrait of His Majesty's Royal Yacht Sovereign, having on board His Majesty Louis 18th, escorted by a squadron of British and Russian ships of war, under the command of His Royal Highness the Duke of Clarence, the squadron saluting, on the afternoon of the 24th of April, 1814'. Now in the collections at Greenwich, the painting has acquired the less unwieldy title *The Royal Sovereign yacht conveying Louis XVIII to France, 1814* (plate 70). It is not signed but it is entirely characteristic of Nicholas Pocock's work. The treatment of sea and sky, and the play of sunlight on the water's surface, could only be his handiwork. It is possible that one of his sons assisted him with the painting of the ships

plate 68
The 'Java' and the 'Constitution', 29 December 1812
National Maritime Museum, London
Dated 1813 this is one of a sequence of four watercolours which Pocock painted of the famous fight between the British frigate *Java* and the American frigate *Constitution* – later known as 'Old Ironsides' and preserved to this day as a museum ship in Boston. This watercolour shows the scene at five minutes past three, after an hour of close action. The *Java*, on the left, has just lost her foremast. She later blew up and sank.

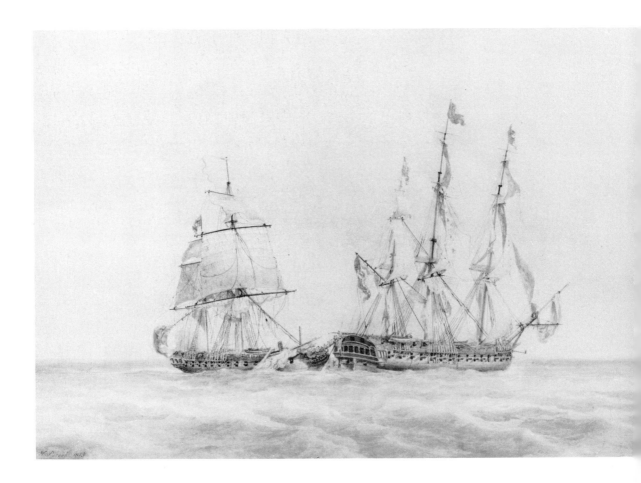

plate 69
Captain Manby's First use of his Mortar Apparatus to rescue the crew of a Brig wrecked near Yarmouth in 1801
National Maritime Museum, London
Dated 1811 this large and accomplished watercolour was exhibited at the Old Water-Colour Society exhibition in the same year. Pocock also exhibited two oil paintings of Captain Manby's apparatus at the Royal Academy in 1815, and these pictures are now in the Castle Museum, Norwich.

(the central yacht is perhaps brighter in colouring and harder in its drawing than is usual with Pocock), but this seems unlikely. His eldest son Isaac was a regular exhibitor at the Royal Academy between 1803 and 1818 but most of his pictures were portraits and none were marines. His second son William was a talented marine artist but his medium was watercolour and no other oil paintings by him have come to light. There is, it is true, a small watercolour sketch of this composition among the William Innes Pocock material in a private collection, but it is not signed and must either be a study by Nicholas or a copy by William from the oil painting.[3] It is inconceivable that an amateur artist (William was a full-time naval officer until the Congress of Vienna in 1814) could suddenly take up oil painting and produce a work of such assurance.

plate 70
**The 'Royal Sovereign' yacht
conveying Louis XVIII to
France**
*National Maritime Museum,
London*
Pocock exhibited for the last
time at the Royal Academy in
1815, and this is one of the
four pictures which he showed
on that occasion. It was
described as 'Portrait of His
Majesty's Yacht Royal
Sovereign, having on board His
Majesty Louis 18th, escorted by

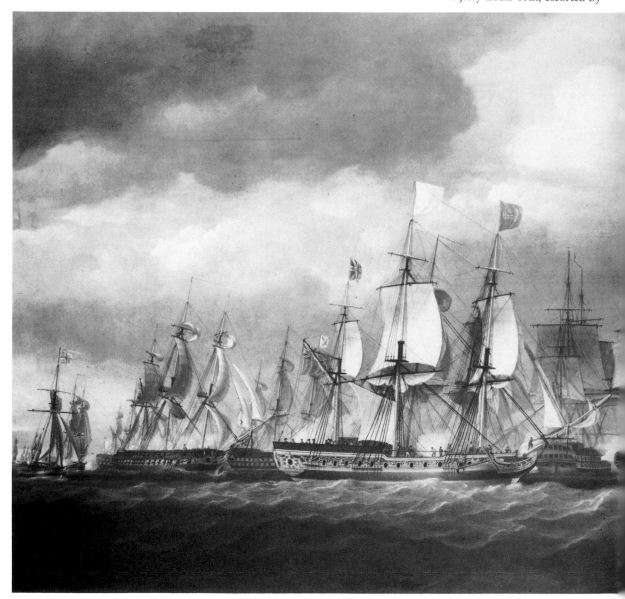

a squadron of British and Russian ships of war, under the command of His Royal Highness the Duke of Clarence, the squadron saluting, on the afternoon of the 24th of April, 1814'.

POCOCK'S PRICES FOR PAINTINGS AND DRAWINGS

In the letter quoted at the beginning of the chapter Pocock talks of his debtors being very provoking and gives the impression that he is suffering from disappointment, even some bitterness, at his circumstances. However there is insufficient evidence to conclude that he fell on hard times and that his eventual move from London was caused by a drop in income and the expense of his London home. His move to the West County in 1817 was almost certainly prompted by ill health rather than financial circumstances.

The prices for Pocock's oil paintings appear to have been modest. He charged Sir Harry Neale 25 guineas in 1797 for *The Capture of the Resistance and Constance*. For the two very large dockyard paintings of Woolwich Yard and Plymouth, commissioned in 1785 he received £84 apiece, but these were probably exceptional.

Although evidence for the price of similar paintings by contemporary marine painters is hard to come by, the prices paid to some of the more well known, and thus well documented, painters of his day provides a yard stick. Turner, for instance, was paid £250 guineas in 1801 by the Duke of Bridgewater for *Dutch Boats in a Gale* (the celebrated 'Bridgewater' sea-piece).[4] Gainsborough's *Cornard Wood*, now in the National Gallery, was bought for £78 15s in 1788.[5] Sir Joshua Reynolds, who charged 150 guineas for a full length portrait in the 1780s, was paid £1575 for *The Infant Hercules struggling with serpents*.[6] However this was commissioned by the Empress Catherine of Russia in 1786 and represents the top end of the market. It is worth noting that the seapieces of Willem Van de Velde the Younger, who remained popular with English collectors throughout the eighteenth and early nineteenth century, commanded prices very much lower than the top prices for fashionable living artists such as Sir William Beechey, Reynolds and Benjamin West. Desenfans sold a Van de Velde calm for £294 in 1785 and Walsh Porter sold a sea-fight for £430 10s at Christie's in 1803.[7]

While Pocock's prices for oil paintings were on the low side, his watercolours were comparatively expensive. This is clearly shown by J L Roget in *A history of the Old Water-Colour Society*. Roget took the valuations of every picture submitted by the sixteen artists who showed their work at the first of the Society's exhibitions in 1805. He divided the sums by the number of drawings sent in by each artist and arrived at the following table[8] which gives the average prices for each artist's work that year:

1. Shelley	£26.10.6	9. Wells	£7.0.0
2. Glover	22.1.0	10. Cristall	6.13.0
3. Pocock	13.0.0	11. Havell	5.14.0
4. Nattes	12.2.6	12. Nicholson	5.12.0
5. Hills	10.18.0	13. J Varley	4.14.0
6. Rigaud	10.2.6	14. Barnet	4.9.6
7. Gilpin	9.18.0	15. Pyne	4.8.0
8. Holworthy	9.0.0	16. C Varley	3.14.0

Although Pocock's average prices are half those of the now forgotten Samuel Shelley, they are well above those of such distinguished names as John and Cornelius Varley, Francis Nicholson and W H Pyne.

Some examples of the prices Pocock received for individual watercolours may be found among his papers and sketchbooks. In 1792 he charged Richard Bright of Bristol 4 guineas for a view of Wales.[9] A few years later, in 1804, he charged the same patron (£18 18s for three landscape drawings.[10] In 1809 he received £7 17 6 from a Mr Sargeant for a watercolour of the beach at Brighton.[11] And in 1810 he charged 5 guineas each for his series of watercolours of lesser known incidents in the life of Nelson.[12]

Pocock's prices maintained their level in the years immediately following his death. At the studio sale following his wife's death in 1828 an oil painting of Caernarvon Castle was priced at £42, seven pictures were priced at £31 and nine at £26.[13] However, they had slumped by the end of the nineteenth century. Roget, whose book was published in 1891, noted 'Pocock's drawings are of small commercial value now'[14], though a study of the sale-room records suggests that Pocock's oil paintings did not fare so badly. *The fight between the Brunswick and the Vengeur* (plate 52) sold at Christie's for £168 in 1895; and Pocock's *Battle of Quiberon Bay* (now at Greenwich) sold for £336 in the same sale-rooms in 1928[15]. Unlike the marine paintings of Whitcombe and Luny which constantly appear on the market, remarkably few paintings by Pocock have appeared in the sale-rooms in recent years. However his watercolours come up for sale at regular intervals, the landscape subjects tending to be undervalued (mostly between £500 and £700 in 1985) and his shipping subjects commanding higher prices[16]. Bonhams sold *British merchantmen and yachts sailing out of Portsmouth Harbour* for £2500 in 1973, but this was unusual and most have fetched much lower sums – no doubt because so many of Pocock's watercolours have been wrecked by prolonged exposure to daylight.

BATH AND MAIDENHEAD

Pocock exhibited no more pictures at the Royal Academy after 1815, and the following year is the last year in which his name is recorded in the rate books at Great George Street. When he sent in pictures to the Old Water-Colour Society in 1817 his address was entered in the catalogue as 36 St James Parade, Bath.[17] According to one authority he suffered a paralysis,[18] but there was no further reference to the exact nature of his illness. In a letter which he wrote to his son William from Bath he simply mentions, 'I am weak but I think gaining ground'.[19] It is possible that he went to Bath on the advice of his doctor to see whether he could be cured by the celebrated waters. Exactly how long Pocock stayed in Bath is not recorded and there is no mention of any of the family in the rate books of this period. However in the summer of 1818 he was staying at Melksham Spa, a few miles from Bath, because a letter survives which was written to him at that address. The letter is of some interest because

it indicates the value which Pocock placed on his illustrated logbooks. Dated 8th August 1818, the letter is from Charles Harfod who was presumably a friend of the family.

> Your son's letter came here when I was unfortunately absent. I much regret that the state of your health prevents my having the pleasure of seeing you, but I will no longer hesitate to tell you that the Log Book of the *Minerva* is in the possession of Mr. Linnell who says as it was given to him by Miss Champion he cannot think of parting with it. I have in vain represented to him that Miss C. had no right to it, consequently he has no right to detain it.

Harford suggested that a member of the Pocock family should go and see Mr Linnell and personally demand the return of the logbook, and continued: 'if it were possible for your son to come it might have more weight as he could truly state that he came on purpose to recover what is of real *use* and *value* to you & the family, but only a curiosity to Mr. Linnell'.[20] A note in another hand on the back of the letter records that Mr Linnell returned the *Minerva*'s logbook to Miss Champion.

By August 1819 Nicholas Pocock had taken up residence at Ray Lodge, Maidenhead, and here he was to stay until his death two years later. Ray Lodge had been built by Sir Isaac Pocock[21] who was the most successful of the younger brothers of Nicholas. After a period at sea during which he commanded a privateer and fought two actions against American rebel ships, he settled at Biggin in Northamptonshire. He eventually became High Sherriff of that county and was knighted. He moved south and built Ray Lodge in extensive grounds on the banks of the Thames near Maidenhead Bridge. The house still stands today (plate 71) and in spite of being converted into flats, it remains an imposing building, typical of many of the residences erected by country gentlemen in the later Georgian period.

In 1810 Sir Isaac died of a heart attack while boating on the river near his house. He and his wife had no children and on the death of Lady Anne in July 1818, the estate and the house were left to Nicholas Pocock's eldest son Isaac.[22] With so many spare rooms at his disposal it is little wonder that Isaac invited his parents to move in with him. Indeed the surviving correspondence of Pocock's second son William suggests that other members of the large family spent much of their time in this pleasant spot. Betsy, Pocock's youngest daughter, was certainly living there with them in 1819. Pocock's health seems to have improved at Maidenhead. In a letter to his father from Leeds in October 1819, William wrote, 'I had a letter from George in Edinburgh – saying you were all well at Maidenhead, which is the best news & almost the only news I have heard for some time'.[23] Another letter on 30 August 1820 contains no references to his father's health.

Pocock died at Ray Lodge on 9 March 1821. The briefest of notices appeared in *The Gentleman's Magazine*:

March 9. At Maidenhead Bridge, Berkshire in his
81st year. Nich. Pocock, esq., late of Great George Street.[24]

Pocock was buried at Cookham parish church. The elegant memorial tablet (plate 72) erected to his memory in the church has a simplicity which is in marked contrast to that of his brother on the nearby wall. Details of his will are recorded in the Public Record Office but they give little information about his financial circumstances at his death: 'In case there shall by any Surplus of my unsettled Property and Effects after making up the sums intended for my for my Sons Nicholas William and George ... I give and bequeath such Surplus to my dear Wife Ann Pocock for her own absolute use and benefit'.[25]

plate 71
Ray Lodge, Maidenhead
Photograph by Pieter van der Merwe
Ray Lodge was built by Pocock's brother Isaac, who had been knighted for his services as High Sheriff of Northampton. The property was inherited by Pocock's eldest son, also called Isaac, in 1818. Shortly afterwards Nicholas Pocock, his wife and some of his children, moved to Ray Lodge, and it was to remain Pocock's home until his death in 1821.

plate 72
Nicholas Pocock's memorial tablet in Cookham parish church
Photograph by Pieter van der Merwe
The simple elegance of Nicholas Pocock's memorial is in striking contrast to the magnificent monument to his brother Sir Isaac Pocock which is on a nearby wall. Sir Isaac's was designed by the sculptor John Flaxman and depicts him in the moment of death while out punting on the Thames near Maidenhead.

NICHOLAS POCOCK'S FAMILY

Pocock's wife survived him by six years. She died on 27 December 1827 and was also buried at Cookham. She had borne him nine children; Isaac, who died as a baby; Isaac, who became an artist and dramatist; William Innes, naval lieutenant; Nicholas who became captain of HM packet *Princess Mary*; John Innes and George who both became lawyers; Mary Ann who married the Rev Samuel Fripp of Queen's College, Cambridge (two of their sons became artists); Peter who became captain of HM packet *Lapwing*; and Elizabeth, called Betsy.

Two of Pocock's sons deserve more than a passing mention. The eldest surviving son, Isaac,[26] showed talent as an artist and was sent to study painting under Romney. William Hayley was sufficiently impressed by him to compose some verses which he included in his *Life of Romney*:

Ingenious son of an ingenious sire,
Pocock! with friendly joy I saw thee start
For Honor's goal, in the career of art.

On the retirement of Romney, Isaac then studied with Sir William Beechey. He first exhibited at the Royal Academy in 1803 at the age of twenty-one, and during the next sixteen years he showed seventy-three pictures.

In 1808 Isaac embarked on a second career as a playwright with a musical farce which opened at the Theatre Royal in the Haymarket. For the next ten years or so he devoted much of his energy to the writing of melodramas. He seems to have lacked his father's single-minded devotion to his art, however, and when he inherited his uncle's estate he ceased to exhibit pictures at the Royal Academy and turned his attention to the varied pursuits of a country gentleman.

Although Nicholas Pocock was no doubt proud of his eldest son's talents, he was probably much closer to his second son whose naval career gave him much in common with his father's interests. William went to sea at the age of twelve and after much active service in which he distinguished himself in a number of actions, he arose to be second lieutenant of HMS *Eagle*. While in the navy he travelled widely and visited China, the East Indies, the West Indies, and the Adriatic. *The Gentleman's Magazine* portrays him as intelligent and resourceful. He could speak French, Spanish and Italian, and in addition to his thorough grasp of his own profession, 'he possessed a cultivated mind, much taste, and great talents as a draftsman; his charts being models of accuracy and neatness, and his drawings of the various places he visited being in a very superior style'.[27]

The watercolour drawings of William Innes Pocock are most attractive and similar in style to those of his father. Indeed some of his drawings of the coastline of St Helena (plate 73) are almost indistinguishable from Pocock's views of the coastland of Iceland. Both, of course, portray ships and small craft with accuracy, but, perhaps because he was taught to draw at an early age by his father, the

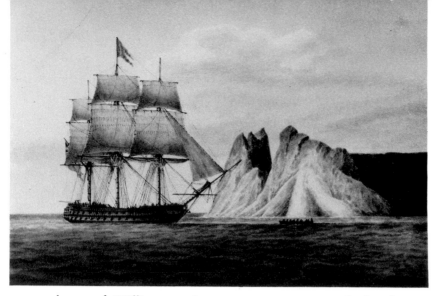

watercolours of William are in some ways more professional. His father's work, particularly his landscape and coastal views, always retained the freshness and naivety of the amateur artist.

CONCLUSION

No lengthy obituaries appeared on Pocock's death, nor have any tributes from fellow artists come to light. The only indication of his reputation in the years immediately following his death appeared on the title page of an auction catalogue advertising the sale of sets of Pocock's engravings in 1828:

> The Subjects represented were Drawn under the immediate inspection of the Officers engaged, and may consequently be considered as faithful representations of events connected with the Marine History of the Country – When it is considered that Mr Pocock attained the highest reputation, as a Marine Painter, since the time of Van de Velde, it may be reasonably expected that time will add greatly to their value.[28]

Pocock would have been the first to disown such an extravagant claim. The diffidence which Sarah Champion noted as one of his characteristics when he was a young man remained with him all his life. Apart from his modest role in the foundation of the Old Water-Colour Society he does not seem to have played an active part in the artistic and intellectual circles of his day. The rare glimpses of his life that we have, suggest that he spent his time working, travelling in search of subjects, and corresponding with the publishers and naval patrons who were his chief source of livelihood. Perhaps this was the way he wanted things to be. It meant that he was able to produce an impressive volume of paintings and drawings in the years following his retirement from the sea.

By the end of the nineteenth century Pocock's marine paintings had lost their interest for all except the naval families who owned most of them. Redgrave's *Dictionary* dismissed his large paintings of naval

engagements as 'careful and literal, but lifeless and wanting the interest and spirit of a battle'. And Roget noted in 1891 that 'Pocock's drawings are of small commercial value now'.

For a public which had been encouraged by John Ruskin to admire the splendidly vigorous seapieces of Clarkson Stanfield, and the calms and storms of Turner, Pocock's restrained and meticulous renderings of distant sea battles inevitably sank from view. He was rescued from oblivion by the abiding charm of his watercolours. Laurence Binyon, in his study of the English watercolour school, found that 'his drawings are pleasing in their modest way'.[29] Iolo Williams singled out for praise 'a very beautiful and free study of a waterfall', a quarry scene 'which makes one think of early Turner', and his sketches which 'are occasionally very poetical, with creamily rich washes of blue and grey'.[30]

Martin Hardie, one of the few historians of English painting to have made a special study of marine artists, treated Pocock at some length. He drew attention to the colouring of his watercolours which 'has the great charm belonging to the early stained drawings', and made the point that 'The true disposition of the ships was more important to him than their value as part of a design; but like van de Velde, he did manage to seize the aspect of an engagement which allowed for compositional effect'.[31] The most eloquent tribute to Pocock comes from the pen of John Betjeman, the late Poet Laureate. His biographer, Bevis Hillier, discovered a watercolour by Betjeman in the visitor's book at Pakenham Hall (now Tullynally). It is a delicate portrayal of the house painted in Pocock's manner. Betjeman has signed his drawing 'N. Pocock 1781' and has written underneath:

Oh! Give me Pocock's pencil
 And give me Pocock's art!
And I will paint the Sylvan scenes
 Engraven on my heart!

Pocock's knowledge of ships gave his marine paintings an authenticity which was not surpassed by any of his contemporaries. His powers as an artist were less certain. He was most at ease when painting in watercolours. His coastal subjects in this medium were invariably successful, and his picturesque landscapes have a charm of their own. His oil paintings are more variable in quality. Some of his pictures of sea battles are dreary in conception and laboured in execution. They lack the sparkle and the fresh atmosphere which Charles Brooking brought to his seascapes. They do not have the decorative qualities of Robert Salmon's seaports and ship portraits, or the fluid, turquoise seas of Thomas Whitcombe's accomplished paintings. But a few of Pocock's paintings are masterly. They are subtle in colouring, exceedingly skilful in execution and full of finely rendered detail. He could on occasions fill a tranquil scene with a golden light worthy of the great Dutch masters, or bring drama to a picture of ships in turbulent seas by his bold use of sunlight and shadow. These occasions were rare but they secure him a place among the finest marine painters of the eighteenth century.

NOTES TO THE TEXT

ABBREVIATIONS

Davis, 1962
Davis, Ralph *The rise of the English shipping industry in the 17th and 18th centuries*, London 1962

Minchinton, 1957
Minchinton, Walter 'The trade of Bristol in the eighteenth century', in *Bristol Record Society's publications*, volume XX, Bristol 1957

NMM
National Maritime Museum, Greenwich

Owen, 1873
Owen, Hugh *Two centuries of ceramic art in Bristol*, 2 volumes, London 1873

PRO
Public Record Office, London

Randall Davies
Davies, Randall 'Nicholas Pocock' in *Old Water-Colour Society's Club*, volume V, London 1927-8

Roget, 1891
Roget, J L *A history of the Old Water-Colour Society*, 2 volumes, London 1891

NOTES TO CHAPTER 1

1 NMM. Print Room, box D81
2 NMM. Print Room, box D84
3 Owen, 1873, p.49

NOTES TO CHAPTER 2

1 Minchinton, Walter 'The port of Bristol in the 18th century', in *Bristol in the 18th century*, ed P McGrath, Bristol 1972, p. 132

2 Nicholas Pocock was baptised on 28 May 1742. See Register of St Stephens Church, Bristol.

3 In the eighteenth century the present Prince Street was called Princes Street. See Donne's Map of Bristol 1773, James Sketchley's *Bristol Directory*, 1775, and Dening, C F W *Eighteenth century architecture of Bristol*, Bristol 1923.

4 Bristol Record Office. In the Watch Rate Books the following are recorded in Princes Street (now Prince Street: see note above): Nicholas Pocock 1756-59; widow Pocock 1761-69; and Nicholas Pocock 1780, 1786. The following are recorded in Princes Street in the Lamp and Scavenging Rate Books: Mary Pocock 1769; Mrs Pocock 1772; Mary Peacock [sic] 1773; Mary Pocock 1775.

5 James Sketchley's *Bristol Directory*, Bristol 1775.

6 Most of the houses in Cashin's picture were built in the first quarter of the 18th century. A few still remain although not number 41. For further details of the street and the surrounding area see: Dening, C W *Eighteenth century architecture of Bristol*, pp.71, 99; and Latimer, J *Annals of Bristol in the 18th century*, 1893, p. 149.

7 According to the *Gentleman's Magazine*, December 1835, Mary Innes was 'one of the daughters and co-heiresses of William Innes, one of the sons of John Innes of Leuchars, in the county of Moray, who was the King's Judiciary in that county and a cadet of the ancient family of Innes of that ilk, of which the present Duke of Roxburghe is the head'.

8 The arms and crest of Pocock were assigned by Patent dated 14 March 1811 to Nicholas Pocock of Great George Street, Westminster and William Innes Pocock of Bristol. A pedigree of Innes and Pocock was registered at the College of Arms in the same year, signed by Nicholas Pocock. These and other Pocock family details are in the records of the College of Arms.

9 *Gentleman's Magazine*, volume XCL, part I, p. 385.

10 Bristol Record Office: the Apprentice Books of the Bristol Corporation.

11 Owen 1873, p.42.

12 Ibid, p.49

13 Minchinton, Walter 'Richard Champion, Nicholas Pocock and the Carolina trade: a note', in *South Carolina Historical Magazine*, volume 70 (1969), p. 97, note 2

14 Owen, 1873, p. 176

15 Davis, 1962, p. 79; and Minchinton, 1957, p. XVIII.

16 Minchinton, 1957, p. 181.

17 Minchinton, Walter, *South Carolina Historical Magazine*, volume 65, (1964), p. 87.

18 Hay, David *The English Pilot for the Southern Navigation*, part I, Dublin 1772, p. 42.

19 Davis, 1962, pp. 137-8

20 Ibid, p. 324.

21 Minchinton, Walter *South Carolina Historical Magazine*, volume 65 (1964), p. 95.

22 Guttridge, G H *The American correspondence of a Bristol merchant, 1766-1776*, Berkeley, California, 1934.

23 PRO. E/190/1228/2 (Bristol Port Book for 1770-1).

24 Davis, 1962, p. 156.

25 Ibid, pp. 230-1.

26 Minchinton, 1957, p. 69.

27 Ibid, p. 181.

28 Randall Davies, p. 29.

29 Owen, 1873, p. 176.

30 Guttridge, G H *The American correspondence of a Bristol merchant, 1766-1776*, Berkeley, California, 1934, p. 66-7.

31 Owen, 1873, p. 270.

32 There is a useful introduction to the navigational methods of Pocock's day in *Man is not lost: a record of two hundred years of astronomical navigation with 'The Nautical Almanac'*, National Maritime Museum, London 1968.

NOTES TO CHAPTER 3

1 Many of these are described and illustrated in Francis Greenacre's exhibition catalogue, *Marine*

Artists of Bristol: Nicholas Pocock and Joseph Walter, City of Bristol Museum and Art Gallery, 1982.

2 *Pinney Papers*, Family letter book 1790-3 (V), p. 83.

3 Northcote, James *The Life of Sir Joshua Reynolds*, London 1818, volume II, pp. 90-1.

4 This information is held in the Bristol Record Office, and also in the College of Arms.

5 There is an earlier signed drawing in a private collection. It is a primitive ship portrait 'A VIEW OF THE RUBY 1759', inscribed 'N. Pocock fecit', and is similar in style to a series of pen and wash drawings at Bristol depicting privateers engaged in the slave trade. These are illustrated and discussed in Greenacre, Francis *Marine Artists of Bristol*, City of Bristol Museum and Art Gallery, 1982, pp. 15-25

6 The catalogues of three sales of Pocock material conducted by George Jones and Co of Leicester Street, Leicester Square, are in a private collection. The sales were in April 1828 following the death of Pocock's wife in the previous year.

7 Randall Davies, p. 26.

8 NMM. Caird Library, AGC/XXII (49 MS. 9389).

9 *The Works of the late Edward Dayes*, London 1805, pp.129-30, 283, 298. For an admirable discussion of the watercolour methods of English artists see: Hardie, Martin, *Water-colour Painting in Britain*, London 1967-9, volume 1.

10 I have received advice on Pocock's oil painting technique from the staff of the Conservation Department at the National Maritime Museum. I am particularly grateful to Westby Percival-Prescott and Elizabeth Hamilton-Eddy for producing conservation records and explaining the more technical aspects of the artist's technique.

NOTES TO CHAPTER 4

1 London County Council, *Survey of London*, ed M Cox and P Norman, London 1926, volume X, pp. 12-14, 34, 35.

2 William Capon's *Views of Westminster* were printed between 1801 and 1815. They were published by the London Topographical Society in 1923-4.

3 The original catalogues are in a private collection. Photocopies are held at NMM, Greenwich.

4 There is an account of the voyage in *The Early Married Life of Maria Josepha, Lady Stanley*, ed Jane Henrietta Adeane, 1899, pp. 55-86.

5 Seventeen of Edward Dayes's drawings were sold at Sotheby's on 9 December 1964, and sixteen of Pocock's Iceland drawings were sold in the same sale-rooms on 10 March 1965.

6 A manuscript copy of this volume (which, unlike other volumes in the series was never published) is in the National Maritime Museum, Caird Library, P/16.

7 Roget, 1891, volume 1, p. 203.

8 Ibid, volume I, p. 143.

9 Ibid, volume II, p. 291

10 *The Farington Diary*, ed James Greig, London 1922-28, volume 6, p. 14.

11 NMM. Print Room, Press 85, box H.20.4 (4).

12 NMM. Caird Library, AGC/XX11 (MS. 55/076).

13 I am grateful to Francis Greenacre for transcripts of some of the correspondence of the Bright family. The original letters are in a private collection in Malvern, Worcestershire.

NOTES ON CHAPTER 5

1 The ballad 'Admiral Rodney's Triumph – or the French Fleet defeated' is quoted in Welch, John, *Famous Sea Battles*, London 1964, pp. 102-3.

2 This information was kindly supplied by Lord Hood. Lord Bridport (1727-1814) was formerly Alexander Hood. He was the younger brother of Samuel Hood, and had an eventful naval career, rising to the rank of admiral and being elevated to the peerage for his achievements.

3 Randall Davies, p. 21.

4 Samuel Hood (1724-1816) was created Viscount Hood in 1796. The son of a vicar, he entered the navy in 1741, became a captain in 1756, a rear-admiral in 1780, and was appointed Admiral of the Blue in 1794. He was Governor of Greenwich Hospital from 1796.

5 I am grateful to Roger Morriss for drawing my attention to the Pocock reference in the Navy Board correspondence.

6 The Navy Board's original order of 18 May is referred to in a letter from the Admiralty Office dated 19 February 1804. NMM. Caird Library, ADM/A 2973 (Admiralty Office letters, February 1804).

7 Ibid.

8 PRO. ADM 106/2233.

9 *The Farington Diary* (Yale edition) ed K Garlick and A Macintyre, London 1978, volume I, p. 213.

10 Ibid. p. 215.

11 See Kingzett, Richard, 'A catalogue of the works of Samuel Scott', in *Walpole Society*, volume 48, 1980-2, p. 69.

12 Randall Davies, p. 3.

13 NMM. Sir Geoffrey Callender correspondence, letter dated 24 August 1932.

14 The notebook was examined by Roy Davids, Head of the Autograph Department at Sotheby's, in June 1976.

15 Warner, Oliver, *The Glorious First of June*, London 1961, p. 40.

16 Ibid, p. 137.

17 ibid, p. 137.

18 PRO. 51/680 (Captain's Log of the *Pegasus*, 1794).

19 Warner, *the Glorious First of June*, p. 125.

20 Ibid, p.126.

21 Ibid, p. 75.

22 Diary of William Dillon, midshipman in the *Defence*. Quoted in Warner, *The Glorious First of June*, p. 79.

23 Page 11.

24 NMM. Print Room

25 NMM. Caird Library, AGC/XXII.

26 Written from Bath, and therefore dated between 1817 and 1818, the letter is in the collection of Pat Bryan of Cheltenham. Pocock writes, 'George Millett used to live near Mr Cotton at Layton Stone. Perhaps you may see him the same time there', and 'I will endeavour to pave an easy way to introducing your scheme of India hydrography to Alan Cooper Esq. Gower Street to George Millet Esq Marine Society's Office'

27 *The Naval Chronicle*, volume 2, 1790 has a vignette engraving of a ship as the heading for chapter I. The caption describes this as being 'from an accurate Drawing by Mr Pocock representing the Model of the TRITON, Capt. Gore, built on Admiral GAMBIER'S improved plan.' The *Triton* was built of fir at Deptford 1796 to the designs of Vice-Admiral James Gambier (1723-1789). He was the uncle of Admiral Lord Gambier (1756-1833) who, as a captain, commanded the *Defence* at the battle of the Glorious First of June. The painting of the *Triton* remained in the family until 1865 when Rear Admiral Robert Fitzgerald Gambier presented it to Greenwich Hospital.

28 I am grateful to Alan Pearsall for pointing out the connection between the pictures described in the album, and Lord Barham. Pocock's son Isaac exhibited a portrait of Lord Barham at the Royal Academy in 1806.

29 Mrs Noel was Lord Barham's daughter. She married Gerard Noel Edwardes in 1780, and in 1798 she succeeded to the estates of the Earl of Gainsborough who was Noel Edwardes' uncle. At that time she assumed the name of Noel by royal licence. See *Dictionary of National Biography* under Middleton, Charles, first Baron Barham.

30 NMM. Caird Library. *Middleton Papers*, MID/1/151.

31 Graves, Algernon, *Royal Academy Exhibitors 1769-1904*, (8 volumes), London 1905-6.

32 *Naval Chronicle*, Volume I (1799), p. 44.

33 Ibid, p. 521.

34 The panoramic view and its relationship to the Dutch tradition of map-making is discussed by Margarita Russell in *Visions of the Sea: Hendrick C. Vroom and the origins of Dutch marine painting*, Leiden 1983, and by Svetlana Alpers in *The art of describing: Dutch art in the seventeenth century*, London, 1983.

35 The sale catalogue of Hodgson's sale of Pocock material which was held on 2 April 1913 mentions correspondence between Pocock and John Livesay on the subject of the battle of Trafalgar. Livesay was a drawing master at the Royal Naval Academy, Portsmouth, and sent Pocock a plan of the action and sketches of several ships which took part. Hodgson's Sale catalogue is reproduced by Randall Davies in *Old Water-Colour Society's Club*, volume V, London 1927-8, p. 25.

36 NMM. Caird Library, AGC/XXII/4 (36. MS. 0539).

37 Ibid. AGC/XXII/4 (36. MS. 0540).

38 Ibid. AGC/XXII/4 (36. MS. 0541).

39 Correspondence between Pocock and his son William Innes Pocock is in the collection of Pat Bryan of Cheltenham.

40 Ibid.

41 Ibid.

NOTES TO CHAPTER 6

1 This letter is in the collection of Pat Bryan of Cheltenham.

2 This must be the oil painting in Norwich Castle Museum entitled *Vessel in distress, Yarmouth*. It is signed and dated 1815, and its subject matter corresponds with the lengthy title reproduced in Graves *Royal Academy Exhibitors*. Pocock painted a very fine watercolour of a similar subject, *Captain Manby's First use of his Mortar Apparatus*, dated 1811, which is in the National Maritime Museum.

3 Collection of Pat Bryan of Cheltenham.

4 Butlin, Martin and Joll, Evelyn, *The Paintings of J.M.W. Turner*, New Haven and London, 1977, text volume, p. 11.

5 Reitlinger, Gerald, *The Economics of Taste: the rise and fall of picture prices 1760-1960*, London, 1961, p. 320.

6 Ibid, p. 429.

7 Ibid, p. 473.

8 Roget, 1891, volume 1, p. 207.

9 Letter from Pocock to Bright, 18 November 1792. NMM Caird Library. AGC/XXII/9 (MS. 55/076).

10 Letter from Pocock to Bright, 17 January 1804. In volume of letters in a private collection, Malvern.

11 NMM. Print Room. Press 19, box 8.

12 Letter dated 29 June 1810. NMM. Caird Library AGC/XXII/4 (36. MS. 0540).

13 See auction catalogue of George Jones and Co., Leicester Street, Leicester Square, April 1828.

14 Roget, 1891, volume I, p. 416n.

15 I am grateful to Margie Christian for providing details of the relevant sale records at Christie's.

16 A signed and dated version of Portishead Point (plate 14) sold for £550 at Sotheby's on 14 March 1985, and others have sold for similar sums in the same year.

17 Roget, 1891, volume I, p. 297.

18 *Dictionary of National Biography.*

19 *Collection of Pat Bryan, Cheltenham.*

20 Ibid.

21 For further information on Sir Isaac Pocock (1751-1810) see *The Gentleman's Magazine*, volume LVI, part I, p. 177, and volume LXXX, part II, p. 396, and the *Dictionary of National Biography*.

22 See the Will of Sir Isaac Pocock: PRO (Prob. 11/1316/360) and the Will of Dame Anne Pocock: PRO (Prob. 11/1606/333).

23 Collection of Pat Bryan, Cheltenham.

24 *The Gentleman's Magazine*, volume XCI, part I, p. 385. *The Times* for 12 March 1821 included an almost identical notice under Deaths: 'On the

9th inst., at Maidenhead Bridge, Berkshire, in the 81st. year of his age, Nicholas Pocock, Esq., lately of Great George-street, Westminster.' *The Gentleman's Magazine* included a more expansive note on Nicholas Pocock in its obituary for Pocock's eldest son Isaac Pocock (1782-1835) in December 1835.

25 PRO Prob. 11/1645, f.357.

26 For further information on Isaac Pocock see article by Pieter van der Merwe, 'The Ingenious Squire: New Aspects of Isaac Pocock (1782-1835)' in *Theatre Notebook*, XXXI (2), 1977.

27 *The Gentleman's Magazine*, 'Memoir of Lieutenant W. I. Pocock, RN.' September 1836.

28 Sale catalogue of George Jones and Co., Leicester Street, Leicester Square.

29 Binyon, Laurence, *English Water-colours*, London, 1933, (cited 1962 edition), p. 27.

30 Williams, Iolo, *Early English Watercolours*, London 1952 p. 217.

31 Hardie, Martin, *Watercolour Painters in Britain*, London 1967-9, volume I, p. 234.

BIBLIOGRAPHICAL NOTE

Primary Sources

The National Maritime Museum has four of Pocock's logbooks (LOG/M/72, LOG/M/28. LOG/M/54, LOG/M/3), his First of June notebook (JOD/12), a number of letters to patrons (AGC/XXII/4 and AGC/XXII/9), and some 300 drawings many of which relate directly to pictures and are heavily annotated. There is also a Pocock album in the Middleton papers (MID/1/151). Bristol Record Office has Pocock's log of the *Lloyd's* voyages 1771-2, and references to Pocock and his family in the parish registers, apprentice books and ratebooks. The Mariners Museum, Newport, USA, has Pocock's log of the *Minerva's* voyages 1772-1776. The Public Record Office has Pocock's will, and relevant material in Navy Board and Admiralty papers. There is very little manuscript material relating to Pocock's domestic life, but Pat Bryan, a descendent of William Innes Pocock, has a collection of family papers which include correspondence between Pocock and his naval son.

Secondary Sources

Most of the publications consulted will be found in the Notes to the Text. The article by Randall Davies in the Old Water-Colour Society's annual volume (volume V, 1927-28) is particularly useful because it contains a complete list of all the artist's exhibited works at the Old Water-Colour Society, the Royal Academy and the British Institution, and the catalogue of the major sale of Pocock material held at Hodgsons in 1913. My own article 'Nicholas Pocock's voyages from Bristol' in *Sea Studies* (National Maritime Museum, London 1983) contains further information about the voyages and a summary of the contents of the Logbooks. Francis Greenacre's exhibition catalogue *Marine Artists of Bristol* (Bristol Art Gallery, 1982) covers Pocock's early life and work, and also contains a useful bibliography.

Appendix I

THE FIRST OF JUNE NOTEBOOK

The notebook reproduced below was kept by Nicholas Pocock during the action which culminated in the Battle of the Glorious First of June. For the sake of clarity, a number of abbreviations and contractions have been spelt out in full. For instance 'TK' has been expanded to 'tack', 'sig.' to 'signal', 'pr.' to 'prepare', 'LH' and 'Ld H' to 'Lord Howe' and 'S by W' to 'south by west'. The original punctuation, spelling and use of capitals has been retained.

Notes taken on board His Majestys Ship Pegasus
from May 28 to June 1st 1794

Wind at South by West a Fresh Breeze Heavy Weather.
The British Fleet in the Established order of Sailing in
two Columns, on the Starboard Tack Lord Howe leading the Weather
Column. On the Weather beam of the fleet. Four ships
being stationed at 3 miles distant under the Command of
Rear Admiral Pasley. Viz. Bellerophon Russell, Thunderer
& Marlborough. at 8 AM our advanced Frigates made
Signal for a Strange Fleet to Windward. Lord Howe order R
A Pasley & Squadron prepare Signal to reconnoitre –
The Strange Fleet bore down upon us & were soon
discovered to be the Enemy consisting of 30 Sail in all
When they reached within about 7 Miles of us they began
to Haul into a Line on the Larboard Tack. Lord Howe accordingly
at 10 Tacked the British Fleet to keep under their lee
At 11 the enemy began Tacking in succession from their
Van, & from the length of time it took to perform this
Joined to their loss of Ground in backing and filling, being
in very bad order of Battle, our Chasing Squadron
Gained much on their Rear.
Lord Howe seeing they did not mean to come d[?]
made the Signal for a General Chase, to Attack or Har [ry]
the Enemys Rear. soon after to attack as arriving up [sic]
Lord Howe then tacked in Chase, as did the fleet, to keep
under the Lee of the Enemy. The ships of our Chasing
Squadron (having passed so near as to fire on the
Enemys rear in passing) stood on & tacked, nearly in
the Enemys wake, & pushed up towards their Rear
At 5 PM some of their near ships dropping astern
Obliged their Van to shorten Sail, as did the Whole Fleet
soon after. at 6 PM the Bellerophon having fetched within [?]
of a mile of the Sternmost ships Lee Quarter began firing
upon her & soon made signal for having a mast Wounded [sic]
which obliged her to keep a little further distant. The
Thunderer. Marlborough & Russell came up & fired unsuccessfuly on the
Sternmost ship & then dropped into the rear of each other
The Leviathan now coming up with a crowd of sail passed
the three ships above mentioned, & going between the
Bellerophon, & sternmost Ship of the Enemy engaged her close by
Lord Howe made Signal for Russell & Marlborough to assist Ships going
into Action, Audacious & Gibraltar were now also coming up
with a Press of Sail Leviathan seemed closely engaged &
the rest of the Advanced ships Attacking successively as before
at 8 Lord Howe made the General Signal to recall & form a
line ahead & astern of him as most convenient. The evening
being hazy 'tis possible this signal was not seen by all the
Ships, as some of them still remained by the enemy &
as long as we could discern [?] the Audacious, she carried
a crowd of Sail. Standing up in the Enemys Wake.
 The British Fleet got formed tolerably regular
in the beginning of the night & carried a smart sail
to fore reach & get abreast of the Enemy & the last
time we could see them, our Van had extended to
Almost the 8th or 9th ship from their Rear.
Wind still South by West a stiff Breeze & Cloudy Weather the Two
Fleets still on starboard tack, and distant about 4 miles
Our Van was abreast the headmost part of the Enemys

plate 74
The First of June notebook: Sketch no. 1
National Maritime Museum, London
Pocock's caption reads, 'This Sketch taken at ¼ past 6 PM. When the Russel A & Thunderer B are bearing up under the Enemy's Stern & Firing'. It shows the inconclusive action on 28 May. The French fleet is stretched out in a line from the middle distance to the horizon, and Lord Howe is flying the signal for the British to attack and harrass the enemy's rear.

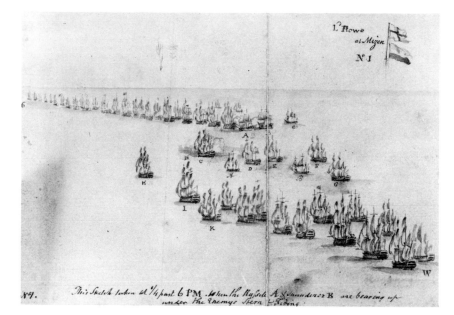

Notes for the Annexed Sketch No 1

A. Russell firing on the Enemys rear Ship
B. Thunderer, firing but farther astern
C. Bellerophon, firing on the Enemys Quarter
D. Marlborough having fired and dropped into the Rear
E. Leviathan coming up with all Sail set
F. Audacious coming up also –
G. Gibraltar coming up under Crowded Sail
H. The Caesar gaining ahead of the Queen Charlotte

I. Queen Charlotte
K. The Remainder of our fleet in chase, and without any prescribed order
A Pegasus
B Niger
C Latona
No1 The Sternmost Ship of the Enemys line a 3 deck
26 Their van Ship

Centre – As soon as the Admiral could see the position of each Fleet & that the *Audacious only* had parted Company during the Night He made Signal to Tack in Succession & soon after Signal (34) Viz that he means to pass through the Enemys line & gain the Wind. Our leading Ships when Tacked lay up a little to windward of the rear of the Enemy. The Enemy fearing that some of their Rear might be Cut began to wear, in succession from the van, Run down along their line to the sternmost ship & then hauled to the wind on the Larboard Tack in a line Parallel to ours. Our headmost ships passed so near as to fire on their Rear in passing. the Enemys Van then edged down on our van & seemed inclined to begin a General Action taking their own distance which in general is not very favourable to a British Fleet. This Lord Howe perceiving made signal to Tack in succession ½ past Eleven which he again annulled, supposing that it might not be completely seen in the Van through the Smoke as Six or Seven were now firing. at ½ past 12 Lord Howe again made Signal to Tack but *some unlucky Accident* Obliged our Leading Ship to make the Signal of Inability & she soon after Clewed up her Main Topsail. However at 20 minutes past One She again wore, & those astern of her tacked or wore as

NB

plate 75
**The First of June notebook:
Sketch no. 2**
*National Maritime Museum,
London*
Pocock's caption reads, 'This
Sketch taken at ½ past 11 when
Lord Howe made the Signal to
tack in succession from the
Van.'. It shows the situation
during the morning of 29th
May when Howe unsuccessfully
tried to close with the enemy in
order to bring the two fleets
into a general action.

References to Sketch 2

A.	Caesar not being ably to comply with Signal to Tack
B.	Queen
C.	Russell
D.	Valiant
E.	Royal George
F.	Invincible
G.	Orion
H.	Majestic
I.	Leviathan
K.	Queen Charlotte
L.	Bellerophon
M.	Marlborough
N.	Royal Sovereign
O.	Ramillies
P.	Tremendous
Q.	Montagu
R.	Alfred
S.	Brunswick
T.	Culloden
U.	Gibraltar
V.	Barfleur
W.	Glory
X.	Impregnable
Y.	Thunderer
Z.	Defence

most convenient. Lord Howe now having repeated the
Signal that he meant to pass through the Enemys line
and seeing that the Headmost Ships did not Clearly
understand his intentions & being impatient to Close
with the Enemy Tacked himself before it came to his turn
which Occasioned an Irregularity in our line & left the
Queen Charlotte to lead through the Enemys line followed
by the Bellerophon & I suppose some others, at ¼ past
2 *He* was passing between the 5 & 6 Ships from the
Enemys rear – *When* all the rest of our fleet had
passed the Rear & to Leeward of the Enemy, Lord Howe
made the Signal to Tack & for a General Chase –
The Queen, Russell & Invincible made Signal for wanting to
lay by, they being much damaged as were several
Others of the *Fleet*. The near ship of the enemy being
totally disabled, lay astern of them in the Midst of
Our ships, several of which fired at her in all directions
The French Admiral seeing this ship must be taken
if he stood on *Wore* his fleet in Succession from the Van
and rallied in a very Gallant Manner & in Good Order towards
Our Fleet, Lord Howe made Signal to wear also
Intending I suppose to oppose the Enemys van & cut
off the disabled ship & to this purpose bore down
himself, but seeing that there were but 2 or 3 ships
Near him, and many unable to join him, he
made Signal to Form the Line, as most Convenient

29th May
1794

on Starboard Tack & then kept his Wind, While the
French Fleet pushed up & carried off their disabled
Ship in tow. Then Wore in Succession & edged away
On Larboard Tack.

 Lord Howe remained on the Starboard Tack until
the Queen & other disabled Ships were able
to Join him & at 20 minutes past 5 He Wore & Edged down
after the Enemy. Which had now got to the distance
of about 6 miles & there appeared to have Hauled their
wind. Lord Howe edged down towards them till 7 PM
When he hauled to the Wind & then our van was
abreast the Rear of the Enemy distant about 6 miles

From the 29th at Night, 'till this day at noon a fog 1794
May 31st
Prevented anything of consequence occurring
and at intervals *only*, when the fog cleared. We
cou [ld] see the Enemy. Lord Howe seems determined
not to push at them under these Circumstances, for
 fear that we should not be able to do the business
Completely, even if they did allow us to Close, in
Consequence of the Obscurity of the Weather, at
Noon today what *He* looked for seemed to approach
the fog cleared away at ½ past one & the Enemy appeared
in a line to Leeward 7 miles distant Lord Howe formed the
Established Line of Battle hereunto annexed & edged
down on a prescribed Course, but the Enemy keeping
from the Wind, prevented our closing near enough
At ½ past 6 the Admiral seeing nothing decisive could
be done that night made the Signal to haul the Wind
on Larboard Tack. The Enemy soon after did the same &
then our van was abreast of their Centre the Frigates
from each fleet were placed in the Middle to observe
the Motions of their respective Enemies & the two fleets
remained nearly in this situation during the night
The British however carrying more sail in order
to be right abreast of the Enemy by daylight.

<div align="center">June 1st.</div>

Wind remains about South by West. Moderate Breeze & Cloudy
a Heavy Swell from the westward, at 4 AM saw 4 AM
the Enemys fleet right abreast of us & distant about 7 miles
right to Leeward & all still on Larboard Tack with
all Damages from 29th apparently repaired on both
sides, at 5 Lord Howe made signal to bear down,
Altering the Course *All together* at 7 being within
3 miles of the Enemy, the British Fleet hauled their
wind together & lay abreast the French which
was then waiting to give them Battle. During
this interval Lord Howe made the signal (34) that
He meant to pass through the Enemys Line &
Engage to Leeward N.B. the Captains not being
able to effect the specified purpose, are at liberty
to act as circumstances require. He then made
Signal: 36. viz that each ship was to steer for
& engage Independently of each other the ship
Opposed in the Enemys line, after sufficient
time had elapsed for the Several Captains to
Consider the present situation of each Fleet

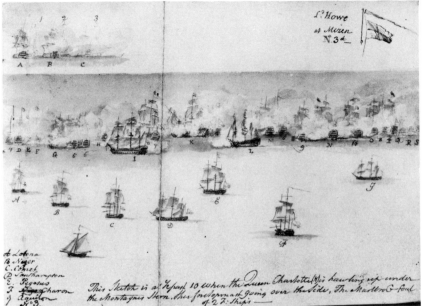

plate 76
The First of June notebook: Sketch no. 3
National Maritime Museum, London
Pocock's caption reads, 'This Sketch is at ½ past 10 when the Queen Charlotte (K) is hawling up under the Montagnes Stern. Her foretopmast going over the side. The Marlborough G foul of 2 French ships'. It shows the early stages of the battle on the 1st June. The frigate *Pegasus* (E) is in the centre of the picture, clear of the line-of-battle ships so that she can repeat the signals of Lord Howe's flagship, the *Queen Charlotte*.

Reference to No 3

A. Caesar Van Ship of Our fleet Engaging their Van
B. Bellerophon
C. Leviathan
D. Royal Sovereign driving & chasing a 3 decker out of the line
E. Barfleur
F. Impregnable
G. Marlborough H. Defence / I[?] [illegible] Invincible
J. Tremendous M Stays & Rigging Cut to pieces

K. Queen Charlotte luffing up under Montagus Stern
L. Gibraltar
M. Brunswick on board a French ship (Vengeur)
N. Queen
O. Orion
P. Royal George
Q. Montagu
R. Glory
S. Thunderer

And determine what plan was best to pursue in present Serious Situation, Lord Howe bore away & steered for the Montagne, a three decker in the Centre of their Line, the ships of the British fleet each did the same each towards his opponent.

At 9 the enemy began firing on the Headmost part of our Centre, & a Cannonade throughout the centre & van immediately took place & shortly after in most parts of our Rear, the Queen Charlotte for sometime desisted firing, She not being able to reach the Montagne, the latter endeavouring to Draw ahead, but the Gallant Charlotte at this Period though fired at by several of the Enemy at the time Set her Top Gallant sails & pushed through the line, with the Signal flying for Closer Action Soon after she had got Close to the Montagnes Quarter Firing into her and was endeavouring to come up alongside, but in coming to the wind after passing her Antagonists Stern, we saw Her Foretopmast Go. Which enabled the Montagne of course to shoot ahead & get clear of her. At ½ past 10 we saw the Marlborough Closely Engaged & a French Ship shot up under [illegible] & got foul

AM

½ past 10

plate 77
The First of June notebook: Sketch no. 4
National Maritime Museum, London
This sketch shows the situation around 1.30pm on the 1st June when the firing had ceased. Those French ships which have not been disabled are heading for the horizon (top left) 'in Tolerable Good Order'. Lord Howe in the *Queen Charlotte* (L) is making the signal to wear together and form a line ahead and astern of him.

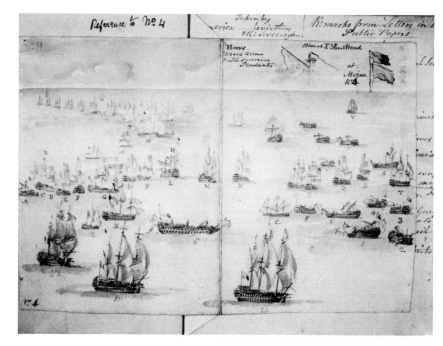

Reference to No 4

A. Bellerophon. Fore & Main Topmast gone & much shattered
B. Valiant – Main Topsail yard gone & much damaged
C. Royal Sovereign. No Masts or yards gone in this Action but much shattered
D. Russel. Foretopmast and Gib boom gone
E. Caesar, not materially damaged to Outward View but Several shot through her sails
F. Barfleur. Masts Rigging & Sails Much Cut
G. Impregnable. Ditto.
H. Defence – Totally dismasted
J. Invincible, not much damaged this Action
K. Orion Main Topmast & Main Yard Gone
L. Queen Charlotte Fore & Main topmasts gone Yards much wounded hanging up and down. Signal to Wear.
M. Thunderer Sails & rigging Cut but not very Materially
N. Gibraltar. ditto

O. Alfred - ditto.
P. Ramillies ditto
Q. Glory – Foretopmast gone, otherwise not much disabled.
R. Montagu. Sails & Rigging much damaged
S. Royal George Foremast Main topmast gone, Much disabled.
T. Culloden much disabled in Sails & Rigging
U. Marlborough. totally dismasted
V. Brunswick Mizen Mast gone & running before the Wind to get Clear of the French Fleet
W. Queen – Main Mast Mizen topmast & fore yard gone Firing on Enemy in Passing
X. Leviathan, Foremast & Foreyard much wounded Sails & Rigging much damaged
A. Pegasus being ordered to take the Queen in Tow
B. Niger.
C. Aquilon, taking the Marlborough in Tow.

Of Her lee Quarter & having fresh way shoved the
Marlborough round head to wind, when all her
sails took aback & she fell on board the Frenchman
to Windward. While they were foul of each other
another Frenchman got foul of the ship [illegible]
On board the Marlborough & they all three remained
So for some time the Middle Ships Bowsprit
at last gave way & the Marlborough got clear &
left the two Frenchmen foul of each other
We once or twice also had a good opportunity of seeing
the Royal Sovereign sticking Close to a Three decker
in the van & at last obliging him to bear up & she
then chased him to Leeward. The Queen I also

June

had an opportunity sometimes of observing & though
it may be improper to particularise where Clouds
of smoke kept the chief part of the Fleet totally covered
yet there appeared something so superior in her fire
to that of the Enemy that I cannot desist mentioning
Her. The action continued very violent till
Near one o'clock & the ships dismasted seemed
to emerge from the Smoke
in such a manner that we could not see even
who they had engaged last. at about One the
French who had it in their power disengaged
themselves from the British Fleet 10 Sail appeared
to Leeward of ours & Endeavouring to form a line
Three sail of the Line had tacked from the Van &
were working to Windward Clear [?] of all our ships
About ½ past one Lord Howe seeing that the Enemy
had formed the line to Leeward & were standing up
towards their disabled ships 8, 9, 10 & 11 (in Sketch 4)
He made signal to Wear together & form a line
ahead and astern of him as most convenient
The Ships being so disabled 'twas a long time
before this was Effected, so that the four disabled
ships going before the Wind all the while
had got so far to leeward before our ships could
prevent them that they joined the above mentioned
ten sail. Lord Howe now made signal to secure
the disabled ships and Seven were taken possession of

<div align="center">June 1st Continued</div>

The firing having Ceased about 1 PM the following	No 4
Sketch represents the situation 1.2.3.4.5.6.7. &c. the	
French ships the 7 first of which being totally	
dismasted we took possession of, the ship 4 is the	
Vengeur which sunk the same evening.	
The ten sail mentioned to have run to	12.13.14.15.16.
Leeward, and are forming a line on the Starboard Tack	17.18.19.20.21
Most of which are in Tolerable Good Order	
These are three ships which with the America	22.23.24
Tacked from the Enemys van & hauled their wind	
and got clear, except the latter which was	
dismasted by the [blank] in the attempt	
Two of which are ships of 74 Guns from a Three	8.9.11
Decker totally dismasted & driving before the	
Wind under their Spritsails & afterwards Joined	
their Own Fleet & were carried off.	
A Three decker with the Foremast only Standing	10.
and running to Leeward Escaped –	

LIST OF PICTURES
IN BRITISH PUBLIC COLLECTIONS

Explanation

Measurements are in centimetres, followed by inches, height before width (s) indicates that the picture bears the artist's signature or initials, (d) that it is dated; 'oil' is an oil painting on canvas; 'w/c' is a watercolour or pen and wash drawing; 'pencil' is a pencil drawing with no wash additions.

ABERYSTWYTH, National Library of Wales

From the Priory Walk towards the Beacon, w/c, 16.0 × 20.7 (6 ¼ × 8 ⅛).
Part of the Castle, Brecon, the Van and Beacon hills in the distance, w/c, 16.0 × 20.7 (6 ¼ × 8 ⅛).
The Priory church and part of Brecon, w/c, 15.9 × 20.8 (6 ¼ × 8 ¼).
The Priory at Brecon, w/c, 16.0 × 20.5 (6⅜ × 8⅛).
Crickhowell looking westward, w/c, 15.3 × 20.5 (6 × 8 ⅛).
Crickhowell from the west, w/c, 16.0 × 20.5 (6 ¼ × 8 ⅛).
Two miles from Abergavenny, w/c, 20.5 × 16.2 (8 ⅛ × 6 ⅜).
Brin Arrw, 3 miles from Abergavenny, w/c, 16.0 × 20.1 (6 ¼ × 8).
Christ Church, Monmouthshire, w/c, 20.1 × 28.6 (8 × 11 ¼).
From Llantony Abbey towards Llanvihangell, w/c, 15.8 × 20.4 (6 ¼ × 8).
Llantony Abbey, w/c, 20.7 × 33.0 (8 ⅛ × 13).
Llantony Abbey with surrounding countryside, w/c, 20.3 × 28.2 (8 × 11 ⅛).
At Llanvihangell 5 miles from Abergavenny, w/c, 16.0 × 20.5 (6 ¼ × 8 ⅛).
Near the Rt. Hon. Earl of Oxfords, w/c, 16.2 × 20.9 (6½ × 8¼).
Seat of Lord Oxford near Abergavenny, w/c, 15.7 × 20.6 (6 ¼ × 8 ⅛).
Aberystwyth from the north side of the bay, (s), w/c, 17.8 × 26.3 (7 × 10 ⅜).
Llanfarian, near Aberystwyth, w/c, 21.6 × 31.2 (8 ½ × 12 ¼).
Aberystwyth, (s and d 1794), w/c, 43.5 × 61.5 (17 ⅛ × 24 ¼).
Beaumaris Bay from Redhill, Anglesey, (s and d 1814), w/c, 19.4 × 27.7 (7 ⅝ × 10 ⅞).
Caernarvon Castle from the South East, (s and d 1796), w/c, 40.4 × 52.7 (15 ⅞ × 20 ⅞).
A view of Kilway Hill towards Brittons Ferry, taken from the waterside opposite the bay of Neath, (s and d 1790), w/c, 43.3 × 60.7 (17 ⅛ × 24).
St. Vincent's Rock near Bristol, (s and d 1789), w/c, 26.8 × 49.8 (10 ½ × 15 ⅝).
Merioneth Slate Quarry, (s and d 1795), w/c, 42.5 × 59.6 (16 ⅝ × 23 ½).
Loading slates with Dolbardern Castle and Snowdon in the background, (s and d 1795), w/c, 41.7 × 59.4 (16 ⅜ × 23 ½).
Welsh peasant family, w/c, 12.7 × 16.8 (5 × 6 ⅝).

BELFAST, Ulster Museum

Attack of the French Squadron under Monsieur Bomport chef d'Escadre upon the coast of Ireland, by a detachment of His Majesty's Ships under the command of Sir J.B. Warren, Oct. 12, 1798, (s and d 1799), oil, 69.4 × 99.5 (27 ⅜ × 39 ⅛).

Pursuit of the French Squadron after the surrender of 'Lettoche' 84 and 'Coquille' 44, with the action of the 'Ethalion' and 'Bellone' and the 'Anson', bearing down the war ships of the enemy, Oct. 12, 1798, oil, 70.0 × 100.0 (27 ½ × 39 ⅜).
Stormy scene on a rocky coast, (s and d 1792), w/c, 35 × 48.5 (13 ⅞ × 19).

BIRMINGHAM, City Museums and Art Gallery

Town and Harbour of Montego Bay in the Parish of St. James's, Jamaica, (s on verso), w/c, 37.0 × 54.3 (14½ × 21⅜).

BRISTOL, City Museum and Art Gallery

Bristol harbour with the Cathedral and the Quay, (s and d 1785), oil, 57.2 × 81.2 (22½ × 32).
Port of Tenby, (s and d 1789), w/c, 40.3 × 59.5 (15⅞ × 23⁷⁄₁₆).
View over Kingsweston towards the Bristol Channel, w/c, 43.8 × 65.1 (17¼ × 25⅞).
Kingroad from Portishead Point, near Bristol, (s and d 1787 Decr.), w/c, 42.5 × 58.1 (16¾ × 22⅞).
A rural scene with a woman on a horse, children and donkeys, w/c, 31.0 × 44.2 (12¼ × 17⁷⁄₁₆).
Portrait of a boy with bow and arrow, w/c, 30.2 × 21.5 (11⅞ × 8½).
The Old Geyser, Iceland, w/c, 28.8 × 20.5 (11⅜ × 8⅛).
Ilfracombe, w/c, 11.8 × 18.9 (4⅝ × 7⁷⁄₁₆).
Men rowing a boat on stormy sea, w/c, 1⁷.8 × 29.8 (7 × 11¾).
View over Kingsweston to the Bristol Channel at sunset, w/c, 16.5 × 23.5 (6½ × 9¼).
The Bristol Channel from near Kingsweston, w/c, 18.4 × 25.7 (7¼ × 10½).
The Welsh Back, Bristol, (s and d 1816 Novr, 3d), w/c, 26.2 × 39.0 (10⁵⁄₁₆ × 15⅜).
A view of the ship 'Cumberland,' (s and d 1778), w/c, 24.9 × 48.2 (13¾ × 19).
His Majesty's frigate 'Arethusa', w/c 47.7 × 63.8 (18⅞ × 25⅛).
A view of Dover and a ship of war making sail, (s and d 1769), w/c, 17.5 × 25.4 (6¹⁵⁄₁₆ × 10).
A view of a ship of war clearing hawse and making the signal to unmoor, (s), w/c, 17.6 × 25.5 (6⅞ × 10).
A view of the 'Jason', privateer, w/c, 41.1 × 60.6 (16³⁄₁₆ × 23⅞).
The 'Southwell' frigate, trading on the coast of Africa, w/c, 43.8 × 55.6 (17¼ × 21⅞).
A view of the 'Blandford' frigate, w/c, 42.5 × 55.2 (16⅞ × 21¾).
The docks at Wapping, Bristol, w/c, 45.1 × 58 (17¾ × 22⅞).
A view of the south west side of the house of Thomas Tyndall, Esq., at the Fort near Bristol, (s), w/c, 37.4 × 50 (14¾ × 19¾).

ALSO

Examples of Pocock's eight engraved views on the Avon in various states (many of them hand-coloured and signed and dated by the artist); and a sketchbook of landscape and coastal views.

CAMBRIDGE, Fitzwilliam Museum

Mountain landscape with sea and boats in the foreground, (s and d 1802), w/c, 15.9 × 23.2 (6¼ × 9⅛).

CARDIFF, National Museum of Wales

Caernarvon Castle and Bay, oil, 94.0 × 118.1 (37 × 46½).
Barmouth, w/c, 21.0 × 30.5 (8¼ × 12).
Beddgelert, w/c, 19.7 × 28.3 (7¾ × 11⅛).
Conway Castle, w/c, 19.1 × 25.7 (7½ × 10⅛).
Conway Castle, (s and d 1797) w/c, 42.6 × 60.3 (16¾ × 23¾).
A Cottage, w/c, 20.3 × 29.8 (8 × 11¾).
Castle by a river, w/c, 22.2 × 33.0 (8¾ × 13).
Landscape, w/c, 14.6 × 23.8 (5¾ × 9⅜).
Landscape, w/c, 19.0 × 27.0 (7½ × 10⅝).
Landscape, w/c, 22.2 × 29.8 (8¾ × 11¾).
Llanstephan Castle, w/c, 24.2 × 36.9 (9½ × 14½).
Llyn Idwal, w/c, 15.9 × 22.9 (6¼ × 9).
Nr Llyn Idwal, w/c, 18.4 × 31.7 (7¼ × 12½).
Menai Straits, w/c, 18.4 × 29.5 (7¼ × 11⅝).
Mountain Scene, w/c, 18.4 × 27.3 (7¼ × 10¾).

View in Snowdon, w/c, 15.9 × 22.2 (6¼ × 8¾).
Near Tan-y-Bwlch, w/c, 19.0 × 28.6 (7½ × 11¼).
Tan-y-Bwlch, w/c, 20.3 × 29.9 (8 × 11¾).
Tenby Castle, (s and d 1790), w/c, 31.7 × 43.8 (12½ × 17¼).
Tonge, w/c, 19.7 × 15.2 (7¾ × 6).

EXETER, Royal Albert Memorial Museum
Dunster Castle, w/c, 49.8 × 71.6 (19⅝ × 28¼).

GATESHEAD, Shipley Art Gallery
A coast scene, oil, 71.1 × 48.2 (28 × 19).
Seapiece with British men-of-war, oil, 55.8 × 43.2 (22 × 17).

LEEDS, City Art Gallery
Towing a warship out of Bristol harbour, (s and d 1783), w/c

LONDON, The British Museum
HMS 'Windsor Castle', w/c, 14.6 × 22.2 (5¾ × 8¾).
Lynton, Devonshire, (s and d 1801), w/c, 26.0 × 37.2 (10¼ × 14⅝).
View on the sea coast, w/c, 181. × 26.4 (7⅛ × 10⅜).
On the coast of Somerset, w/c, 14.3 × 21.9 (5⅝ × 8⅝).
Shipping in a storm, w/c, 23.2 × 27.6 (9⅛ × 10⅞).
A series of four drawings of Rear Admiral Sir Samuel Hood's actions in the West Indies, each drawing accompanied by an explanatory memorandum by the artist. All four memoranda are signed by the artist and dated 1784:
The English and French fleets off Fort Royal, Martinique, April 29, 1781, at 7 a.m. w/c, 19.7 × 41.0 (7¾ × 16⅛).
The English and French fleets in the same position, from a different point of view, w/c, 19.4 × 40.6 (7⅝ × 16).
Partial engagement between the English and French fleets off Martinique, (s and d 1784), w/c, 19.7 × 41.0 (7¾ × 16⅛).
Skirmish between the English and French fleets off Dominica, 9th April 1782, (s), w/c, 20.0 × 41.3 (7⅞ × 16¼).
Eastbourne, Sussex, (s and d 1800), w/c, 32.7 × 45.1 (12⅞ × 17¾).
Dunster from Blue Anchor, Somerset, w/c, 30.3 × 44.2 (12⅛ × 17⅜).
Brockly Combe, Somerset, (s and d 1790), w/c, 34.2 × 47.3 (13½ × 18⅝).
Ischia from Posilipo, (s and d 1793), w/c, 55.2 × 80.0 (21¾ × 31½).
A series of watercolour drawings for the 1804 edition of William Falconer's poem *The Shipwreck*. Pocock's illustrations were engraved by J. Fittler.
1) *The launch of the 'Britannia' merchantman off Deptford*, w/c, 10.2 × 13.4 (4 × 5¼).
2) *The ship unmooring by moonlight off Candia*, (s and d 1803), w/c, 17.2 × 13.4 (6¾ × 5¼).
3) *The waterspout* (s and d 1803), w/c, 12.0 × 13.3 (4¾ × 5¼).
4) *The ship driving past Falconera* (s and d 1803), w/c, 20.7 × 13.3 (8⅛ × 5¼).
5) *Arion and the body of Palemon; rejected design*, w/c, 22.9 × 13.3 (9 × 5¼).
6) *Arion and the body of Palemon; final design*, w/c, 14.6 × 13.3 (5¾ × 5¼).

LONDON, Courtauld Institute
On the Dart, (s and d 1790), w/c, 28.9 × 40.3 (11⅜ × 15⅞).
Coast scene, w/c, 19.0 × 38.8 (7½ × 15¼).
York Minster, w/c, 30.0 × 42.1 (11¾ × 16½).
Jacomb relating his dreams, (s and d 1781), w/c, 12.0 × 20.6 (4¾ × 8⅛).
Eight figures in costume (from Lord Stanley's expedition to Iceland), w/c, 14.1 × 22.8 (5½ × 9).
A sailing ship and other vessels in the Thames estuary, (s and d 1796), w/c, 25.5 × 38.1 (10⅛ × 15).

LONDON, National Maritime Museum
1 Oil paintings: actions, in chronological order.
The battle of Quiberon Bay, 20 November 1759 (after Dominic Serres), (s and d 1812).
The battle of Frigate Bay, 26 January 1782, (s and d 1788), 120.6 × 215.8 (47½ × 85), GI I.23.
The 'Defence' at the battle of the Glorious First of June, 1794, (s and d 1811), 25.5 × 50.8 (14 × 20), GH.134.

The fight between the 'Brunswick' and the 'Vengeur' at the battle of the Glorious First of June, 1794, (s and d 1796), 137.8 × 189.5 (54¼ × 74⅝), 34–59.
The battle of Cape St. Vincent, 14 February 1797: the 'Captain' capturing 'San Nicolas' and 'San Joseph', (s and d 1808), 35.5 × 53.3 (14 × 21), 38–1269
The capture of Trinidad, 17 February 1797, (s and d 1800), 77.5 × 118.1 (30½ × 46½), 36–51.
The capture of the 'Resistance' and the 'Constance' by the 'San Fiorenzo' and the 'Nymph', 9 March 1797, 77.2 × 114.6 (30⅜ × 45⅛), 25–157.
The battle of the Nile, 1 August 1798, (d 180[8?]), 71.1 × 101.9, (28 × 40⅛), 38–1270.
The cutting out of the 'Hermione', 24 October 1799, 48.2 × 64.5 (19 × 25⅜), GH.56a.
The battle of Copenhagen, 2 April 1801, (s and d 1806), 71.4 × 101.9 (28⅛ × 40⅛), 38–1271.
The battle of Trafalgar, 21 October 1805: breaking the line, 71.4 × 101.9 (28⅛ × 40⅛), 38–1272.
The battle of Trafalgar, 21 October 1805: the close of the action, (s and d 1807), 71.6 × 101.9 (28¼ × 40⅛), 38–1273.
Duckworth's action off San Domingo, 6 February 1806, (s), 122.5 × 183.5 (48¼ × 72¼), 39–1761.

2 Oil paintings: general subjects
His Majesty's dockyard, Woolwich, (s and d 1790), 135.2 × 276.8 (53¼ × 109), GH.255.
His Majesty's dockyard, Plymouth, (s and d 1798), 134.6 × 186.7 (53 × 73½), GH.257.
Portrait of the frigate 'Triton', (s and d 1797), 39.7 × 56. 2 (15⅝ × 22⅛), GH.147.
Ships of the East India Company at sea, (s and d 1803), 61 × 92.1 (24 × 36¼), 50–352.
Nelson's ships, (s and d 1807), 37.2 × 55 (14⅝ × 21⅝), 38–1274.
The 'Royal Sovereign' yacht conveying Louis XVIII to France, 24 April 1814, 127 × 177.8 (50 × 70) 27–246.

3 Oil paintings formerly attributed to Nicholas Pocock
His Majesty's dockyard, Deptford, by Joseph Farington (1747–1821), 138.4 × 195.1 (54⅛ × 77), GH.254.
His Majesty's dockyard, Chatham, by Joseph Farington, 90.2 × 279.3 (35½ × 110½), GH.256.
The battle of the Saints, 12 April 1782, probably by J.T. Serres. (1759–1825), 86.7 × 136.8 (34⅛ × 53⅞), 39–427.

4 Watercolours
There are some 300 watercolours and loose pencil drawings by Pocock in the Print Room. They range from highly finished exhibition pieces to the most cursory of notes and sketches. There are also three albums of sketches. The most significant of the watercolours and drawings were shown in the Pocock exhibition which was held at Greenwich in 1975, and were described in the exhibition catalogue. The remainder await detailed examination and cataloguing.

LONDON, Royal Collection
Sir Robert Calder's action off Cape Finisterre (s and d 1812), 101.6 × 154.9 (40 × 61).
Sir Richard Strachan's action off Ferrol (s and d 1812).
Ships in a gale, 48.6 × 74.2 (19⅛ × 29⅛).

LONDON, Victoria and Albert Museum
Llanstephan Castle, coast of Carmarthenshire, w/c, 36.6 × 52.4 (14⅜ × 20⅝).
Shipping in a calm, and groups of figures ashore at Basseterre, St Kitts, (s and d 1791), w/c, 49.5 × 69.9 (19½ × 27½).
Melincourt Cascade, Neath, South Wales, (s and d 1789), w/c, 29.2 × 37.5 (11½ × 14¾).
Mountainous country, (s and d 1790), w/c, 43.2 × 60.6 (17 × 24).
Humorous sketch, (s), w/c, 19.7 × 31.7 (7¾ × 12½).
Coast scene, w/c, 18.5 × 26.4 (7¼ × 10⅜).
Bangor with Penmaenmawr in the distance, (s and d 1795), w/c, 30.1 × 43.0 (11⅞ × 17).

Rocky landscape with children, (s and d 1791), w/c, 56.5 × 77.8 (22¼ × 30⅝).
Coast scene with merchant shipping, w/c, 16.8 × 25.1 (6⅝ × 9⅞).
View of Bristol harbour with St Mary Redcliffe, (s and d 1784), w/c, 24.5 × 37.6 (9¾ × 14⅞).
Children and goats, w/c, 26.4 × 31.5 (10⅜ × 12⅜).

MANCHESTER, City Art Gallery
Shipping, (s), w/c, 20.8 × 28.5 (8¼ × 11¼).
View of the Bristol Observatory and Old Pump Room on the River Avon, 1787, (s and d 1787), w/c, 41.2 × 58.5 (16¼ × 23).

MANCHESTER, Whitworth Art Gallery
Carrick on Suir, Waterford, Munster, (s and d 1805), w/c, 24.9 × 31.7 (9¾ × 12½).
Mount Vesuvius, w/c, 15.2 × 23.7 (6 × 9¼).

NEWCASTLE-UPON-TYNE, Laing Art Gallery
Coast scene with shipping, w/c, 59.0 × 82.5 (23¼ × 32½).
Seascape with shipping, w/c, 15.2 × 22.2 (6 × 8¾).

NEWPORT, Museum and Art Gallery
Clifton from the River Avon, 1788, w/c, 40.5 × 55 (16 × 22).
Chepstow Castle, Monmouthshire, from the North, w/c, 52.1 × 77.5 (20½ × 30½).

NORWICH, Castle Museum
Vessel in distress, Yarmouth, (s and d 1815), oil, 43.2 × 61.2 (17¹⁄₁₆ × 24¹⁄₁₆).
Saving a crew at Corton, oil, 43.3 × 60.9 (17¹⁄₁₆ × 24).
Dixon Church near Monmouth on the Wye, (s and d 1791), w/c, 26.4 × 39.5 (10⅜ × 15½).

OXFORD, Ashmolean Museum
The Hotwells with St. Vincent's Rock from Rownham Ferry, (s and d 1791), w/c, 25.6 × 37.5 (10⅛ × 14¾).
Cooks Folly from ye new Hotwells, (s and d 1791), w/c, 25.4 × 38.3 (10 × 15⅛).
Italianate landscape with a waterfall, w/c, 37.1 × 50.5 (14⅝ × 19⅞).
Wooded landscape with cattle watering, (s and d 1793), w/c, 45.0 × 60.7 (17¾ × 23⅞).

PLYMOUTH, City Museum and Art Gallery
The wreck of the Dutton in Plymouth Sound, oil, 66.5 × 96.6 (26⅛ × 38).
Sketch of Drake Island, Plymouth, w/c, 9.5 × 22.8 (3¾ × 9).

TRURO, County Museum and Art Gallery
Warships in the Solent, (s and d 1793), w/c, 29.8 × 47 (11¾ × 18½).

INDEX